The reality oᵢ ᵢᵢᵢᵢᵢ

Manchester University Press

The reality of film

Theories of filmic reality

RICHARD RUSHTON

Manchester University Press

Manchester and New York

distributed exclusively in the USA by Palgrave

The right of Richard Rushton to be identified as the author of this work has been asserted by him in accordance with the Copyright, Designs and Patents Act 1988.

Published by Manchester University Press
Oxford Road, Manchester M13 9NR, UK
and Room 400, 175 Fifth Avenue, New York, NY 10010, USA
www.manchesteruniversitypress.co.uk

Distributed in the United States exclusively by
Palgrave Macmillan, 175 Fifth Avenue,
New York, NY 10010, USA

Distributed in Canada exclusively by
UBC Press, University of British Columbia, 2029 West Mall,
Vancouver, BC, Canada V6T 1Z2

British Library Cataloguing-in-Publication Data is available

Library of Congress Cataloging-in-Publication Data is available

ISBN 978 0 7190 9137 7 paperback

First published by Manchester University Press in hardback 2011

This paperback edition first published 2013

The publisher has no responsibility for the persistence or accuracy of URLs for any external or third-party internet websites referred to in this book, and does not guarantee that any content on such websites is, or will remain, accurate or appropriate.

Printed by Lightning Source

For Donna

Contents

List of illustrations

Acknowledgements

This project has benefited from input, suggestions and debate with a number of colleagues, especially Nick Gebhardt and Fred Botting. Others have given great support along the way, including Elizabeth Cowie, Annette Kuhn, John Mullarkey and D.N. Rodowick. Many thanks to the staff at The Picture Desk for making the gathering of images such a painless task. A Research Leave Award from The Arts and Humanities Research Council in the United Kingdom enabled most of this book to be written. Special thanks to James Donald at the University of New South Wales and John Lechte at Macquarie University who set up research seminars for me to test-run some of the material from this book.

Introduction: On the reality of film

1 *Listen to Britain* (Humphrey Jennings, 1942)

What this book is about

Some years ago Cornelius Castoriadis asked why the imaginative products of human existence – dreams, works of art, cultural objects and so on – are never seriously considered to be of primary importance. He wondered why objects that are imbued with what we call 'reality' are invariably things that are physical, material or natural, as distinct from the creations of human imagination. Castoriadis stated his position in the following terms:

> Remember that philosophers almost always start by saying: 'I want to see what being is, what reality is. Now, here is this table. What does this table show to me as characteristic of a real being?' No philosopher ever started by saying: 'I want to see what being is, what

reality is. Now, here is my memory of my dream of last night. What does this show to me as characteristic of a real being?' No philosopher ever starts by saying: 'Let Mozart's *Requiem* be a paradigm of being, let us start from that'. Why would we not start by positing a dream, a poem, a symphony as paradigmatic of the fullness of being and by seeing in the physical world a *deficient* mode of being, instead of looking at things the other way round, instead of seeing in the imaginary – that is, human – mode of existence, a deficient or secondary mode of being? (Castoriadis 1997a: 5)

What Castoriadis argues here is that philosophers ought to consider that they have things back to front: they have sought to determine the reality of things only in so far as those things are divorced from human imagination and creativity. He therefore asks the philosophers to reverse their approach and begin with humanity's creative acts – dreams, poems, music – as the basis of ontological enquiry. Let the imaginary aspects of human life be those that determine the reality of things. Why should the creative aspects of the world be deemed secondary, as ornaments, as products devoid of being, a being which is reserved solely for natural or physical objects? Why shouldn't we take up Castoriadis's challenge and instead begin from the creative imagination of the human as a primary mode of being and then regard the physical, material world as a secondary one, as one that can only be secondarily derived from the primary substances of human creativity?

In this book I take up Castoriadis's challenge – though my examination of the 'reality of things' is here concentrated on films. I argue that films are part of reality. Against the idea that films are abstracted from reality and can thus only offer a deficient mode of reality, I instead try to see films as part of the reality we typically inhabit, as part of the world we live in, as parts of our lives. I argue that films help us to shape what we call 'reality'. It is this attempt to acknowledge the reality of film that I call *filmic reality*.

My attempts to spell out exactly what I mean by filmic reality over the many months of this project have most often led to my being tied up in rhetorical knots. Why might this be so? I believe that my difficulty in providing a clear definition of just what filmic reality is derives to a large extent from the fact that it is a concept that lies well beyond the accepted paradigms of thinking about films (as indeed Castoriadis stresses a similar blind spot central to conceptions of philosophy). It seems to me that film scholars and students are invariably drawn towards trying to determine what a film represents, that is, to looking at films as at best a secondary

mode of being, so that any claim for the reality of films is most often met with either the blank stare of bafflement or outright repudiation (one recent book, for example, can only bear to say that films are a cousin of reality, not reality itself; another that they are refractions of reality; see Frampton 2006: 2; Mullarkey 2009). In fact, I know of only one research project that has aimed to take the reality of film seriously. Martin Barker and Kate Brooks (1998), in their audience study of *Judge Dredd* (1995), repudiate the widespread belief that films can be accounted for on the basis of their adequacy to reality; that is, in terms of how 'true to reality' they are. They argue that an emphasis on truth and adequacy as determining criteria for films can only presume a rigid demarcation between what is real and what is non-real, between what is real and what is make-believe or illusion. If some films are merited for their adequacy to reality, then it stands that other films must fall short of the claim to reality. Barker and Brooks thus emphasize that the demarcation between the real and the non-real in films effectively blocks a more important question: 'what do people *do* with their filmic experiences?' (Barker and Brooks 1998: 165). Although I do not share in Barker's and Brooks's faith that audience research can effectively provide answers to the question of what people do with films, I am nevertheless asking a very similar question: what can films do and, as a consequence, what can we *do* with films? This question is central for an understanding of filmic reality precisely because it is one that breaks down the rigid dichotomy of real versus non-real in the cinema, or, as I put it more forcefully in the early chapters of this book, the distinction between reality and illusion in the cinema.

One of the central arguments of this book is that, by relying on the distinction between reality and illusion in the cinema, film studies has – perhaps unwittingly – relied on a logic of representation; it has shut films off as a deficient and secondary mode of reality. If the task for film scholars is to clarify what should be accepted as real in the cinema, and to warn against what is illusory or non-real, then such arguments can be made only on the basis of judgements about truth and adequacy. Such 'truths' about cinematic experiences in the final instance must be made on account of any particular film's strategies of representation and can ultimately only be guided by the question of whether such and such a film is representing the 'real world' truthfully or adequately. It is such questions of the truth or adequacy of filmic representations that the present book tries to repudiate. I am well aware that cinema is often regarded as being one of what is known as the 'representational arts' or 'repre-

sentational media', but what I want to take issue with here is the question of why anyone would feel the need to declare that cinema re-presents anything. Rather, what I want to argue by way of filmic reality is that films do not re-present anything. Instead, they create things; they create realities, they create possibilities, situations and events that have not had a previous existence; they give rise to objects and subjects whose reality is filmic.

Therefore, the question of what a film represents is antithetical to the aims of this book. Rather, what this book asks is: what do films do? How do films feature as part of the way we structure our lives? In what ways might films influence the ways we think about the world? In what ways do the impressions or thoughts we collect from films add to our experiences of reality? In what ways do films contribute to our understanding of reality? In short, in what ways do films become parts of our lives, parts of our world, parts of our reality?

An example

I think the best way to begin is with an example. In one section of her book on *Family Secrets*, Annette Kuhn investigates some very specific and personal responses she had to two films. The first of these, Humphrey Jennings's ode to the British home front experiences of the Second World War, *Listen to Britain* (1942), is especially poignant for Kuhn, for it provides her with what she takes to be memories of the war even though the images which provide these memories are of events that occurred before she had been born. She thus defines the way *Listen to Britain* helps her to flesh out a reality, even if this reality is one that for her never took place in the so-called 'real world'. What concerns Kuhn is not what these images represent. Rather she is concerned to discover what these images make possible. What certain images in this film have become for Kuhn are realities, realities she associates with the war effort and the experience or memory of the war. These are not experiences or memories of things that 'really' happened to her, but they are experiences or memories that have been imbued with a *filmic* reality. The reality of her filmic experiences of *Listen to Britain* are such that they give rise to real feelings, real meanings and even what seem to be real memories. Kuhn's responses to the film go some way towards defining what I mean by filmic reality.

Kuhn's ruminations in fact go far deeper. She reveals the intensity with which the film's images worked their way into her experience

and understanding of the world. She does so by ascribing to the film a 'story'. This story unfolds in the following way. Walking around a particular area outside the British Museum in London, for reasons that are not entirely clear to her, evokes the ambience, mood, feeling, memory or, perhaps one might say, the *presence* of *Listen to Britain*. Kuhn explains that 'Although no such scene occurs in the film, this experience is unequivocally associated for me with *Listen to Britain*' (Kuhn 2002: 113). She further explains that 'This feeling is so strong that I am convinced my reverie must depend on my knowing the film' (ibid.). What Kuhn thus acknowledges is that this experience is one that does not depend on her knowledge of the events of the war – it does not depend on a prior reality which the film evokes or represents – and nor is it an experience reducible to the atmosphere of a particular area outside the British Museum. It is an experience that depends for her on knowing the film – it is a reality that is produced by *Listen to Britain* and by the impact this film has had on her understanding of the world. In this way, I think the experience Kuhn describes is one of filmic reality.

With Kuhn's insights in mind, some more questions can be asked of the notion of filmic reality. Perhaps it is possible to say that one of the questions to be asked of filmic reality is: How do we use films in ways that help us to understand the world, ourselves, and our relations to others? Or more pointedly: What is it possible for films to *make real*? For Kuhn, *Listen to Britain* makes real an experience or memory of the Second World War at the same time as it gives body to her experience of walking in a particular area outside the British Museum. Her reverential experience near the British Museum is granted some degree of meaningfulness to the extent that it allows her to experience herself, to realize a specific memory, even though that memory is not a personal memory of anything that 'really happened' to her. What makes this kind of experience one that can be associated with the notion of filmic reality is that it is one that could have arisen only on the basis of Kuhn's having seen *Listen to Britain*. The film contributes to her knowledge, understanding and negotiation of the world around her and, as such, this filmic reality enables her to experience reality in a way that it could not be experienced without the intervention of *Listen to Britain*.

Perhaps a simpler way of conceptualizing these issues is by more straightforwardly asking: What do films allow us to realize? How do films allow us to make sense of experiences, thoughts and feelings in such a way that we become able to incorporate them into the reality of our personalities, our memories, our 'being'? It

seems, more often than not, that films are understood to be mere fantasies, escapes from the real world, dream worlds that allow audiences to forget the reality of their lives for a few hours so as to be withdrawn into another world, a world that is distinctly separated from the realities of everyday lives. Or, correlatively, films are understood to be imbued with signs or symbols that reflect real historical instances or cultural predilections (in the former case, for example, that *The Searchers* (John Ford, 1956) is indicative of race relations in the United States in the 1950s; in the latter, to give another example, that *HouseSitter* (Frank Oz, 1992) expresses a return to old-fashioned conceptions of the romantic heterosexual couple; on these films, see Henderson 1985; Krutnik 2002). From such a perspective, a film can only ever 'reflect' or 'represent' issues that have their foundation in the 'real' social world. It is as though, by drawing these comparisons, film scholars and critics express a need to maintain a strict division between what happens in the 'filmic' realm and what happens in the 'real' world. On the basis of this division, the 'real world' is always the realm by virtue of which films themselves are judged; in one way or another, films are measured by their adherence or faithfulness (or lack of adherence or faithfulness) to the real world. Of course, adherence and faithfulness to the real world have nothing to do with a film's real*ism* – films need not be in any way realistic to represent the struggles or joys of the real world. Whether films are fantastic or realistic, the dominant way in which films are judged and measured is on the basis of their adherence or faithfulness to the real world – at least, that is the claim this book defends.[1] From such a perspective, films in themselves cannot be repositories of reality, they can only ever be reflections or expressions of or references to a 'real world' reality that exists outside films, and from which films themselves are irrevocably severed.

Against such an understanding, an understanding of films which, so far as I can see, emphasizes cinema's lack of reality, the notion of filmic reality insists that films cannot ever be understood as mere fantasies or illusions unfolding in a realm that is definitively separated from the actions, objects and events of the 'real world'. To hold on to an opposition between 'filmic fantasy' and 'real world reality' is to compromise both what fantasy and reality are capable of. Above all, in this context, such a division substantially constricts the possibilities available for films (discussions of the complexities and deficiencies of the perceived split between filmic 'fantasy' and the 'real world' occur at numerous points throughout this book).

Kuhn, when writing of her experience outside the British Museum, refers to the sensation as a 'reverie'. If this sensation is one of reverie, does this therefore mean that it is a mere escape, that it cannot be described as a filmic reality? My contention is that what the notion of filmic reality makes explicit is the way in which something like a reverie contributes to, or indeed is at the very basis of, what human beings encounter as reality. Human beings have the capacity to dream and to imagine, to the degree that, to again invoke the views of a philosopher, Castoriadis has gone so far as to declare that 'the human being *is* imagination' (Castoriadis 1997b: 159; emphasis added). For Castoriadis, this is what specifies the capacities of the human subject and human societies: they have the ability to posit in imagination that which does not have objective existence. He calls this capacity one of 'reflectiveness': the ability for the human being to posit a state of the world other than what it objectively is. And this is precisely what occurs for Kuhn outside the British Museum: her reverie, invoked by *Listen to Britain*, enables her to posit in imagination something other than what objectively exists. It is her reverie that gives to her experience a sense of meaning and significance; it is her reverie that makes her experience into something.

In this way, I argue that films provide what might be called 'reverential experiences' that help us to flesh out our understanding of the world and our place in that world. Films make available concepts, feelings, and ways of seeing and relating to the world that contribute to what we understand as reality. What would our experience of reality be like without films? It would be entirely different, for films have changed the nature of reality itself. Films have given us new ways to dream, but those dreams have also made available new domains of reality. It is the reverie sparked by *Listen to Britain* that provides a something for Kuhn's experience outside the British Museum. Without that something provided by the film, the experience would have been a totally different one. By making a contribution to our understanding and negotiation of reality, films can thus be described and analysed in terms of their filmic reality.

Film theory and filmic reality

Does film studies need a theory of filmic reality? Many scholars, I imagine, would think not. Film studies has, for the most part, been dedicated to denying the reality of film. In a recent book, for example, Laura Mulvey writes that 'Finding the "film behind the film" is the main aim of textual analysis' (Mulvey 2006: 145). There

can surely be little question that finding the 'film behind the film' has been and remains one of the guiding aims of some of the most influential strands of films studies. What such positions make clear is that a great deal of film studies has failed to be interested in films at all. Instead, as David Bordwell recently noted, such approaches to film focus on how or what ideas or social issues are reflected by a film; in other words, such analyses fail to be guided by what film itself *is* or *does*, and instead are motivated by aims that are external to the film itself. 'For many scholars', Bordwell writes, 'films exist as less a part of an artistic tradition than as cultural products whose extractable ideas about race, class, gender, ethnicity, modernity, postmodernity, and so forth can be applauded or deplored' (Bordwell 2005: 266). What such social and political approaches to cinema make clear is that films themselves are not actually of great importance; such positions assume that films are secondary and that the truly important stuff of life happens outside films and without them. From this perspective, films are not important in themselves, for they can only reflect or represent the 'important stuff of life' that occurs outside them. The 'important stuff of life' is primary, while films in themselves are only secondary; a film itself is a degradation of a truer reality, and that truer reality is a reality that exists, as Mulvey puts it, 'behind the film'. From this perspective, the truly important stuff of films is composed of a reality that transcends mere film. Films in themselves have no reality but can only refer to or reflect the realities of life that exist outside, beyond, or behind them.

With such arguments in mind, then, this book has one aim: to dispel the myth that there is anything behind films. Its central point is quite simply that films are enough – they do not need to be something else; there does not need to be anything behind a film that would be better or more significant than a film as it is. Filmic reality – the reality of film – is film as it is. *The Reality of Film* is guided by various attempts to delineate what films are capable of producing and by the understanding that what films produce is their reality. Films do not produce something that is behind or beyond them; rather, films are defined by what they produce. It is Gilles Deleuze who eloquently stated that 'cinema produces reality' (Deleuze 1995b: 58). By this he meant that there is no need to conceive of films as being composed of secondary materials that then need to be decoded in order for their truth to be revealed. On the contrary, films are made of a primary material – 'signaletic material', Deleuze calls it – that is as real as any other reality it is

possible to come into contact with. The reality of films does not lie behind or beyond them. Rather, the reality of film is what films themselves are.

Making sense of this book

This book begins with a chapter that fleshes out the current state of film theory and film studies – or, at the very least, it fleshes out the predominant strand of film studies with which *The Reality of Film* takes issue. That strand is one I trace back to the notion of 'political modernism', a term denoting a particular period of film studies brilliantly examined by D.N. Rodowick (1994). My purpose in that chapter is not one of criticizing political modernism *per se*, for it is by way of political modernism that many of the most important founding debates of film studies were initiated in the late 1960s and 1970s. What I really bring into question *vis-à-vis* political modernism is that so much of what passes for film studies today has failed to go beyond the debates of political modernism. Instead, as I argue, the same debates that began with the political modernist intervention have been replayed over and over again during the last forty years. Even scholars who believe they are pursuing domains of study which are purportedly beyond political modernism are, I claim, in fact, merely restating the very same terms of discussion.

With this in mind, I argue that the logic of political modernism is based on a fundamental distinction between *illusion* and *reality* in the cinema. I further argue that many arguments in contemporary film studies are still mounted on the basis of this very same distinction, which is to say that, in the main, film studies has predominantly been guided by a desire to forge clear distinctions between what can be considered real in the cinema and what can be considered illusory or non-real. The characteristic way in which this argument has been pursued, certainly if one considers the framework of political modernism, is by distinguishing between transparency and reflexivity in the cinema. According to this logic, films which claim diegetic transparency are offering illusions to their audiences – the 'illusion of reality' – while films that foreground the apparatuses of cinematic production are deemed to provide 'reality'. Such arguments have exerted a tremendous strength over the field of film studies,[2] so that what I ultimately claim is that, if studies of cinema are based upon distinguishing between illusion and reality, or between the real and the non-real, then such approaches to cinema rely on a logic of representation. For this strand of film studies, then,

the origins of which rely on the logic of political modernism, films are, and can only ever be, representational. On this count, films can only ever aspire to representing reality; they can possess no reality in and of themselves. It is explicitly against the logic of representation in film studies – a logic predicated on making distinctions between illusion and reality – that this book argues.

The remaining six chapters of the book try to posit various ways of going beyond political modernism and its logic of illusion versus reality in the cinema. Each chapter focuses on the work of a specific film theorist, so that there are chapters on André Bazin, Christian Metz, Stanley Cavell, Gilles Deleuze, Slavoj Žižek and Jacques Rancière. What pans out, I think, is less a singular, pointed and specific theory of what filmic reality *is* and more of a sense that what I mean by filmic reality is an attitude one takes towards films. That attitude is this: to see films as being part of reality instead of as representations of it.

Possibly the most difficult of these theorists to defend is André Bazin, especially as his writings on the 'Ontology of the photographic image' and the 'Myth of total cinema' (among others) would appear to fundamentally cement his approach to cinema as one that is unflinchingly representational (see Bazin 1967a; 1967b). What the traditional Bazin is purported to claim is that cinema's primary aim should be to maintain the sanctity of the reality with which it comes into contact. The camera's role, according to this argument, is merely to record the prior reality that is 'out there' waiting to be captured. The task of the filmmaker is to refrain at all costs from intervening in or interfering with that prior reality, for example, the filmmaker must not distort that prior reality by way of gratuitous editing or by fabricating unnatural settings, and so on. Cinema, then, in this classic Bazinian view, is once again conceived as a system of representation which, if films are to be properly Bazinian, refer to an unimpeachable prior reality, a reality which it is possible only for cinema to capture and represent.

I uncover, however, another Bazin, one who was less interested in questions of cinema's representational capacities and who was more interested in the modes of life offered by cinema. Bazin's emphasis on what I call modes of life sets him on the path towards discovering another kind of realism, a realism not based on representation or verisimilitude, but a realism that has far more in common with realizing a way of life. For Bazin, the cinema has the capacity to create reality in a specific way, and that way is, I argue, one that conceives of modes of life in an 'authentic' manner. The kind of

authenticity Bazin envisages is explicitly non-representational – it has nothing to do with reflecting, representing or capturing reality, and instead is about creating modes of life that are to be considered 'real'. It is with Bazin, then, that theorizing film begins to move away from conceiving cinema in representational terms and towards a conception of filmic reality.

The position of Christian Metz examined in Chapter 3 might be even more complicated. On the one hand he has been discredited with trying to reduce cinematic expression to linguistic terms while on the other hand he has been further criticised for being an advocate of 'apparatus theory'. I aim to argue that Metz cannot be held culpable on either of these counts. Even more to the point, it seems to me that one more or less gains one's 'stripes' as a film scholar on the basis of criticizing Metz somewhere along the line, especially when it comes to Metz's attempts at theorizing cinema by way of psychoanalysis. Against such trends, I defend Metz's notion of the 'imaginary signifier', for it is the notion of the imaginary signifier that has probably been subjected to more punishment than any other concept in the history of film theory (Metz 1982). Why is this? Well, in short, I think Metz's concept has been so roundly attacked because it placed the imaginary at the heart of the cinematic experience. His position has been criticized because critics argue that his theorization of the imaginariness of the cinema signifier places an emphasis on cinematic illusion instead of endorsing cinematic reality. If the imaginary is made central to the cinematic experience then, so the critique of Metz goes, the cinema can have nothing to do with reality or with our experiences of reality. If the cinema is imaginary, then it can allow us only to turn ourselves away from reality. Furthermore (I am here continuing to describe the criticisms of Metz), if the cinema is imaginary, then it is also incapable of being properly symbolic. Again, if this is the case, then the cinema cannot reveal anything about the symbolic structures of social reality. Instead, it can only reduce the complexities of symbolic structures to the fictions, illusions and simplifications of the imaginary.

With such arguments mounted against Metz, is it any wonder that recent theories of film have treated him so cruelly? Nevertheless, I rally to his defence. I claim that Metz's understanding of cinema in terms of its purportedly imaginary signifier is in no way intended to point towards cinema's deficiencies. The cinema presents, for Metz, an imaginary signifier, but this does not mean that the cinema is thereby a reduced or subtractive mode of experience. In terms that

are entirely consonant with Castoriadis's challenge to prioritize the imaginary factors of human existence, Metz makes the notion of the imaginary central to his conception of cinema. By calling the cinema signifier imaginary, Metz is in no way pointing to cinema's deficiencies. Rather, the operation by way of which cinema has achieved its greatest triumphs is that operation by way of which the imaginary signifier comes into play.

What I argue, therefore, is that the imaginary signifier in no way signals the failure of cinema but instead accurately characterizes its triumph. In short, the imaginary signifier is one of the key ways of determining the reality of film. The cinema signifier is not symbolic and nor does it evoke the real world directly. Rather, the cinema signifier is imaginary. Paradoxically, perhaps, I thus argue that it is this imaginariness of the cinema that defines its reality. To put it another way, I claim that, from Metz's perspective, the reality of film is precisely that it is imaginary. And, for Metz, this is a central defining quality of the cinematic experience: it offers us a reverie (as Annette Kuhn might say) that gives us the possibility of re-imagining our relationship to the world. Filmic reality, by passing through the imaginary, allows us to imagine new orders of reality.

Chapter 4, on the writings of Stanley Cavell, provides a general survey of what I think are Cavell's most important contributions to theorizing cinema. The importance of those contributions is expressed succinctly by William Rothman and Marian Keane in their commentary on Cavell's ambitious approach to the ontology of film, *The World Viewed*. Rothman and Keane claim that, for Cavell, films are real rather than realistic (Rothman and Keane 2000: 67). What this means is that, for Cavell, our experiences of films cannot simply be seen as some kind of lesser version of the so-called 'real' world. Instead, films provide something akin to a more intense – perhaps one might even say 'truer' – experience of reality. Films have the capacity to enable us to open our eyes to experiences that normally go unnoticed by us in the real world, experiences to which we have a tendency to remain blind. By way of an example, I might suppose that, if the 'real world' is one in which we can no longer afford to cry, then, at the cinema, no such prohibition is in force. As Walter Benjamin once so poignantly claimed, and it is a supposition which Cavell would fully endorse, 'people whom nothing moves or touches any longer are taught to cry again by films' (Benjamin 1996: 476).

It is in this way that Cavell's articulation of the significance of cinema offers a powerful understanding of filmic reality. At all

times, for Cavell, films cannot be said to offer representations of the world or of some purportedly 'real' or 'true' world. Instead, films are exhibitions of the world; they offer experiences that are as much a part of reality as any other experience, perhaps even more so, for while at the movies, we are less on guard, more receptive, more vulnerable and less fearful of the possibilities the world is capable of offering to us.

Deleuze's position (Chapter 5) is in many ways analogous to Cavell's. Like Cavell, he argues that films offer orders of experience that are normally hidden or unavailable in everyday life. Indeed, for Deleuze, the cinema presents us with new modes of perceiving and experiencing, modes which are not derivative of our experiences in the 'real' world, and not modes that insist upon an adherence or faithfulness to the 'real' world. Rather, the cinema produces modes of perceiving and experiencing that offer the possibility of another kind of world. The cinema does not present us with images that merely re-present various states or stages of the 'real' world; instead, the cinema has the ability to redefine for us what reality itself is.

Deleuze's understanding of cinema is fleshed out in relation to his extraordinary claim that 'cinema produces reality' (Deleuze 1995b: 58). What is perhaps most challenging about this claim is that, in making it, Deleuze signals his intention to refrain from all forms of judgement. His discussions of films and types of films do not revolve around questions of which films are better or more valuable than others, they refuse to draw up tables of judgement which determine that some types of films are bad while others are good; to put it another way, he refrains from demarcating between reality and illusion in the cinema, between the real and the non-real. Rather, in the *Cinema* books, Deleuze charts the myriad kinds of realities films are capable of producing. From this standpoint, Deleuze emerges as the most important theorist of filmic reality.

An example is appropriate here. Jean Renoir's *The Golden Coach* (1952) is a film with which I had been familiar prior to reading Deleuze's comments on it, and I must admit that I had regarded it as a somewhat second-rate and ostensibly unimportant film, certainly not on a par with other of Renoir's films, like *La Règle du jeu* (1939), *La Grande Illusion* (1937) or *The Crime of Monsieur Lange* (1936). Deleuze's approach to the film refrains, however, from making such judgements. Instead, he tries to uncover the significance of the system of reality *The Golden Coach* proposes. The actions of the film are set in a town in a Spanish colony

somewhere in the Americas in the late eighteenth century. A touring troupe of actors visits the town with the intention of performing there for a number of months, and they do so with great success. One of the touring actors, the central character of the film, Camilla (Anna Magnani), becomes involved in three love affairs during the film, one with Philippe, a co-member of the acting troupe, another with the Vice-Royal (the governmental leader of the colony), and a third with Ramon, a champion bullfighter. At the end of the film the suitors all go their separate ways, and Camilla is left on her own, but with the comfort of still having the stage on which to perform.

For many viewers, *The Golden Coach* will be little more than a tawdry historical romance, moreover, one with slightly confusing, often seemingly unmotivated plot turns, and an ending that appears to be far from satisfactory. Deleuze, however, feels that with *The Golden Coach* certain of Renoir's filmmaking traits are 'taken to their highest point' (Deleuze 1989: 84). He bases his interpretation on the melding or mixing of roles that occur in the film, the question of 'where does the stage end and "real life" begin?' As with Camilla's performances on stage, so too are her love affairs with the three men so many attempts at *acting*, at trying out roles, of experimenting with the opportunities and possibilities that life presents to her. The stage is not taken as a realm that is divorced from 'real life', but instead is understood as a part of real life, and nor is 'real life' ever considered to be free from experimentation, fantasy, imagination or hypothesizing. It is by way of this experimentation, Deleuze argues, that *The Golden Coach* points to the possibility of the emergence of a 'new Real' (Deleuze 1989: 86). Deleuze claims that all the characters in the film – not only Camilla – are inspired 'to try out roles, as if roles were being tried in until the right one were found, the one with which we escape to enter a clarified reality' (Deleuze 1989: 86). 'At the end of *The Golden Coach*', he continues, 'three characters will have found their living role, while Camilla will remain ... to try out still other roles ..., one of which will perhaps make her discover the true Camilla' (Deleuze 1989: 87).

Deleuze is here, I would like to think, pointing to a theory of filmic reality: in so far as the stage in *The Golden Coach* is a stage upon which experimentation is encouraged and where roles are tried out for their suitability, and in so far as that experimentation upon the stage is not an experimentation that can be sufficiently distinguished from the role-playing that occurs in 'real life' itself, then the importance of role-playing is not that it is play acting, but

rather that it is a mode of 'clarifying reality', with the intention or hope of creating a 'new Real'. Such stakes are precisely those of a theory of filmic reality: a film is a zone of experimentation, of trying out roles, and, by way of such experimentation and role-playing, a film is thus a way of clarifying reality and creating new realities.

The Golden Coach – and Deleuze's comments on it – encapsulate what are the central concerns of this book. *The Golden Coach* sees no need for marking clear dividing lines between 'the stage' and 'real life'. Examples abound in the film, from Camilla's exasperation at one point, when she asks 'Where does the theatre end and life begin?' to the pronouncement at the end of the film by the manager of the theatre troupe: 'Don't waste your time in the so-called "real life"; you belong to us, the actors, acrobats, mimes, clowns, mountebanks; your only way to find happiness is on the stage and in platform and in public place, during those two little hours when you become another person, your true self.' *The Golden Coach* proposes that its stages are everywhere imbricated in the realities of existence, that life upon the stage is every bit as real as anything that occurs off stage. And so I am making much the same claim for film: that what is expressed on screen is every bit as much a part of reality as anything that might occur off screen (where off screen here means the so-called 'real world'). One is not automatically more real than the other; one is not an illusion in the face of the other's reality; one is not real while the other is non-real. Furthermore, lest I be misunderstood here, *The Golden Coach* is not a simile or allegory for filmic reality (filmic reality is not *like* the staged realities at the heart of the film's story). Rather, if we are to take the narrative of *The Golden Coach* seriously, then this involves understanding Camilla's playing of roles and trying out roles to be a challenge the film sets up for its audience: *What if I were to try out roles for myself, what would that be like?* It is this element of the film, its invitation to the audience to *try out roles*, that allows it to express its filmic realities as explicitly as it does.

Indeed, the argument of this entire book is here precisely: against the demarcation between illusion and reality; against the notion that the diegetic worlds of films are a step removed from 'real world reality'; against the logic of representation that has guided the history of thinking about films. To the same degree that *The Golden Coach* refuses to clearly demarcate between the concrete materiality of 'reality' and the presumed fabrications of the 'stage', then so too does this book refuse to automatically presume that films are illusions in the face of a 'real' reality that exceeds them. And that is

what filmic reality is: understanding films as part of reality.

With the encouragement accorded self-experimentation and role-playing in *The Golden Coach*, might it be possible to see self-experimentation and role-playing in evidence in the example with which this Introduction began? It is indeed possible to claim that Annette Kuhn's 'reverie' outside the British Museum is precisely an example of experimentation and role-playing, of an imagination that changes the very nature of reality itself – a new Real. Kuhn 'inhabits' *Listen to Britain* in order that it may create for her a new reality, a reality that could have no existence without the serendipitous conjunction of that film and a particular space outside the British Museum. Her reverie is not something that distorts reality or abstracts from reality; rather it is a reverie that creates reality.

Chapter 6 examines one of the more controversial contributors to recent debates in film studies: Slavoj Žižek. While not a film scholar as such, Žižek has certainly made significant contributions to film studies (see Žižek 1992a, 1992b, 2000, 2001). Perhaps more to the point, his reconceptualization of Lacanain psychoanalytic theory around the category of the Real has steered psychoanalytic film theory in new and interesting directions. I am less interested in Žižek's version of the Lacanian Real, however, for the Real has a tendency to become a shorthand term for transcendental freedom – it is only by way of the 'Real' that one becomes, as it were, 'Real'. To take Žižek's works in this way is, however, to be mistaken. The 'Real' is impossible, so 'getting in touch with' or experiencing the Real will never lead to any kind of freedom (on the contrary: it is more likely to induce psychosis), except in so far as that freedom is posited as an impossible ideal. If Žižek posits the category of the Real as an ideal, then what does he have to say about reality itself (that is, those things we *can* experience)? He declares that they are shaped by the ideals we posit in the Real, but in so far as that is the case, our experiences of reality are always shaped by ideological fantasy. This, ultimately, is Žižek's most fundamental breakthrough: that ideological fantasy is a good thing, not something that should be eschewed or dispensed with. In other words, ideological fantasies are not illusions; they are not illusions of reality or distortions of reality. Rather, it is only by way of ideological fantasy that we can come to experience reality itself in the first place.

Žižek's claims have far reaching consequences for film studies. For the theorists of political modernism, anything called 'ideological' was anathema. Ideology was something that had to be exposed, ridiculed and dispensed with in order that a true reality

(what Althusserians in the wake of structuralism called 'science') could be revealed. Ideology was also something that films seemed to promulgate with ease, especially the kinds of films produced in Hollywood. Žižek, for his part, is not interested in the political modernist version of ideology critique. His critique of ideology, on the contrary, is much more of a Kantian critique, that is, an inquiry into the causes and consequences of ideological fantasy (its 'conditions of possibility'). And Žižek's conclusion is that ideological fantasy effectively *makes* the world in which we live: ideological fantasy is at the foundation of what we call 'reality'. Following from these theoretical formulations, I argue that Žižek's understanding of ideological fantasy allows us to understand cinema's ideological fantasies not as illusions or distortions of reality, but instead as ideological fantasies which constitute reality itself.

The book's final chapter, on Jacques Rancière, examines that scholar's approach to cinema as a category of the aesthetic. For Rancière, film is part of the historical bloc in which we live which defines artworks by means of the category called 'aesthetics'. We live in an era of what Rancière calles 'the aesthetic regime', a regime by means of which art has been defined for the last two hundred years or thereabouts. Prior to this, until the end of the eighteenth century, art had been defined in a quite different manner, in accordance with what Rancière refers to as 'the representative regime'. Now this regime was not representational in the way we typically understand that term today: its practices were not based on imitating or reproducing objects. Rather, what Rancière means by 'the representative regime' is that, during that period, artworks were the products of specific sets of codes, techniques and practices. The task of the artist was to replicate these codes and practices with a high degree of skill; the goal of the artist was to conform to the rules of art which were handed down to him or her. When the representative regime comes to an end, so too are the rules of art up for grabs.

There is, however, something strange about the cinema. For Rancière, yes, certainly, the cinema is a product of the aesthetic regime, and it is entirely a product of that historical period. But, at the same time, the kinds of films the cinema has produced seem to have very much of the flavour of the kinds of craft accorded to artworks by the representative regime. The cinema, Rancière tells us, is very good at telling stories which have a precise beginning, middle and end. Indeed, this is one aspect of art that the cinema almost completely borrows from the representative regime: the ability to tell great stories. As a result, the cinema finds itself at a

crossroads: it is not a modernist art which can be wholly defined by the aesthetic regime, but nor is it an entirely antiquated artform which merely clings to practices that are well past their use-by date. Rather, the conjunction of the aesthetic and the representative regimes is what most fully defines what film is and which contributes to making it such an important artform. That, for Rancière, is the reality of film.

Rancière's contribution is important because it disrupts the quest for 'purity' in theories of cinema. Like the other thinkers examined in this book, Rancière's framework offers a way beyond the dead-ends of political modernism. If the film scholars associated with political modernism desired a film practice freed from the constraints of storytelling (and we shall see that this is precisely what they desired), because stories can do little but invoke the illusions against which political modernism pits itself, then Rancière rebukes such theorists by defending the cinema's ability to tell stories. The lesson to be taken from Rancière, quite simply, is that we must stop trying to designate what the cinema should be, might be or could be, and instead try to understand what the cinema is. Only by facing up to such a task will we then be able to discover the reality of film.

And such are the stakes of filmic reality. To reiterate some of the questions that can be asked of filmic reality: What do films do and what do we do with films? How do films feature as part of the way we structure our lives? In what ways might films influence the ways we think about the world? In what ways do the impressions or thoughts we collect from films add to our experiences of reality? In what ways do films contribute to our understanding of reality? These, to me, are incredibly important questions, and the fact that most theories of film have been reluctant to ask them points to serious shortcomings in the ways that film studies have been conducted during their brief history. Of course, there are still other questions that are pertinent: What is it possible for films to make real? What do films allow us to realize? What, for example, is realized in *The Golden Coach*? What is realized, I would argue, is that it is only by entering into a film and accepting a film as something that is part of reality that it will be possible to then exit from that film with a new reality. Only by opening oneself up to the experimentation, hypothesizing, reverie and imagination that are presented by films can one hope to accept the realities that films provide. Only by accepting that films are part of reality, not things which have to live up to an already-conceived reality, or which have to mirror reality, represent or reflect reality or, conversely,

'criticize' reality; only if we give up on the understanding that films are somehow severed from reality, can we begin to account for the realities that films themselves are. To affirm the reality of film is exactly what this book proposes to do.

1 Beyond political modernism

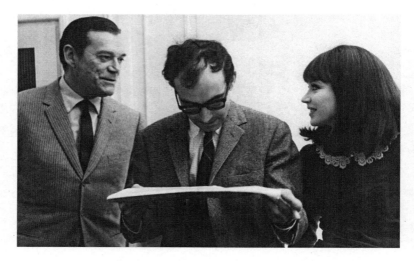

2 The key political modernist *auteur*: Jean-Luc Godard with
Eddie Constantine and Anna Karina on the set of *Alphaville* (1965)

In an important article written in 1972, Peter Wollen set forth
the stakes of a counter-cinema that could be opposed to what he
referred to as orthodox cinema (Wollen 1985). He proceeded to
map the 'seven deadly sins' of orthodox cinema in order to oppose
them directly to the 'seven cardinal virtues' of counter-cinema. The
opposition declared here was one that, in time, became known as
the discourse of 'political modernism' (see Harvey 1978; Rodowick
1994). The defining trait of political modernism was that it operated
a critique founded on an opposition between orthodox, Hollywood,
commercial cinema and the types of avant-garde or political cinema
that could be opposed to the orthodoxy.[3]

I want to argue here that the opposition made by political modern-
ism between orthodox cinema and counter-cinema is, at its most
fundamental, an opposition between illusion and reality. According
to the arguments of political modernism, orthodox cinema provides

illusions of reality, whereas counter-cinema provides ways of breaking down the orthodox cinema's illusions of reality. By breaking down such illusions, counter-cinema clears a path towards a more genuine reality, a reality freed from illusion. At its simplest, then, political modernism operates on the basis of an opposition between illusion and reality.

Why, however, is it important to point to the demarcation between illusion and reality? I imagine not many scholars would disagree with the diagnosis I have briefly given and, moreover, I imagine many would claim that my diagnosis is a positive and necessary one. It is necessary to pinpoint precisely what is at stake here, however. For example, a range of theorists, typically associated with cognitivism and analytic philosophy, have condemned the political modernist paradigm for its supposed reduction of cinema to the realm of illusion *tout court*. Writers such as Noël Carroll (1988) and Gregory Currie (1995), for example, dismiss the theories of Christian Metz and Jean-Louis Baudry on this count: that political modernists like Metz and Baudry write off *all* cinema on account of its illusions, on account of the fact that spectators are hoodwinked, deceived and manipulated by the cinematic apparatus. So it is here, first of all, that we have a problem. For political modernists *not all cinema* is illusory; rather, cinema is divided between illusion, on the one hand, and reality on the other. For writers like Carroll or Currie to overlook this fundamental dichotomy in favour of what they conceive as being an overarching 'illusion' theory of cinema is quite simply to be entirely mistaken about the project of political modernism.

And yet, the consensus today is that film studies has moved on from the discourse of political modernism. The great dichotomies – between popular and avant-garde cinema, between regressive films and progressive ones, between films which hypnotize their viewers and those which allow reflexive thought – have been overturned as theories that are too dependent on binary oppositions. Postmodern theorists, as those who have supposedly progressed beyond the political modernists, deign to go beyond simplistic dualities of the latter's discourse in order to investigate the myriad folds and layers of the cinema experience. A central argument of this book, however, against the postmodernists, is that, for much of contemporary film theory – say, of the last ten to fifteen years – the dichotomies of political modernism have continued unabated. Indeed, this chapter aims to set out some of the trends in cinematic theorizing of recent times in order to demonstrate how these theories merely repeat the

division between illusion and reality so earnestly encapsulated by political modernist discourses.

And yet again: what could be wrong with the division between illusion and reality? The major problem is this (as I have already hinted in the Introduction to this book): if a theory of cinema is based on dividing films between those which convey illusion and those which convey reality, then the judgement about a film's relative illusions or realities can be made only on the basis of a prior, already existing reality. In other words, on this count, films are judged according to their adequacy to reality. Films are not judged according to what films themselves are, but instead are judged in terms of how they 'measure up to' reality.

Wollen argues, for example, that it is the opposition between illusion and reality that allows Jean-Luc Godard's films of the 1960s to be defined as examples of counter-cinema. Godard's adoptions of picaresque forms were, according to Wollen, 'supposed to represent the variety of ups and downs of real life' (Wollen 1985: 501). In other words, Godard's methods explored ways of representing 'real life' rather than the illusions of life projected by orthodox cinema. By the same measure, Godard's use of direct address was a way of breaking down a spectator's 'fantasy identification' with a film; i.e., it was a way of counteracting the illusionistic spell of orthodox cinema. Or, most emphatically, the sheer fictionality of orthodox cinema was opposed in Godard's works by the order of 'reality': for Wollen, where orthodox cinema is predicated on 'fiction', Godard's films set out from reality.[4]

These terms, then, are firmly established: orthodox cinema provides illusions, fictions, 'fantasy identifications', while counter-cinema delivers reality, 'real life' and a breaking down of all forms of deception and illusion. Such is the logic of political modernism: illusion is opposed to reality.

Why might it be necessary to map the terrain of political modernism today? The simplest answer to this question is that the discourse of political modernism is just as prominent a discourse today as it was during the 1970s and 1980s, the period charted so rigorously by D.N. Rodowick in his *The Crisis of Political Modernism*. In the second edition of that book, Rodowick argued for the continuing relevance of the discourse of political modernism. He claimed, for example, that 'political modernism is still with us in many ways' (Rodowick 1994: viii). Even more emphatically, he wrote that 'the discourse of political modernism marks the emergence of contemporary film theory as a discursive field in which we still live and think' (ibid.).

Although it is a number of years since Rodowick penned these words and a great deal has changed in film studies and film theory since then, it is my contention that Rodowick's claims are every bit as relevant today. Other writers will no doubt agree with my contention: David Bordwell, along with Richard Allen and Murray Smith, argues that the fundamental terrain of film theory – which these writers tend to capitalize as Film Theory or otherwise refer to as Grand Theory – has not shifted significantly since the heyday of political modernism (see Bordwell and Carroll 1995; Allen and Smith 1997). The rise of cultural studies has widened the field upon which the problems of political modernism are discussed, but the questions posed by political modernism have neither been resolved nor, as Rodowick claims, 'fully worked through'.[5]

In this chapter I explain in more detail some of the fundamental precepts of political modernism, but I do so only in order to demonstrate that many, if not most, approaches to film studies today are still beholden to the political modernist distinction between illusion and reality in the cinema. Therefore, I provide examples of the ways that contemporary film analysis and film theory still cling to the divisions established by political modernism. These contemporary examples fall into three broad categories (though doubtless there are many others): the 'modernity thesis', 'realism' and 'culturalism'. Each of these approaches claims to have moved beyond the discourse of political modernism, but what I demonstrate here is that, if the discourse of political modernism is predicated on a distinction between illusion and reality in the cinema, then these contemporary approaches merely repeat the terms of that distinction. Finally, I indicate some ways of getting beyond political modernism: by abandoning the theoretical distinction between illusion and reality in the cinema.

Political modernism

Stephen Heath was one of the most astute advocates of political modernism. One of his most forthright arguments, advanced in an article on 'Narrative space', was that orthodox cinema could be distinguished from counter-cinema according to the kinds of subjectivity provoked in its spectators (Heath 1981a). The systems of unity, transparency and continuity editing in orthodox (Hollywood) cinema served to fix and unify the viewing subject. Such subjects are ideological ones: passive receivers who are 'put in place' by Hollywood's strategies of ideological fixity. Against this, Heath

favoured the kinds of spectatorial subjectivities that are not fixed, but which are fluid, mobile, disjunctive and creative. Some alternative modes of filmmaking – the counter-cinemas of Oshima and Godard are prime examples in Heath's 'Narrative space' – make possible a disruptive spectator-subject who has the potential to break free from the shackles of ideological fixity.

The spectre of a passive, ideologically fixed spectator-subject, as defined by Heath in this key work of political modernism, has not left the scene of film studies. The search for fluid, mobile, disruptive, multiple subject-spectators remains one of the central tenets of film studies and film theory (see, for example, Wilson 1998; Shaviro 1993; Pisters 2003). Once again, the stakes of these contemporary arguments hinge on an opposition between illusion and reality: it is an illusion to construct subjects as unified and fixed, and this illusion is reinforced by orthodox cinema. Against the illusionistic fixity of the unified subject, political modernists and their heirs theorize subjects who are freed from illusion into fluid and multiple subjectivities. This latter, de-illusionized or de-alienated subject is no longer imprisoned by the strictures of ideological fixity, but instead is freed into the fragmented disruptiveness that is proper to the reality of subjectivity as such. Proper, real, or true subjects are disruptive, whereas false, illusory subjects are fixed and unified (they are 'ideological'). In short, then, the argument in favour of disruptive subject-spectators in opposition to unified, fixed subject-spectators, is predicated on an opposition between the illusions of orthodox cinema (which creates static, passive subjectivities) and the realities of counter-cinema (which promotes fluid, multiple subjectivities). Again, the fundamental dichotomy is between illusion and reality.

The modernity thesis

While the 'fragmented' or 'deconstructed spectator' argument is certainly a favourite for postmodernists and culturalists alike, the argument has also found favour with advocates of what has become known as 'the modernity thesis'.[6] The origin of the arguments that have informed the modernity thesis can be traced to what some historians of early cinema, especially Tom Gunning, have called the 'cinema of attractions'. Although the cinema of attractions posits itself as a significant advance on the arguments of classical film theory and political modernism – especially against the kinds of theories advanced by the likes of Christian Metz, Jean-Louis Baudry and Stephen Heath – the premises none the less remain the

same (see Metz 1982; Baudry 1985). Where political modernism posits an illusionistic orthodox cinema in opposition to counter-cinema, so too is an illusionistic, Hollywood cinema opposed to the cinema of attractions. Tom Gunning even argues for an explicit link between the cinema of attractions and avant-garde cinema – that is, the cinema of attractions is a sub-species of counter-cinema. In short, the cinema of attractions replays precisely the same debates found in Wollen or Heath.[7]

Gunning makes the opposition between illusion and reality especially clear. At the heart of this claim is the contention that, when in front of classical-orthodox-Hollywood-narrative films, the spectator is invited to 'get lost in a fictional world'; that such films are a matter of 'mistaking the image for reality' (Gunning 1989: 36). The spectator of orthodox cinema is thus one who gets lost in cinema's illusionistic powers and who is mistaken by those powers. In short, the orthodox cinema is one that suffers from the sin of graven images: illusions.

Spectators can, however, be saved from the perils of such illusions, for the 'cinema of attractions' offers a mode of viewing that is at odds with the orthodoxy of cinematic illusionism. What the cinema of attractions achieves is to 'expose the hollow centre of cinematic illusion' (Gunning 1989: 42). Spectators, rather than being 'lost' in the illusion, 'delight' in 'film's illusionistic capabilities', Gunning argues (ibid.: 43). The spectators of the cinema of attractions do not 'mistake' the illusion for reality, but instead are 'astonished' by the 'illusion of projected motion' (ibid.: 34).

A double step is thus made by Gunning: he does not explicitly claim that the cinema of attractions offers reality in opposition to orthodox cinema's illusions, but this assertion is nevertheless implicit in his argument. What Gunning criticizes in orthodox cinema is not so much illusion *per se*, for the cinema of attractions also offers illusions. Rather, what Gunning criticizes in orthodox cinema is its *illusion of reality*. He argues that the purpose of orthodox cinema is to offer 'a seamless reproduction of reality' or 'a dream of total replication of reality', a 'belief in the reality of the image'; in short, a 'reality effect' (Gunning 1989: 34, 42, 43, 36).[8] In other words, using terms that have long been accepted in film studies, Gunning argues that what orthodox cinema presents are illusions, but it wants to pass off those illusions as reality; it wants to trick or delude spectators into believing that the illusions they watch on the screen are in fact 'real'. It is with this latter deception that the illusionistic nature of orthodox cinema resides: it wants to

pretend that its images are reality. For Gunning, this pretence – this pretentiousness – is the 'illusion' of orthodox cinema.

Against the illusionism of orthodox cinema, the cinema of attractions makes no such claim for an 'illusion of reality' or 'reality effect'. It does not pretend that its images are real; it does not try to pass off its illusions as reality. Rather, it acknowledges its illusionism; it admits that it is just a set of technological instruments (cameras, lights, projectors) displaying phantoms, a mechanism of 'magical metamorphosis' that is of an 'incredible nature', writes Gunning (1989: 34). What the cinema of attractions presents to its spectators is a form of directness (as is evidenced by its common use of direct address); it refuses to pretend or trick the spectator into believing that its illusions are in any way 'real'. Instead of providing an illusion of reality, then, the cinema of attractions provides the reality of illusion. Thus, spectators of the cinema of attractions do not believe, for example, in the reality of a train rushing towards them in the Lumière brothers' *Arrival of a Train at the Station* (1895), but instead are delighted and astonished by the reality of the apparatus that brings forth these illusions – they are amazed by the reality of the cinema itself (see Gunning 1989: 31).

The basis of Gunning's argument is thus one that sees the reality of the cinema apparatus opposed to the illusions of the cinema apparatus; the cinema of attractions does not try to deceive its viewers with illusions of reality, but provides spectators with the reality of cinema's illusory mechanisms. The classical, orthodox cinema, on the contrary, merely provides illusions of reality. The argument for the cinema of attractions therefore relies on precisely the same dichotomy that was central for political modernism: illusion is placed in opposition to reality.

The modernity thesis and subjectivity

If, according to the precepts of Gunning's argument, the orthodox cinema presents illusions while the cinema of attractions presents reality, then what kinds of subjects do these types of cinema produce? It is implicit in arguments which adopt the modernity thesis that the subjects of early cinema (who are also subjects of 'modernity') are fragmented and disrupted, for their subjectivity is said to incorporate the fragmentations and disruptions of modern life.[9] While there is evidence for such a position in Gunning's arguments, the notion of a 'fragmented subject of modernity' is presented most forcefully in a number of articles written by Miriam Hansen. At all times,

however, it is clear that Hansen remains wedded to the same dichotomies established by political modernists like Wollen and Heath: the fragmented subject of modernity is a more genuine – and thus more 'real' – subject than the supposedly fixed and unified subject of orthodoxy. Hansen's arguments are thus, once again, based on an opposition between reality and illusion.

In one of her most influential essays, 'Benjamin, cinema and experience: "'the blue flower in the land of technology"'' (Hansen 1987), Hansen acknowledges her indebtedness to Gunning's theorization of the cinema of attractions on the basis that it 'offers a historical concept of film spectatorship' that is at odds with the 'standardization' of Hollywood and its strategies of 'viewer absorption and identification' (ibid.: 180). The modes of viewing encountered in the cinema of attractions offer, Hansen argues, 'a range of film / spectator relations that differ from the alienated and alienating organization of the classical Hollywood cinema' (ibid.: 181). Hansen is thus drawing a clear distinction between the standardized, orthodox practices of Hollywood and those different strategies (non-standardized, unorthodox) offered by the cinema of attractions. Again, it will become clear that this distinction is one that is founded upon the opposition between illusion and reality. Furthermore, the kinds of spectatorship available in the cinema of attractions are fundamentally at odds with the 'alienating' practices of Hollywood spectatorship, for the latter is associated with 'individual contemplation and illusionist absorption', Hansen claims (ibid.: 184–5). Again, here, 'illusion' is posited as the evil that must be broken down by the strategies of counter-cinema (e.g., the cinema of attractions).

Hansen has produced some genuinely sophisticated meditations on the writings of Walter Benjamin and their relationship to film theory (see Benjamin 2002, 2003). Nevertheless, amid their undeniable sophistication, the opposition between illusion and reality is found at their core. For example, at one point, Hansen tries to get to the bottom of what Benjamin means by claiming that cinema provides something akin to an 'equipment-free aspect of reality'. What, indeed, can Benjamin mean with this phrase? For one thing, Hansen is utterly certain that what Benjamin means by the 'equipment-free aspect of reality' has nothing to do with the illusion of reality; it has nothing to do with the 'reality effect' or the ideological fixations of the cinema apparatus. She states her case in straightforward terms:

> How, one might ask somewhat bluntly, does it [the 'equipment-
> free aspect of reality'] differ from the reality-effect, the masking of
> technique and production which film theorists of the 1970s were to
> pinpoint as the ideological basis of classical Hollywood cinema?[10]
> First of all, the reality conveyed by the cinematic apparatus is no
> more and no less phantasmagoric than the 'natural' phenomena of
> the commodity world it endlessly replicates; and Benjamin knew all
> too well that the primary objective of capitalist film practice was to
> perpetuate that mythical chain of mirrors. Therefore, if film were to
> have a critical, cognitive function, it had to disrupt that chain and
> assume the task of all politicized art. (Hansen 1987: 204)

First of all, then, Hansen's approach to cinema via Benjamin is
one that is resolutely opposed to the 'reality effect' of Hollywood
cinema, for the latter is a 'phantasmagoric' practice which merely
replicates the commodity world's 'mythical chain of mirrors'.
Orthodox, Hollywood cinema is thus an illusionistic medium that
perpetuates the illusions of the capitalist world. Benjamin's theori-
zation of cinema, on the contrary, promises to smash such illusions,
argues Hansen, and replace them with something altogether more
critical.[11]

In Hansen's terms, if a truly Benjaminian cinema did exist, what
would its effects be like? For one, subjects would be free to experi-
ence a different kind of gaze in the cinema, the kind of gaze, Hansen
describes, 'which defies the social and historical organization of
looking, with its ceaseless reproduction of the subject in terms of
mirror identity, unity, presence and mastery' (Hansen 1987: 215).
The kind of subjectivity promised by a Benjaminian cinema is thus
one in which the subject is not shackled by the imprisoning forces of
unity and fixity, a Benjaminian cinema would defy and go beyond
such subjective mastery. 'Benjamin seeks to reactivate', Hansen
continues, 'the abilities of the body as a medium in the service of
new forms of subjectivity' (Hansen 1999: 323). These new forms
of subjectivity are entirely at odds with 'capitalist society's perpetu-
ation of the self-identical, individual subject' (ibid.). Again, the
Benjaminian cinema spectator has the ability to transcend the
strictures of self-identical individuality. What such new forms of
subjectivity promise are forms that are commensurate with 'the
realities of modern mass experience', as Hansen claims (ibid.). What
Hansen theorizes, by way of Benjamin, is thus a position that takes
into account what she calls the *realities* of modern mass experi-
ence, realities which are diametrically opposed to the illusions of
capitalist subjectivity and its mirror identities, identities which no

doubt form another link on the commodity world's 'mythical chain of mirrors'.

Once again, then, the opposition which structures the argument is one between illusion and reality. Fixed, capitalist subjectivities are illusionist, whereas Benjaminian subjectivities are appropriate for the reality of modern experience. Hansen acknowledges that Benjamin 'participates in the critique of Western bourgeois conceptions of the subject' (Hansen 1999: 325) which he replaces with what is described as 'a convulsive collapsing into each other of body- and image-space [that] assaults traditional boundaries between subject and object' (Hansen 2003: 23). In much the same manner as Heath's arguments in 'Narrative space', then, Hansen draws a distinction between, on the one hand, bourgeois forms of subjectivity that are identical, unified and illusionist and, on the other hand, forms of counter-subjectivity that are 'convulsive', mixed, disrupted and patently non-illusionistic. The opposition is between illusionistic forms and real ones. In ways that solidify my contention that her argument is predicated on a binary opposition, Hansen reiterates that her reading of Benjamin promises, for contemporary existence, an environment in which

> new forms of alternative and oppositional publicness are confronted by a dominant public sphere – or whatever one might call the powerful alliance between an oligarchically instrumentalized state and the conglomerated mass media industries – which is becoming ever more fictitious, disconnected from economic, social, and cultural realities on a global scale. (Hansen 2003: 44)

Once again, the 'dominant sphere' (the sphere of 'orthodoxy') is derided as fictitious – that is, as illusionist – and 'disconnected' from the 'realities' of contemporary existence. The dichotomy that structures Hansen's arguments from beginning to end is that between illusion and reality.

If classical film theories of political modernism built their arguments on the basis of an opposition between illusion and reality in the cinema, then nothing much has changed for current defenders of the 'modernity thesis' in film studies. In precisely the same way as was the case for political modernism, advocates of the modernity thesis form their arguments by reducing orthodox, Hollywood cinema to a system of illusionism against which is then placed a counter-cinema – a cinema of attractions or an avant-garde that can break down the illusions of orthodoxy and replace them with a reality of true experience (the 'realities of modern existence' to which Hansen refers). Furthermore, and again repeating the stakes

of Heath's classic political modernist argument, for Gunning and Hansen, the spectator-subjects produced by orthodox cinema are bourgeois, ideological, fixed and unified subjects. Against this static orthodoxy, counter-cinema can produce radically disrupted subjects, 'new' subjectivities that shatter the unified, self-identical subject-spectators of classical cinema.

Realism

There is another point worth acknowledging in the arguments of Gunning and Hansen. Gunning seems to argue that *all films* are illusionistic, and Hansen, at some points, appears to concur with this view. The distinction between orthodox cinema and counter-cinema is that the former tries to hide its illusionism (and it is at this second level that the true deviancy of its illusionism lies), whereas forms of counter-cinema, such as the cinema of attractions, do not attempt to hide their illusionistic nature. It is only if a film openly confesses its illusions that the illusions then cannot be mistaken for reality. If the nature of this argument is followed through to its logical conclusion, then, on the one hand the illusions of cinema must be derided and exposed as illusions, while on the other hand exposing illusion as illusion is, according to the logic of the argument, more real, or at least such forms can offer an experience of the realities of modern existence.

There can be little wonder, then, why political modernists – and, along with them, Gunning and Hansen – were (and are) opposed to all forms of realist representation, for the only things realism can possibly represent are the inadequacies of contemporary, bourgeois capitalist existence. Against realism, according to the precepts of political modernism, what cinema's images must do is to avoid at all costs the replication of reality: they must denounce the representation of reality and all cinematic attempts at verisimilitude. Any realist forms can only be forms of seeming to be real; they can only ever be illusions of reality. For political modernism (and so too for the modernity thesis), any sense in which cinema might be said to offer copies of reality must be smashed apart and exposed as a sham, as an illusion. If such strategies are opposed by the practices of counter-cinema, then films can demonstrate not the illusion of reality but the reality of the illusions that structure the contemporary world. Orthodox cinema's illusions of reality merely exacerbate the illusionistic nature of the 'alienating and alienated' conditions of modernity (as Hansen puts it). What cinema must

do, for these writers, is denounce the illusionistic nature of those illusions.

All the same, not all film scholars today are opposed to the aesthetic of realism. Some writers have tried to rescue realism from its political modernist critique. Ivone Margulies, for example, in her introductory essay to a recent volume which defends an aesthetic of realism, claims still to trust in cinema's abilities to capture something of the truth of reality (Margulies 2003b). She openly admits, in a way that would seem to contradict everything that has been claimed against realism by political modernists, that she 'subscribes to the epistemological promise of referential images: that what we see refers to an existing reality' (ibid.: 1). For Margulies, the referentiality of these images is not one of verisimilitude – of appearing to look like reality – but rather is a question of capturing reality, or of re-creating it in one way or another.

Margulies explicitly opposes her argument to one put forward by – once again – Stephen Heath. In an essay on 'Film performance', Heath argued against the aesthetic of reality by claiming that any film which tries to copy reality can do so only as a mode of artifice (Heath 1981b). If film attempts to capture reality, Heath seems to be arguing, then it can do so only by deforming that reality, by 'making it up', as it were. Heath calls this attempt to capture reality representation: 'Cinema is founded as the memory of reality', he writes, 'of reality captured and presented. All presentation, however', Heath asserts, 'is representation – a production, a construction of positions and effects' (ibid.: 115). What Heath is castigating here, then, is the 'reality effect', and his argument is one that is common enough for political modernists.[12] Against the aesthetic of realism, Heath argues in favour of the avant-garde practice of film, for only an avant-garde practice could bring into question the nature of representation as such. Heath writes that 'an avant-garde – and political – practice of film is involved necessarily at least in an attention to the real functioning of representation' (ibid.: 115).

It is very easy to find here once again the operation of the illusion–reality dichotomy. On the one hand, the aspirations of realism's attempts to 'represent' the real are criticized by Heath in so far as any attempt to represent the real cinematically can only ever be illusionist: films can only ever construct or fabricate reality in a representationalist manner. In short, they can only offer impressions of reality; they can never actually *be* real. On the other hand, avant-garde or political practices of filmmaking, according to Heath's argument, dismantle the illusions of representation by displaying

them as illusions; they lay bare, as Heath puts it, 'the *real* nature of representation'. By laying bare illusions as illusions, the counter-cinemas of avant-garde or political filmmaking foreground the reality of representation as such.[13]

Likewise, to continue with Heath's argument, the system of illusionistic representation as required by realism is one that captures and fixes the spectator, whereas the works Heath favours have the capacity to free subject-spectators from their ideological shells. As Heath claims, such practices can produce 'another subjectivity – material, heterogeneous, in process' (Heath 1981b: 129). He even goes so far as to claim that such practices can result in 'a film that *makes a body*' (ibid.).

These are the kinds of claims that are familiar to defenders of political modernism: classic realism anchors subjects in an illusionist, bourgeois subjectivity, whereas modernist forms of filmmaking have the ability to free subject-spectators into the reality of their existence. But is this illusion-reality dualism still functioning for Margulies's recent defence of the realist aesthetic? There can be little question that the same duality still exists for Margulies, even if the terms of her argument are somewhat different from Heath's. Where Heath has no faith at all in the representational capabilities of the cinema to the point where he thinks that any representation must be denounced as representation, Margulies counters with a belief that some types of cinema have the ability to capture reality. That is to say, Margulies does not think that all films are illusionist, for there are some that, instead of offering illusions, can indeed present reality. She thus defends films in which there is, she claims, 'a firm desire to safeguard images as indisputably linked to truth' (Margulies 2003b: 10). She even imagines, while commenting on an essay by Mary Anne Doane, a very specific criterion by which such realities can be captured: contingency (Doane 2003). In what amounts to a bold statement, Margulies argues that 'Contingency – the barely grasped instant, which is nevertheless recorded – is the main measure of cinema's particular significance' (2003b: 11).[14]

What kind of realism, then, does Margulies favour? Adopting a term coined by Fredric Jameson, 'oppositional realism', she promotes an approach to realism that is positioned against 'the equation of realism with a politics of identity' (ibid.: 12). Her position thus seems to be firmly at odds with Heath's political modernist dismissal of realism and its 'reality effect', for Margulies, contra Heath, wants to understand realism as a far more nuanced and complex practice.

Can it thus be concluded that the terms of political modernism have been swept away via Margulies's return to realism? Heath certainly identifies 'realism' with the 'reality effect' and he criticizes it on this count. But Margulies too criticizes all recourse to the 'reality effect' and its desire for verisimilitude. She argues, in direct opposition to the notion of the 'reality effect', that 'the category of verisimilitude is inadequate to define what modern realist films do beyond differing from classical realist representations' (Margulies 2003b: 4). Margulies is thus defending a form of realism that counters verisimilitude in a manner that is perhaps not very far from the kinds of verisimilitude that were anathema to Heath. Indeed, in so far as she makes a distinction between 'modern' and 'classic' realism, it becomes clearer that what Margulies wants to defend in modern realism is a form of filmmaking that is opposed, in no uncertain terms, to the 'reality effects' of classic realism. Margulies's position thus cannot be as far from Heath's as she may like to believe. Her notion of realism is opposed to precisely the same forms of realism that Heath and other political modernists were opposed to – those associated with verisimilitude and the reality effect. As if to drive this point home, she asserts that the collection she is introducing and editing 'does away with verisimilitude as a working category appropriate to considering modern realist film' (Margulies 2003b: 5).

The opposition Margulies invokes, then, is one between illusion and reality. Illusions are the kinds of things that come from the practices of classic realism and verisimilitude, while Margulies's defence of 'modern' realism promises the defeat of illusionism. There are a number of terms used to describe the kinds of reality favoured by modern realism: it is characterized by 'unpredictable heterogeneity', its tendency towards 'disfiguration' and 'contingency' (Margulies 2003b: 9, 11, 12). Such terms cannot fail to invoke the terms that are also advocated by political modernists: disruption, discontinuity, the breaking down of identities and so on. Indeed, so far as the production of subjectivities goes, Margulies's version of realism repeats precisely the same division established by Heath. If the spectators of classic realism are, for Heath, unified, fixed, bourgeois and ideological, then those of an avant-garde cinema are potentially 'material', 'heterogeneous', 'in process', disruptive, fluid, fragmented and so on. Likewise, for Margulies, as has already been mentioned, classic realism is associated with 'a politics of identity' (Margulies 2003b: 12), by which Margulies means precisely the same as did Heath: subjects who are unified, fixed, static and so

on. Against these practices, the kinds of subjects provoked by Margulies's version of modern realism have a 'particular affinity for a fluid identity' (ibid.). Again the terms can be mapped directly on to Heath's call for subjects that are 'in process', and 'heterogeneous'. Margulies even goes so far as to call for a 'corporeal cinema', for her version of modern realism betrays an especial affinity for bodies. Needless to say that such a call was also made by Heath in his defence of an avant-garde practice where it might be possible to envisage 'a film that *makes a body*' (Heath 1981b: 129).

It should now be quite clear that, even in her attempts to dismantle the structures of political modernism, Margulies nevertheless repeats those very same structures. Once again, filmic illusionism is envisaged in opposition to forms of filmic purity; that is, forms of filmmaking that can break through illusions and deliver some kind of reality. For political modernism, the reality that films had the capacity to convey was indelibly linked to the destiny of avant-garde filmmaking, for only an avant-garde which foregrounded the materiality of the filmic medium could ensure that cinema would not continue on its merry, bourgeois, illusionist way. Margulies does not overtly defend a cinema of the avant-garde, for the project of 'modern realism' conceived by her has less to do with breaking down illusions than with establishing 'links to' or 'evidence for' reality as such. That is to say, Margulies remains entirely faithful to the representational capabilities of the cinema in a way that political modernism did not. But, if this difference is removed, then Margulies's arguments are entirely sympathetic to those of political modernism: they are anti-illusionist, against verisimilitude and the reality effect, and in favour of contingent forms that disrupt unity and fixity and instead produce 'fluid' identities and corporeal complexity. Indeed, in the final account, even the films and *auteurs* highlighted in the collection edited by Margulies fit firmly within the modernist, avant-garde canon: Buñuel, Warhol, Deren, Pasolini, Dreyer and more recent filmmakers such as Mike Leigh, Peter Greenaway and Abbas Kiarostami. The terms established by the discourse of political modernism persist with a vengeance, and readers might be beginning to suspect that film studies has made little progress during the last thirty years.

Culturalism

One could cogently argue that the terms of political modernism have become so ingrained that many film scholars no longer even notice them. The opposition between the 'transparency' of Hollywood's

illusionism and the 'foregrounding' of techniques that break down illusionism is an especially popular one, as if the only thing a film needs to do in order to be subversive is to ensure to its viewers that it is a 'made' product, that it foregrounds its filmmaking techniques. Any film that fails to do such things, on the contrary, can be consigned to capitalist oblivion, for any such film must surely be fooling its audiences into believing in illusions. Culturalist critics[15] favour popular works instead of avant-garde ones, but the distinction between illusion and reality in the cinema remains intact. Culturalist critics still argue, for the most part, that films can be divided between those which aim to dupe audiences by way of illusion, and those that are politically progressive in so far as they undo cinema's illusions and put audiences in touch with something that is, in one way or another, more real. For example, in a recent article discussing Todd Haynes's *Far from Heaven* (2002) in terms of its indebtedness to the history of melodrama – especially the melodramas of Douglas Sirk – Lynne Joyrich (Joyrich 2004) makes the following claim in what amounts to a wholehearted acceptance of terms established by political modernist theorists:

> Sirk's texts themselves are notable for the way in which they call attention to aspects of Hollywood cinema, using dramatic mise-en-scène, cinematography, editing, music, and performance to elevate, rather than diminish, viewers' awareness of cinematic textuality.[16] Indeed, one might argue that the family melodrama in general (that is, not just Sirk's melodramas, but the genre as a whole) insists that viewers see, rather than just see through, cinematic form.[17] By inscribing a level of stylistic, narrative, and performative excess,[18] these texts appear to reject or subvert Hollywood's 'invisible' practices, thereby opening the possibility that viewers might come to question not only the topics treated in the films but cinematic treatment in and of itself. (Joyrich 2004: 189-90)

The terms established by political modernism have here been accepted wholesale by Joyrich, as if there is nothing left to be said. Typical, standard, classical, orthodox Hollywood films are automatically, unquestioningly 'transparent' or 'invisible' (Joyrich fails to provide any examples of which films one might consider orthodox). In other words, Hollywood films are illusionist: their invisible practices encourage audiences to believe in the reality of their illusionism. Against the duplicitous practices of Hollywood's illusionism, the subversive practices of a genre like melodrama, especially those of Douglas Sirk or Haynes's *Far from Heaven*, not only allow viewers to 'see through' the transparent illusionism of

cinematic form but actually allow viewers to 'see' that form itself. Furthermore, Joyrich insists, by allowing viewers to see this form, such films 'expose the contradictions and distortions' that stand at 'the very basis of cinematic representation'. By exposing these illusionistic distortions, finally, melodrama has the ability to 'undermine the naturalization of Hollywood's realist conventions' (Joyrich 2004: 190). Precisely the same opposition as had structured political modernist arguments is here recycled in order to support the analysis of a recent film: orthodox Hollywood films are illusionist, while unorthodox films – even ones from Hollywood – can break down the dominant, bourgeois illusions of cinema. At the end of her article, Joyrich affirms the way that such subversive films, while they can break down the illusionism of orthodox cinema, can be 'mediums of knowing' (Joyrich 2004: 210). Thus, she argues that cinema need not be consigned to the epistemological dustbin of illusionism, for cinema can give rise to genuine forms of knowing. In other words, the subversive practices highlighted by Joyrich can display a genuine sense of reality, rather than merely trotting out the illusions conditioned by orthodox Hollywood. Again, reality is placed in direct opposition to illusion. The films may have changed since the 1970s, but the forms of argument have changed very little.

And still more!

Two recent books, from very different theoretical backgrounds – one psychoanalytic, the other Deleuzian – wholeheartedly repeat the discourse of political modernism. The first of these, Todd McGowan's *The Real Gaze*, aims to overturn the mantras of political modernism (McGowan 2007). According to his account, 1970s psychoanalytic film theory criticized films for too easily pulling spectators into the Lacanian realm of the imaginary, a realm in which all conflicts were resolved, all fragmentation rendered whole, and where spectators themselves could be lifted from the confusing and conflicting drudgery of their everyday lives so as to be lifted on high into a miraculous realm in which all difficulty was levelled out. The guiding precept and problem of cinema was, from this perspective, one of the fulfilment of the spectator's pleasure in the imaginary. Against such conceptions, McGowan argues that the spectator's gaze – if one stays true to Lacan – is not imaginary, but instead is *Real*. On such grounds, the destiny of the spectator is not one of mastery facilitated by an imaginary gaze, but a complete loss of mastery and dismantling of subjectivity by virtue of a Real

gaze. (As an aside: one should not confuse the Lacanian 'Real' with reality, for the Real designates those bits and pieces of experience which precisely cannot be rendered as reality; the Real refers to things which do not and cannot have any place in what we call reality.)

Granted, McGowan's categories are very neatly worked out – there are four categories by means of which he categorizes various films, ranging from the most ideologically conservative films which still facilitate mere pleasure in the imaginary all the way up to the most radical films wherein the gaze can be considered utterly Real. It is the latter which leads to the undermining of subjective mastery, the unveiling of the subject as a mere traumatic void. 'Through this cinematic experience', McGowan argues, 'we can glimpse the impossible', and cinema becomes the ground of 'a radical transformation' (McGowan 2007: 177). Readers should surely be instantly aware that the categories of political modernism are well and truly entrenched in McGowan's account, even as he deigns to be going beyond that paradigm. The cinema of fantasy integration (as McGowan calls it) – that which gives spectators fulfilment via an imaginary gaze – stands at the pole of highest illusion. Such films are, for McGowan, bad films, politically regressive films; they teach us 'to see and experience coherence where none actually exists' (ibid.: 121). The varying levels of cinematic experience which dismantle the cinema of integration ('presenting the gaze', 'absenting the gaze' and the 'traumatic encounter with the gaze') are, for McGowan, ways of subverting cinema's illusions. They are, in other words, ways of allowing spectators to face up to (what McGowan thinks is) the true reality of the world. And if that's not enough, McGowan repeats almost verbatim Heath's call for proper, real or true subjects who are disruptive, against the false, illusory subjects fixed and unified by imaginary fantasy (they are 'ideological', a term which recurs throughout McGowan's book). What can one say other than that history repeats: the arguments and shape of political modernist discourse are writ large in McGowan's book.

David Martin-Jones's *Deleuze, Cinema and National Identity* makes similar claims, but this time from a Deleuzian perspective (Martin-Jones 2006). A fascinating book in some respects (it offers a bold analysis of contemporary cinema) it is strangely out of touch in others. Most problematic is the book's contention that – from a Deleuzian perspective – the time-image is progressive and radical, while the movement-image is regressive or conservative. The former notion is, for Martin-Jones, aligned with deterritorialization, while

the latter is married to reterritorialization (terms taken from Deleuze and Guattari's *Mille Plateaux*: Deleuze and Guattari 1987). Films which convey national narratives, the book's central concern, can therefore be divided into those which offer deterritorializing time-images and those which put forward reterritorializing movement-images. The icing on the cake is provided by the contention that time-image narratives are multiple and fractured – they convey multiple, diversifying narratives of national identity – while movement-image narratives are linear and unifying – they tell singular narratives of national identity. Much of what might have passed for political modernist discourse is therefore present here: movement-images offer illusions; time-images offer reality. The very same hierarchical scales of judgement are used, as was commonplace for political modernist critics. This time, however, the discourse of political modernism has been mapped on to Deleuze's cinematic categories. As this book – especially Chapter 5 – will make clear, such an interpretation of Deleuze is not one I am in agreement with.

Suggestions: beyond political modernism

Many other examples could be brought to bear here, but what is surely clear by now is that the rhetoric of political modernism is alive and well. And what could possibly be wrong with that? The problem with political modernism is that it is predicated on a far too simplistic division between illusion and reality, a division between the false images of orthodox cinema and the true or real images of counter-cinema, whether such counter-cinemas be conceived as an avant-garde, a cinema of attractions, a cinema of modern realism, or even in terms of subversive genres within Hollywood itself. This argument insists that illusionist, orthodox films rely on a 'reality effect', that is, they attempt to represent reality by looking like reality; they create an impression of reality by way of verisimilitude. What counter-cinemas must do is to tear down the veil of verisimilitude; they must burst open orthodox cinema's desire for representation.

Political modernism's desire to burst open orthodox cinema's representations leads to a crucial issue: representation. All of the writers discussed so far – Wollen, Heath, Gunning, Hansen, Margulies, Joyrich, McGowan and Martin-Jones – base their arguments on a desire to avoid cinematic representations that are illusionist in favour of forms that are closer to (what they conceive

as being) the specificities of reality as such. As has been stressed throughout this chapter, the fundamental division that structures these arguments is based on an opposition between cinematic illusion and cinematic reality.

Anne Kibbey, in her book on *The Power of the Image* (2005), has recently noted the fundamental inconsistency of this argument. She argues that, far from offering a convincing critique of representation, political modernist film theory is, in fact, in favour of representation. By drawing a dividing line between illusionist practices on the one hand and practices that could expose reality on the other, Kibbey argues that political modernists are merely putting in place an opposition between good representations and bad representations. Kibbey traces the way that this opposition between good and bad modes of representation is one with a long history in Western thought. She points out that political modernists are, to put it simply, modern-day iconoclasts. What drives them is a suspicion of graven images, a suspicion of the kinds of images that convey illusions rather than a deeper sense of reality. And what could make such a point more apparent than Wollen's characteristic derision of orthodox cinema's 'seven deadly sins'? Wollen, Heath, Gunning, Hansen, and the other writers mentioned here are simply modern-day iconoclasts: they harbour a deep suspicion of the deceptive power of images.

Kibbey's argument is beguilingly subtle. Iconoclasm is typically understood to be a movement that is opposed to images of all kinds; it is a tendency to oppose all forms of representation. From this perspective, it is easy to see where political modernism fits on the iconoclast map, for political modernism is explicitly opposed to the representationalism of cinema and its reality effects. But Kibbey argues that to pigeonhole iconoclasts in such a way is to be mistaken. The iconoclasts were not opposed to images *tout court*. Rather, they were opposed to certain kinds of images. She argues that

> the history of iconoclasm shows not just a hatred of false images as that has generally been understood, and not just an oblique homage to the mesmerizing power of false images. It was predicated on the sanctity of 'true and living images of God': the iconoclasts themselves were the true images. In this sense, iconoclasm was *in favor of* images. The anti-imagism now associated with iconoclasm, based on their destruction of artistic images in the church, was only the corollary, the consequence, of their belief in true and living images. (Kibbey 2005: 10)

Kibbey argues that iconoclasm was less about the destruction of images as such and more about the destruction of the wrong kinds of images. By the same token, I am arguing here that film theory has been based less on a critique of cinematic representation *per se*, and more on a critique of the wrong kinds of cinematic representations. If film theorists have been critical of classical realism or the 'reality effect' of orthodox, Hollywood films, then this is only because they have always believed in the reality of another order – and to call these other images for which film theory has searched 'true and living images' is one way of putting it. For instance, the 'true and living images' for Wollen and Heath are those that foreground the materiality of the cinematic medium; for Gunning and Hansen, the kinds of images favoured are those that invoke the 'reality of modern experience'; for Margulies, they are the images that reveal the corporeal contingency of things; for Joyrich, 'true and living images' are those which promise themselves as 'mediums of knowing'. Each of the positions traced in this chapter is predicated on a division between false images – the illusions of orthodox cinema – and true and living images – the realities of counter-cinema. It is this division upon which film theory in its political modernist guise has been based: the division between illusion and reality in the cinema.

Kibbey explicitly reprimands film theorists for having pursued this distinction. She argues that film theorists unquestioningly inherited 'the iconoclastic paradigm': 'they discredited the representational images of film by using the idea of the cinematic apparatus to expose representational cinema as the work of artifice' (Kibbey 2005: 37). The false images of films are false because they are artificial; they do not expose the working of a true reality, of true and living images. Indeed, for a writer like Jean-Louis Baudry, whose arguments Kibbey examines in some detail, it seemed that the only alternative to the demonic representational regime of the cinema apparatus, the only thing that in the last instance could possibly dismantle orthodox cinema's illusions, was *theory* itself. From this bleak perspective, there was no future for cinema at all; rather, cinema's representations would have to give way to a future of theory. It is in this sense that iconoclasts posit themselves as 'true and living images', for it is they who hold the key to cinema's salvation. Is it any wonder, then, that some have attributed to political modernist film theory less of a desire to understand and analyse cinema and more of a desire to promote the grand truth of Theory (with a capital 'T')? From such a perspective the true and living

images of cinema would be the preserve of academic film theorists. 'All power to the theorist!' one essay wryly proclaims (Allen and Smith 1997: 10).

This chapter has argued that film theory today is still beholden to the ideals of political modernism. Those ideals are framed by a division between illusion and reality in the cinema. I have briefly tried to indicate, following Kibbey's argument, that the strategies of political modernism, even in so far as they tried to dismantle the representational allure of orthodox cinema, were (and are) still clinging to a theory of representation. As Kibbey argues, the iconoclastic theory of the image is one predicated on a distinction between false and true images. In precisely the same way, political modernism is predicated on a distinction between false and true cinematic images; those on the one hand that are illusionistic, and those on the other that give rise to reality. The remainder of this book surveys some of the ways we can go beyond this division between illusion and reality in the cinema in order that we may instead arrive at the reality of film.

2 Realism, reality and authenticity

3 Searching for reality: *Chronique d'un été*
(Jean Rouch, Edgar Morin, 1961)

In terms of the distinction outlined in the previous chapter of this book, one might ordinarily think that André Bazin's position in the history of film theory is set. He is a *realist* and that means, quite simply, that his understanding of cinema is predicated on a distinction between illusion and reality. Some films – especially those with excessive editing, or with fanciful stage settings – will deliver illusion, while others – particularly ones which utilize long takes, depth of field and natural settings – will reveal reality. Bazin's position, the typical commentaries will concur, is one of unabashed realism. This is the kind of Bazin who writes, '[T]he essence of film from the very start ... has been the realism of the image. One could say that this realism is implied by the automatic genesis of the cinematographic image, and that it aims at giving this image the

greatest number of characteristics in common with natural perception' (Bazin 1997d: 88). All the key factors of Bazin's realism seem to be here: that the quest for realism is part of cinema's essence, and that realism is an automatic result of cinema's photographic nature. Finally, Bazin also claims that the aim of cinematic representation is to accord with processes of natural perception. In short, films should aim to reproduce the conditions of natural perception and, as a result, films will correspond with reality. All a filmmaker need do is point a camera at the world, keep that camera rolling, and the result will be undeniably real, and, granted the time and space provided by depth of field and the long take, reality will be free to yield its beauty and mystery.[19]

Most film scholars seem quite content to dispense with Bazin along such lines. For example, Robert Stam and Sandy Flitterman-Lewis infer that the kind of realist ontology pursued by Bazin was overcome by a critique of the mimetic basis of that ontology. 'Film theory', they argue, 'gradually transformed itself from a meditation on the film object as the reproduction of pro-filmic phenomena into a critique of the very idea of mimetic reproduction' (Stam and Flitterman-Lewis 1992: 184). Similar preoccupations are voiced elsewhere, even, for example, in a book that claims to be defending approaches to realism: 'It is ultimately Bazin's commitment to a correspondence theory of representation favouring the use of particular techniques in the interests of "truth" that is so at odds with contemporary theories of representation today' (Hallam with Marshmant 2000: 15). The implication of such positions is that Bazin is old hat, film studies has moved on and the outlook of someone like Bazin is completely out of date: we've improved, we've grown up, we're more sophisticated now.

I think this view of Bazin is well known and well rehearsed. Quite rightly, however, some scholars are beginning to question it. In a recent article, Daniel Morgan insists that the Bazin handed down to us is one whose positions have been grossly simplified (Morgan 2006). Morgan argues that Bazin cannot be held guilty of offering either a direct realism (that cinema offers reality directly by way of its indexicality) or a perceptual or psychological realism (that films look like or are experienced in the same way as the real world is). Instead, when considering Bazin, Morgan argues, one should not begin from the premise of an ontological split between film and reality, but begin from the perspective of an ontological identity between film and reality. In other words, one should not concentrate on cinema's capacities for representing reality, one should

begin from the position that films are, in one way or another, part of reality. What this means for Bazin is that in cinema there is no such thing as seeing through the screen to a reality that might be posited somewhere beyond or behind that screen. Rather, a film always presents its own sufficient reality, independent of any prior reality that might be conceived beyond or behind it. This is what I understand Bazin to be arguing when he states that 'realism in art can only be achieved in one way – through artifice' (Bazin 1971a: 26). That is to say, realism can only ever be a construction and never a straight replication, duplication or representation of reality.

What I want to do in this chapter is to take Morgan's suggestions seriously. Beginning from Morgan's theses we can begin to see how Bazin has been dealt something of a raw deal by the film theorists who have succeeded him. To my mind, the misconception of Bazin boils down to one recurrent issue: representation. Bazin has been accused of one overarching fallacy: that cinema's key characteristic is its capacity to represent reality. That is the claim I wish to counter: for Bazin, cinema does not represent reality, but cinema is, in one way or another, reality itself.

This argument requires considerable unpacking. Therefore, my argument proceeds in three stages. First, I identify the key misconception accorded to Bazin – that films are defined by their capacity to represent reality. Second, I detail the implications of Bazin's ontological identification of cinema and reality, taking some cues from Morgan's article, but also paying attention to what Philip Rosen refers to as a 'realism of subjectivity' in Bazin. Finally, these considerations are positioned in relation to an important conception of realism in art history. I refer to the notion of realism developed by Michael Fried in various writings. Significantly, Morgan also calls upon Fried in characterizing Bazin's realism, so I am not sailing into completely uncharted waters on this count. However, where Morgan concentrates on a conception of acknowledgement wrested from Fried's writings, I instead, for reasons that will become clear, offer a conception of Bazin's realism based on *authenticity*.

Morgan on Bazin

The stakes of Morgan's intervention are, I believe, immense. (I should stress that my attempts to write about Bazin along these lines were in place well before I read Morgan's essay. However, in reading his piece, I became more convinced I was on the right track.) Morgan's argument does nothing less than unravel two or

three generations' worth of thinking about cinema which bases its thoughts on notions of cinematic representationalism. What he is questioning, above all, in our understanding of Bazin is that Bazin held to a belief that it was cinema's task to represent the world, either directly, perceptually or psychologically. The outcome of such a logic is that films can only ever be secondary emanations of the world – that is, copies, imitations, degradations. The 'myth' of total cinema would be where copy and original matched precisely; that is, where cinema would represent the world exactly. But, as Bazin well knew, this perfect representational goal of total cinema was just that: a myth (Bazin 1967c).

The traditional, representational understanding of Bazin is based on an entire ontology of representationalism that dominates debates on film and media theory today. One of the dominant buzzwords of recent times is mediation, that is, the notion that all representational forms (film, television, print media and so on) offer mediations of the world: they filter and mediate reality for us. No media form can offer a pure or direct version of reality because, by definition, media are composed of distinct codes, genres, styles and cultural inclinations (it should come as little surprise, of course, that *media* are defined by their capacity for *media*tion.) These latter ensure that we can never be given a true version of reality by way of the media, because the media are not real and never can be. All media are shackled by their inherent shortcomings: they can never represent the world or reality 'as it is' and, thus, the only option available to them – and to the critics and scholars who analyse them – is to admit to the inadequacies of representation as such. In other words, there is no point in even trying to represent reality, because reality will for ever elude the media's grasp: the media can only ever offer illusions of reality or reality effects; they can never offer reality itself. Such is the kind of position that believes it has moved beyond the naive realism of someone like Bazin.

The assumptions of this position, however, need to be exposed as inadequate and false. The overarching fallacy of the mediation argument is quite simply that it presumes a reality that is out there in some kind of pure and unmediated form. For their part, the media can thus only deform this pure reality because the media are subject to codes, conventions and technologies. For the mediation argument to make sense, a pure and unmediated reality must be predicated as irretrievably distinct from its mediated representations. We can very easily see how this representational ontology fits into the traditional view we have of Bazin: for the cinema, reality is

automatically and *a priori* out there and it can be mediated by way of the apparatuses of cinema. Certain techniques of representation – such as the long take and deep focus cinematography – can represent this reality more accurately or truthfully than other methods can (for example, methods like 'analytical editing' offer poor representations of reality). On this count, all cinematic representations are mediated, but some techniques offer less mediation than others. For the traditional Bazin, the less mediation there is, then the more realistic is the cinematic representation.

This formulation of mediated experience raises serious problems, however. First and foremost, as I have already suggested, it is based on the assumption that reality is out there in some kind of pure form; that reality is unchanging, perfect and impervious to the effects of time, history or human intervention. Therefore, whenever this pure form of reality undergoes any kind of representational process, when this pure, unchanging reality is subjected to any kind of intervention, it automatically becomes mediated, distorted and degraded: it can no longer be called reality as such. But, in a very precise way, such declarations cannot be held as valid. Putting to one side, for a moment, considerations of film and other media, might we think about how it is that human beings themselves encounter 'reality'? The only access human beings have to a reality that is out there is by way of our own perceptual and cognitive processes: for human beings there is no reality that is free from human intervention. For human beings, there is no such thing as 'pure', unmediated reality. In real or pure nature, so physics tells us, there are no such things as smells, sounds or colours; rather, there are only electromagnetic pulses, air waves, molecules, particles and so on. For human perception or cognition to make such particles into sounds, colours or objects, these raw materials need to undergo some kind of creative process – for example, a collection of light waves can somehow be composed by the human mind into the colour red. There is no red located in some pure reality, there is only a notion or thing that humans have invented which is called 'red' (at any rate, it is called this in English). Therefore, the point I want to make here is that reality as we experience, sense and perceive it in our everyday lives is itself always already mediated. What sense does it then make to say that cinema or other media mediate reality, when reality is itself always already mediated anyway? I would declare that it makes no sense at all. The only access to reality we have as human beings is mediated – that is what reality is for us.

My ruminations on this point are guided by the thoughts of Cornelius Castoriadis: 'Light waves are not coloured, and they do not cause the colour *qua* colour. They induce, *under certain conditions*, the subject to create an "image" which, in many cases – and, so to speak, by definition in all the cases we can *speak about* – is generically and socially shared' (Castoriadis 1997c: 323). Castoriadis argues here that reality is for us not an inalienable and fixed entity; it is not out there, as it were, pure and untouched, brimming with essential neutrality. Rather, reality is always mediated by the predilections of human nature: our eyes have the capacity to allow us to sense certain rays of light and our brains can translate these rays into cognitively meaningful things such as 'red'. Furthermore, what we call 'reality' is also mediated by degrees and codes of social understanding that any one individual has the possibility of sharing with others, as now I am assuming readers understand what I refer to by calling something 'red' (the word 'red' gives reality to something we share). That *is* what human beings speak about as reality. Reality is composed of events, objects and experiences that can be 'generically and socially shared', as Castoriadis claims.

This kind of social understanding of reality is central for Bazin's conception of cinema. For him, reality is not a pure, unmediated substance out there. Rather, reality is composed of a set of shared, potentially communicable concerns. As such, realism in the cinema is not a matter of a film's measuring up to a preconceived, prior and pure reality. It is about establishing sets of shared concerns, a matter of discerning degrees of meaningfulness and understanding about what we might be able to agree upon as being real. That is precisely what Bazin takes realism to be: an aesthetic by way of which humans might reach a set of shared judgments about what constitutes reality. 'The cinematic esthetic will be social', Bazin writes at one point, 'or cinema will have to do without an esthetic' (Bazin 1981: 37).

My initial concern here is that these ideas will sound somewhat abstract. Therefore, I intend to provide two initial examples in order to alleviate the reader's potential trepidations. I think Bazin's approach to realism and reality is, in fact, very much 'down to earth', as it were, but it does require readers to think of 'realism' in a way that is substantially different from the usual ways in which realism has been defined. Again, I want to stress first and foremost that this conception of realism is one based on socially shared modes of understanding, on 'ways of life', and that it has little or nothing to do with the way that representations may or may not correspond with what reality 'looks like'.

Roberto Rossellini's *Germany Year Zero* (1948) is directly concerned with such issues: how is Germany to reconstruct a generically and socially shared way of life following the realization that the realities defined by the years of National Socialism were exposed as false, wrong, and disastrous? 'Year zero' is precisely the attempt to start again, to define reality again from scratch, to rebuild senses of a reality worth sharing. The film's central problematic moment concerns the decision of the young boy, Edmund, to poison his father. He has been told by his ex-schoolteacher, who retains Nazi sympathies, that sick people, like Edmund's father, are burdens to society who hold back the ambitions of those who are healthy. And this is certainly one way of defining reality: reality is a Social Darwinist battle in which the strong must strengthen themselves in order to avoid being thwarted and restricted by the weak. This way of building a society, Edmund's schoolmaster insists, is the most effective way to ensure a thriving community – not to offer the weak a helping hand, but instead to dispose of them in order that the strong might become even stronger. Edmund takes his ex-schoolmaster's Nazi, 'survival of the fittest' philosophy as an exemplary way of defining reality and doses his father's tea with poison. His action is, we might say, guided by a way of defining reality, an understanding of 'what one does' or what is 'the right thing to do'.

Nevertheless, the reason Edmund's decision to poison his father becomes problematic is because he begins to doubt that this was a justifiable course of action – he begins to question whether the 'survival of the fittest' ethos is really one that offers a version of a shared social reality to which he is willing to subscribe. In short, he begins to believe that such actions might have no place in a social world that he might want to call 'real'. Edmund's crisis of faith – not a crisis of religious faith but a crisis of faith in reality itself – ends in a sense of utter confusion about what the 'right things to do' are and of a sense of total alienation from the world. By the end of the film Edmund no longer knows what reality is or what it can be. His only way out is to commit suicide.

Bazin mentions these issues in the following way:

> Rossellini's aesthetic clearly triumphs in the final fifteen minutes of the film, during the boy's long quest for some sign of confirmation or approval, ending with his suicide in response to being betrayed by the world. First, the schoolmaster refuses to assume any responsibility for the incriminating gesture of his disciple. Driven into the street, the kid walks and walks, searching here and there among the ruins; but, one after the other, people and things abandon him. (Bazin 1997a: 123)

The world abandons him; the world loses its reality; it becomes a place in which nothing can any longer be generically or socially shared. There are no longer any thoughts, words, images or gestures that can give reality to the particles and substances with which Edmund comes into contact. How do we build societies in which we can agree on what should be regarded as reality? – This might be said to be the overarching question that guides the film. In *Germany Year Zero*, however, no one can agree on how reality should be defined and, in the end, reality comes to be defined much more in terms of the notion of 'every man for himself' rather than in terms that can be socially shared. To build a world in which there can be realities which are socially shared is what is at stake for defining reality itself, for Bazin. Conversely, to define reality in the ways that most of the characters in *Germany, Year Zero* do is to turn one's back on a notion of reality that can be socially shared, to descend into an atomistic world where all social obligations and communication have come undone, where the fabric of reality itself has fallen apart.

Another film directed by Rossellini that Bazin strongly defended is *Voyage to Italy* (1953). Again this film emphasizes the social nature of what is called reality, this time a reality defined by a married English couple and their uncertain reactions to the foreign culture and society of Naples. It is as though the couple in this film are completely unhinged from reality while staying in this foreign country. Kathy (Ingrid Bergman), the wife, declares early in the film that this is probably the first time they have been alone since they were married eight years previously. It is as a result of this fact of being alone, that is, of losing the co-ordinates by which their social reality is typically structured, that they come to doubt the very nature of their existence, of their love for each other, and of the entirety of their spiritual lives. Husband and wife become strangers to each other as their stay in Naples progresses and, eventually, each of them finds ways for compensating for this acute loss of reality: Kathy by visiting tourist spots and ancient sites; Alex (George Sanders), the husband, by hooking up with old friends in the hope of rediscovering what romance is (he tries to 'pick up' one or two attractive young ladies). The relationship between Kathy and Alex becomes more and more spiteful until Alex finally declares that they should be divorced.

At the film's end, however, a miracle occurs – at least, Bazin refers to it as a miracle. The couple realizes, when caught in the middle of a strange Catholic ceremony in which the people of a village fill

the streets, that they do love each other; they come to the realization that their bickering has been calculated and false; they have been mean to one another in ways that were not true. In fact, their antagonism has merely been an escalation of their inability to be honest with one another; their fighting has been a result of failing to tell the truth, a failure of honesty. In other words, they thought each had hated the other, when all along each was hating the other only because the one thought the other was hating them. What this means is that each was defining their reality in terms of falsehood, in terms of dishonesty, in terms of deceiving oneself, of not being true to oneself, and, by extension, by being untrue to others. It is little wonder, I think, that Bazin feels compelled to describe the ending as a miracle, for it is a miracle in which a certain reality comes into being: a miracle of being honest to another and of being true to oneself (Bazin 1971c: 98–100). This conception of realism, which I think goes to the heart of Bazin's realism, has very little to do with notions of 'capturing' reality in a way that corresponds with perception or with phenomenal or material reality. Instead, it is a way of agreeing about what reality is – in the case of *Voyage to Italy*, a couple's realization that they can inhabit a reality which they can share, that they can share a conception of reality. That reality is defined by their being true to each other and to themselves. It is a matter of being 'true to life'. That is what Bazin's realism amounts to.

Criticism of Bazin

The quest for a social or shared reality in Bazin is a long way from the traditional realism we have come to accept as being Bazinian. Because film scholars have become used to a simplified version of Bazin, it has become difficult to ask penetrating questions of his work. Scholars remain tied to a monolithic conception of Bazin's realism that unquestioningly affirms a notion of realism that is based on the accuracy of a representation's correspondence with a prior, preconceived and pre-existing reality. It seems today that Bazin's theories are nonchalantly brushed aside as rudimentary and naive. A couple of recent mentions of Bazin are worth drawing attention to, for they point to the way that he has become something of a straw target against which supposedly more sophisticated theories of cinema's mediations can be erected.

The first occurs in an article written by Sam DiIorio in which an 'end of Bazinian film theory' is proudly exclaimed. This end is

placed in relation to one particular film and its historical context: Jean Rouch and Edgar Morin's *Chronique d'un été* (1961). DiIorio compresses his main thesis into a single statement at the end of his essay:

> Although *Chronique* does hark back to Bazin, however, its inability to confirm a consensual real underscores the necessary artificiality of filmic realism and contradicts what Eric Rohmer described as the main tenet behind all of Bazin's criticism: his belief in the cinema's inherent objectivity, in its innate capacity to represent the world as it exists. (DiIorio 2007: 42)

For DiIorio, then, *Chronique d'un été* harks back to Bazin, but only in so far as it criticizes and surpasses the Bazinian position. DiIorio's position is one that takes the mediation argument to its extreme. His discussion of *Chronique* can only be based on the assumption that reality is 'out there' in a pure and unmediated form, and, if anyone dares to put a camera in front of that reality, then that reality becomes automatically and irrevocably degraded. *Chronique*, on DiIorio's reading, thus decides to turn its back on the quest to represent reality objectively – it denies the possibility of ever arriving at a 'consensual real' – and instead revels in the 'necessary artificiality' of cinematic mediation. *Chronique* is therefore seen as exemplifying the way that pointing a camera at something automatically distorts and degrades that thing. If one points a camera at reality, then one must also admit straightaway that one is ruining that reality. The only solution is therefore to bask in the glories of mediation, to admit that one is constructing mere artificialities and to totally deny the cinema any power whatsoever.

The crippling restrictions of DiIorio's logic are all too clear: he, not Bazin, is proposing a reality that is out there, and it is he who ascribes to Bazin the cinematic quest for representing that (supposed) reality. The value judgement DiIorio places on that sanctified and pure reality out there is that one should never dare to represent it, for to attempt to represent it is automatically to violate it, as if any intervention in the pre-existent real were some kind of crime. What one must do, on the contrary, is crush all attempts to represent, for the reality that is out there must remain pure, sanctified and reified as a for ever impossible real. What DiIorio describes as a 'consensual real' is a reality of which he conceives as being pure and unmediated and, as such, beyond all reach of the camera, that is, as impossible for cinema's representational capacities ever to capture properly or sufficiently. His only retreat is to denigrate

the capacities of cinema itself as faulty, artificial and inadequate, and to fall back on shallow notions of cinema as a 'construct' or as mediated (DiIorio 2007: 42). He fails to understand that reality itself, so far as Bazin conceives it, is already always mediated: it is not pure and unmediated.

Bazin's position is far more subtle than that ascribed to him by DiIorio. Bazin aspires to a 'consensual real' that is not pure or unadulterated. Rather, Bazin's realism is one in which a 'consensual real' is a matter of human understanding, of potentially agreed meaningfulness and social communicativeness. Reality for Bazin is only ever something that is 'generically and socially shared', to invoke again Castoriadis's formulation. And surely this is what *Chronique d'un été* is about: the difficulty, the fight and the need for argumentation about what is to be taken for reality, the need to emphasize that there are no easy ways to determine what reality is, for example, that we cannot work out what reality is simply by looking at it, but, on the contrary, working out what can or should be accepted as real is a matter of discussing what one sees with other people and of working out the ways in which what one person takes for reality might square with – or be opposed to – what another person understands by reality. These are all issues with which *Chronique* is deeply concerned. As such, I think it unduly trite to believe that the film somehow introduces an 'end' of Bazinian film theory. On the contrary, *Chronique* is a carefully considered continuation of and reflection on Bazin.

DiIorio's argument also suffers from an all-too simplistic understanding of technological progress. Back in the 1940s and 1950s, he implies, it might have been possible for a film critic like Bazin to believe in the naivety of representational realism. With the introduction, however, of new cinematic technologies at the beginning of the 1960s – more portable microphones and cameras, for example – the old quest for representational realism had to give way to a new, and for DiIorio unquestioningly more sophisticated, understanding of 'appearances' (DiIorio 2007: 31). Such a line of argument is common for those wishing to dispense with Bazin: a naive, earlier understanding of cinema as a representation of reality must give way to more layered understandings of cinema's mediating textualities in line with notions of reflexivity and cinematic self-consciousness that emerge during the 1960s.[20]

Nowhere is this line of argumentation taken to more questionable extremes than in the celebration of cinema's digitization, in pronouncements that finally cinema can shake off the belief it

might once have had that its task was to represent reality. Digital cinema, so the argument goes, is a completely different beast from the cinema of celluloid, especially as films can now be made without any reference to 'reality' at all. One recent article written by Stephen Prince puts it in the following way, with Bazin again registered as the fall-guy: 'We're a long way here from Bazinian notions of photographic realism, of a necessary connection between the photographic image and the realities that exist before the camera' (Prince 2004: 30). Technology here reigns supreme: back in the old Bazinian days of photo-mechanical filmmaking, it might have been possible to conceive of cinema in terms of indexicality, of the connection between the cinematic signifier and the signified reality. But digital cinema smashes such conceptions to pieces: in the digital age the index is no longer relevant. (Must we presume, according to such a logic, that the 'reality' filmed in Disney's *Fantasia* (1940) was indexical in so far as it utilised photo-mechanical methods?)

An example is offered by Prince as proof of the way that cinema's ties to an indexical real have been rendered obsolete by digital technology. In the Coen brothers' *O Brother, Where Art Thou?* (2000) there is a moment in which a gangster on the run from the police aims his machine gun at some cattle grazing in a field. One of the cows is riddled with digitally produced bullet holes. Because the bullet holes are produced digitally – and it is quite clear to any viewer that this *is* how they are made (the cow's flesh, for example, does not flex under the force of the bullets in the way one would expect of a living, breathing cow, and nor does the cow exhibit the signs of distress that one would anticipate) – then, Prince argues, we can be sure that no real, 'flesh and blood' cows were hurt (or killed) during this scene. In short, the cows in this sequence can be shot without having to shoot any 'real' cows.

Prince takes this as being definitive of a distinction between the new forms of digitized cinema and the old forms of analogue, photo-mechanical cinema. He states, with reference to the cows, that 'they can be exterminated without real consequences to any reality in front of the camera' (Prince 2004: 27). The implication of this point is that because these cows can be fired upon digitally, they can remain unharmed, but, if they had been shot photo-mechanically, they would have been harmed – there would be, as Prince puts it, 'real consequences' for the 'reality in front of the camera'.

In order to clarify Prince's argumentative point here, we need to ask what it is that he means by consequences: the cows in this scene can be shot without real consequences. We can assume without too

much ambiguity that he means that, because of the use of digital special effects, a real cow did not need to be shot in order for this scene to occur. Conversely, it is possible to think that, without digitization, a real cow might have needed to be shot in order for the scene to have been rendered photographically. Is this proof, however, of a definitive difference between digital cinema, on the one hand, and photo-mechanical cinema, on the other? Furthermore, can this be taken as proof that with digital cinema the cinema itself loses its ties with reality? In other words, does Prince's argument for the glories of digitality finally mean we can renounce Bazinian forms of realism in the cinema?

I, for one, do not think Prince's point in any way affirms any kind of difference between the digital and analogue realms, and I also think his point in no way proves that digital cinema somehow signals the end of cinema's associations with reality. Of course, my counter-argument to Prince hinges on our very different understandings of what reality is. Prince's so-called reality is a reality that exists, as he puts it, in front of the camera, while, for the purposes of discussing cinema, I totally deny the validity of the concept of a reality in front of the camera. Instead, following Bazin, I am trying to affirm the positivity of the realities that are inscribed by the camera, to affirm that these can only ever be generically and socially shared realities. To call again to Bazin, 'The cinematic esthetic will be social, or cinema will have to do without an esthetic' (Bazin 1981: 37).

Therefore, how can we work out what Prince means by 'real consequences'? Anyone who is familiar with cows can surely understand what a real, 'flesh and blood' cow is, and anyone used to going to the movies can also understand that when they see a cow being shot during *O Brother, Where Art Thou?* they are not witnessing the shooting of a flesh and blood cow. However, this lack of flesh and blood reality is in no way attributable to the use of digital special effects. It is a matter of shared conventions and understandings of what cinema is and how it functions. We know these cows are being gunned down digitally – or at the very least, we know that flesh and blood cows are not being shot. The shooting of these cows might therefore be understood as being in the order of the many deaths suffered by Wile E. Coyote in his pursuit of the Roadrunner: they are deaths *without consequences*. We know no cows died during this scene in the same way that we know Wile E. Coyote does not die when he falls thousands of feet from a cliff. Such a lack of consequences is not the result of any digital effects. It is an effect

of the meaning that is intended and understood by these scenes and their contexts. The consequences of the gangster's shooting of the cows in O Brother is precisely that it is amusing in a way that shooting a flesh and blood cow most likely would not be. (In much the same way, the Wile E. Coyote's plunge from a cliff is amusing in the way that seeing a flesh and blood coyote fall most likely would not be.) The consequence is that we can accept a cinematic cow being treated in such a way, whether this cow is digital, analogue, painted, sketched, black and white, or whatever. We will most likely not react the same way if a flesh and blood cow is being shot – the latter's consequences, far from being amusing, might even give rise to substantial horror and screams of angst.

And even then, not all cinematic deaths are without consequences – for example, most viewers will not react with amusement when Bambi's mother is shot during Bambi (1941). Or in Groundhog Day (Harold Ramis, 1993), to suggest another example, the main protagonist dies many times in his attempts to escape from the day he seems destined to repeat over and over again. And yet, that is a photo-mechanical film which is, so far as I can make out, bereft of any digital special effects. Are we to assume that a real flesh and blood human being had to die many times in order for these scenes to have been produced, that a reality 'in front of the camera' suffered 'real consequences'?

These are not flippant concerns, for they go to the core of what is at stake in the all-too easy refutation of Bazin. What are the consequences of digitally shooting a cow? They are ultimately not very different from photo-mechanically shooting a cow. What can be defined as reality in the cinema is not the result of the mechanism or technology by means of which images are produced and the supposed consequences of those mechanisms. Instead, what is real in the cinema is a consequence of what we see and hear, of what we, as human beings, count and accept as being consequences. That the cows in O Brother are shot with digitally produced bullet holes in no way expresses a definitive distinction between digital and analogue modes of cinema, and nor does it tell us anything about the distance between digital cinema and reality. Rather, it is an expression a certain sets of 'generically and socially shared' beliefs we have about the realities of cinema.

In fact, Prince ultimately confuses and conflates digital effects with special effects. In the terms which Prince provides, how are the consequences of digital effects different from any other kinds of special effects? Or in what ways does the digitality of digital

effects distinguish them from the other elements of cinema? An example will most likely help the complexities of these questions to be answered to a certain extent, for they are complex questions indeed. If nothing else, however, I wish to point out the all-too-easy assumption that underpins Prince's argument: the assumption that photo-mechanical forms of cinema rely on capturing realities that are 'in front of the camera' whereas digital forms of cinema have no need for things that might be referred to as 'reality'. The example I shall discuss is that of Steven Spielberg's *E.T.: The Extra-Terrestrial* (1982).

I know very little of how the extra-terrestrial in *E.T.: The Extra-Terrestrial* was produced for the cinema, except to say that I am fairly certain no digitization played a part in it.[21] I know enough to realize, however, that when the E.T. is on his deathbed, as a reality 'in front of the camera', the life of no flesh and blood creature is at stake. On the one hand, then, we have to admit that E.T. is a reality 'in front of the camera' because – in accordance with Prince's logic – he is not a digitally produced artefact. That is to say, because E.T. is not digitally produced, he must be a reality in front of the camera. And yet, he most clearly is not a reality 'in front of the camera'; he is a fantasy creature, an actor, a puppet, or robot, or some such contraption, and any viewer who sees this film is aware that E.T. is not a 'flesh and blood' reality. In other words, the E.T. is much the same as the bullet holes produced in *O Brother*'s cows: not something that is a flesh and blood reality. Therefore, we must concede that digital processes do not introduce anything new ontologically to cinema (or, at least, not in the terms that Prince offers). Rather, digital effects are merely the continuation of many cinematic techniques that have been in existence since the time of Méliès which do not need to rely on a reality in front of the camera.

If we therefore concede that E.T. is a 'special effect' and not a reality in front of the camera, does this then mean that, when lying upon his deathbed, there are no 'real consequences'? That is to say, as an 'effect', do we relate to E.T. in the same way we relate to the digital bullet holes in *O Brother*? Because E.T. is not a reality in front of the camera, can we assume that there are no 'real consequences' to be derived from him? Strangely enough, even though he is not a reality in front of the camera – he is merely an illusionary, fabricated figment of imagination – for a substantial proportion of viewers of this film, there genuinely *are* real consequences. Many viewers – and I include myself among them – develop an enormous sense of concern for the puppet-like alien so that at the film's

conclusion, when the E.T. must abandon Earth in order to survive and, as a consequence, forgo the friendship he has developed with the young boy, Elliot, the real consequence of this departure is a tremendous sense of sadness. The real consequence of this film's ending is one in which tears are destined to flow, and such tears depend very little on the mechanisms or technologies of the film's production. Those who cry at the end of E.T. are those who understand the film as being in some sense real for them: these are the real consequences that E.T. can invoke. That the separation of two fictional characters can reduce audiences to tears, especially when one of those characters is a somewhat bizarre-looking and patently unrealistic alien creature, is a testament to the real consequences even the most fantastic of films can have. What is at stake here is a belief in a certain kind of realism – not a belief that E.T. gives us a realistic representation of reality of the kind that might be found 'in front of the camera'. Rather, what is at stake is a belief that E.T. presents situations, actions and characters that can be imbued with reality. The only way that such a reality might be accepted as reality is if it is in accord with what any social group is prepared to accept as definable as reality. Let us say that if one recognizes the reality of E.T.'s predicament, if one is moved to tears by its conclusion, then one probably accepts that the friendship between Elliot and the E.T. is real in a way that is conceivable, understandable and imaginable and thus in a way that has real consequences. Suffice it to say that such a friendship is real in much the same way as the friendships one has in one's own life are conceivable, understandable and imaginable in ways that have real consequences.

It is this kind of understanding of reality that is, I think, central for Bazin's conception of cinema. Far from being a realism of representation or of looking like reality, the reality to which Bazin subscribes is one of placing worth in human actions, of trying to forge agreements about what reality is or should be. To put this in the context of the examples I have already mentioned, then the reality of the friendship between Elliot and the E.T. can be defended as an example of reality – call it a reality of 'friendship' – in a way that the extravagant shooting of a cow in O Brother, Where Art Thou? cannot. (This is in no way to denigrate the latter example, for it is not trying to invoke reality in any way – quite the opposite, in fact.) The deceptions and attempted backstabbings of the main couple in Voyage to Italy are examples of humans turning away from reality – that is, of turning away from any possibility of coming to an agreement about what is real – except that the main

protagonists of that film do, in the end, return to reality, a reality of shared feelings and communication. Edmund's suicide at the end of *Germany, Year Zero* is a result of his inability to discover what reality can be: he commits suicide because he loses belief in the possibility of a reality that is 'generically and socially shared' (to revert to Castoriadis's phrase, once again).

In order to prove my point beyond doubt, it is even possible to find in Prince's article a precise conception of the kind of reality which I am here trying to invoke. Beyond his empty rhetoric of digitization and the abolition of a photographic real, Prince betrays a firm belief in a reality that is 'generically and socially shared'. When discussing *O Brother, Where Art Thou?* he draws on a distinction between an implicit realism (which he ascribes to the general look of *O Brother*) and overt or 'advertised' special effects (the digitized bullet holes in the cows are examples of the latter). He describes the distinction in the following way: 'The dustbowl look, the hand-tinted postcard quality of *O Brother* are, of course, effects, but they do not advertise themselves as such. They do not subvert', he adds, 'a viewer's impression of the photographable character of images' (Prince 2004: 28). Prince thus emphasizes the way that viewers can make distinctions between 'advertised' special effects – effects like the digitized bullet holes in cows – and something else which is not to do with effects, or which, at least, does not advertise itself as such. What Prince is thus alluding to is that audiences are prepared to call some things 'real' or 'realistic' in order that those things be clearly distinguished from things that are 'effects'. Audiences do not expect some things (such as digital bullet holes in cows) to accord with a generically and socially shared reality, whereas there might be other things (things which might include friendships between aliens and young boys) which audiences can understand as being in some sense real. Prince further acknowledges this distinction: 'it seems likely', he writes, 'that the viewer who encounters special effects, with their fantastic, digitalized creatures, is led to frame the image, to contextualize it cognitively, in different terms than images that appear more naturalistic' (Prince 2004: 28). What Prince is trying to say is that audiences can understand the ways in which some images are more naturalistic – that is, they evoke a generic and shared reality – than others.

Prince even reveals himself to be Bazinian to a certain extent, especially in so far as the distinction he draws between effects and naturalism is precisely the same distinction Bazin makes on a couple of occasions. Bazin was not at all against the use of illusion

or effects in the cinema. Rather, he argues that illusion in the cinema goes hand-in-hand with reality. According to his argument: illusion in the cinema is effective only if it is based on a shared conception of what is real; the illusory works as illusory only inasmuch as it is juxtaposed with an already assumed reality. 'Not only does some marvel or some fantastic thing on the screen not undermine the reality of the image', he argues, 'on the contrary it is its most valid justification' (Bazin 1967e: 108). Or again: 'The fantastic in cinema is possible only because of the irresistible realism of the photographic image. It is the image that can bring us face to face with the unreal, that can introduce the unreal into the world of the visible' (Bazin 1997c: 73). As a proof of this claim, Bazin considers James Whale's *The Invisible Man* (1933), for the fantastic invisibility of the man is effective only because that invisibility is juxtaposed with a visible world, a shared, corporeal world, on the basis of which the invisible man is made possible. The invisibility of the man is effective because the audience knows it is something illusory which contrasts with what we know and understand as being real. As Prince might put it, we cognitively frame the invisible man in a way that is different from our framing of visible men (we know, from our socially and generically shared understanding of reality, that men are visible, while, contrarily, an invisible man is not something we understand as being part of our reality). In other words, what is at stake for Bazin is less the verisimilitude of filmic images, and more the notion of a shared world or a shared set of ways of understanding and making sense of the world that are intrinsic to the filmic experience. Janet Staiger has also emphasized this aspect of Bazin in claiming that, from a Bazinian perspective, 'Cinema is a lived experience, a dialectical and historical relation between films and perceiving subjects' (Staiger 1984: 109).

I hope I have begun to indicate the ways in which it is not necessary to assume that Bazin's approach to cinematic realism was based on cinema's capacities to represent reality. Bazin's conceptions of realism and reality were far more complex than a reductive correspondence theory of realism can indicate. I hope I have begun to suggest that Bazin's approach to realism involved a conception of realities that are generically and socially shared and not as something that can be straightforwardly looked at or photographed. There remains, however, much more to be said.

Rosen and the question of subjectivity

One of the most important interventions into debates on Bazin came from Philip Rosen during the late 1980s (Rosen 2003). Rosen's purpose was to articulate the ways in which an appreciation of Bazin's realism is a matter of negotiating the relationship between the subjective and objective dimensions of the cinematic experience. Rosen's guiding questions can be summed up as follows. How does one individual's perception and cognition of the world relate to the ways that other individuals perceive and cognize the world? Or, to put it another way: How is it possible to view the world in a way that is not simply *my* point of view, but which might in some way intersect or 'meet up' with other people's views of the world? With such questions in mind, Rosen argues, at some points, for an understanding of Bazin that relies not on cinema's referential capacities but instead on the ways that human subjects have the ability to make sense of or constitute reality itself. Thus he will claim that 'any reading of Bazin on the image should begin from Bazin's view of the subject' (Rosen 2003: 43). To understand Bazin one should not begin by positing an objective, pure and unmediated reality that is out there, but one must begin from the question of how it is that subjects perceive and cognize reality. One must not begin from a position which claims that reality is in itself objective; rather, one must begin from the position that reality is, for all human subjects, always already mediated.

If one begins, however, from Bazin's view of the subject, Rosen argues, one must nevertheless refrain from remaining entirely within the domain of subjectivity. Rather, in ways that I have already hinted, one must also consider the ways in which the views of one individual subject might find some kind of accord with the views of other individual subjects. One must try to discover the ways in which individuals might arrive at forms of agreement about how they perceive and cognize reality so that, ultimately, they might find some kind of agreement as to what reality itself is. Such attempts to find agreement amount to what could be called a 'consensual real' (a term DiIorio utilizes in his essay). In other words, one must search for designations of reality that are socially shared, a point which I have emphasized throughout this chapter. Rosen puts it in the following way: 'the processes by which human subjectivity approaches the objective constitute the basis of [Bazin's] position' (Rosen 2003: 44).

These are quintessentially Kantian problems (a point which Rosen fails to acknowledge, preferring instead to concentrate on

phenomenological approaches). Daniel Morgan, in his ground-breaking essay on Bazin, makes the link between Bazin's conception of reality and Kant's Copernican revolution in philosophy. The point is one I have already emphasized: the only access to reality we have is by way of the capacities of human subjectivity that can grant us access to that reality. There is no pure, unmediated reality – there is no 'thing in itself', as Kant would say. As Morgan puts it, apropos of both Kant and Bazin, '[w]e can only know the external world in so far as it satisfies the general conditions of human knowledge' (Morgan 2006: 453). Even though he fails to mention Kant in making his point, I nevertheless think this is the kind of point Rosen tries to make. He signals the way in which a Bazinian approach to reality does not need to focus on the factors of cinematic representation, technique or style – or to put it another way, cinematic style or technique does not aim to represent the objective reality of some 'thing in itself'. Rather, what is crucial for Bazin is the attempt to understand how human subjects form ways of encountering the world that they can agree upon as being real, and thus, of ways of seeing and experiencing the world that they can call real. Rosen expresses this point with great eloquence:

> If formal and stylistic procedures cannot provide an actual, unmediated access to the objective, then the basis for evaluating those procedures is located elsewhere than in the relation of text to its referent: in the processes of the subject, its modes of postulating and approaching 'objectivity'. (Rosen 2003: 46)

How do subjects postulate and approach objectivity, Rosen asks, and by extension, how does cinema postulate and approach objectivity? Rosen's point is that objectivity cannot be separated from what subjects postulate as objective; objectivity is not free from the subjective approaches we make to it. Likewise, cinema cannot be characterized by modes of capturing or representing objectively, but must instead be characterized by modes of postulating and approaching objectivity.

Another way in which Rosen clarifies these issues is with recourse to the notion of indexicality and the cinematographic image. Typically, an indexical sign is understood by way of its intrinsic connection with the objective reality that produces it, an objective reality that is said to be liberated from the subjective constraints of human intervention. One of the classic examples is 'smoke', for smoke is an indexical signifier of 'fire'. If I see smoke, then that smoke can only be a result of the objective reality that causes it:

fire. With indexicality, therefore, there exists an intrinsic connection between objective reality – fire – and the signifier caused by that reality – smoke.

The notion of indexicality has therefore had numerous supporters in the theorization of film and photography: the photographic or cinematographic signifier (i.e., what we see in a photograph or on a movie screen) is, according to such arguments, automatically caused by the objective reality that has been filmed or photographed. A photograph or film of a car, for example, can be said to have been caused by the car itself. Hence, indexicality is taken to confirm the connection between film and reality: film truly has the capacity to represent reality because what we see in cinematic representation is intrinsically caused by objective reality itself.

Rosen takes steps towards quashing such conceptions. He argues that there is no intrinsic, objective connection between an indexical sign and its referent. Rather, such connections are ones that are only ever learned by human subjects – they are culturally and socially shared connections. One has to learn, for example, that smoke is caused by fire in the first place to then be able to read smoke as a signifier of fire. There is no automatic connection between smoke and fire, for the connection between them has to be learned. The index is therefore social and cultural – Rosen, for his part, refers to indices as 'existential' (see Rosen 2003: 48–9).

These are incredibly important insights for restructuring the way we conceive of Bazin's realism. First, that objective reality cannot be conceived apart from the subjective determinations it is possible to give to reality in the first place. Second, that any perceived or conceived connection between external, objective reality and cinematic indexicality can only ever be the result of a learned relation between such things. And yet, having discovered these important ways of reconsidering Bazin's realism, Rosen retreats from the boldness of these insights in order to fall back on what he calls the 'mummy complex'. Having defined the necessity of subjective approaches to and postulations of the objective, and having emphasized the cultural, social and thus non-universal connotations of indexicality, Rosen then places his eggs in one universal basket. For Bazin, he argues, all subjective quests for objectivity can be delimited by one overarching universal principle: the quest to overcome time (Rosen 2003: 63). Through cinema the subject seeks to 'tame temporality' (ibid.: 62); films are a defence against the passing of time and, thus, they respond to what Rosen calls the subject's 'preservative obsession' (ibid.: 53).

I find these observations of Rosen's to be rather unhelpful, as though he feels compelled to assign to Bazin some kind of universal claim. Nevertheless, Rosen's insights into Bazin's conception of subjectivity and his rejection of the universality of the indexical sign provide necessary steps along the way to a reconsideration of Bazin.

Forms of life

Daniel Morgan, as I have already mentioned, suggests an intellectual framework from within which a new understanding of Bazin can be prized. He calls upon the writings of Stanley Cavell and Michael Fried while paying particular attention to Cavell's conception of acknowledgement: knowledge, he claims, from a Bazinian point of view, is less about obtaining real facts about the real world in a manner that might be deemed scientific, and is more concerned with how the reality of things might be *acknowledged* by human subjects as real. For Cavell, as much for Bazin, I would argue, knowledge is about a social understanding of reality, intersubjective acknowledgements about what should or can be decided upon as real.

For reasons I will refrain from going into in any great detail, I find Morgan's insistence on acknowledgement to be less illuminating that it probably should be (for an excellent discussion of the relation between Morgan's Bazin and Stanley Cavell's ontology of film, see Rothman 2008). For this reason, I instead aim to take inspiration from the theories of the art historian Michael Fried in a slightly different way. The notion upon which I rely here is that of authenticity. This term is certain a problematic one, but it has the advantage of being able to turn our understanding of Bazin away from a correspondence theory of realism towards modes of filmic portrayal that might be, in various specific ways, true to life. To put it another way, if Bazin is to be considered a realist, then this realism is one in which the images portrayed are images that matter. Bazin's realism is not a realism concerned with the perceptual accuracy of filmic images, or with the correspondence between filmic images and reality. It is, on the contrary, a realism that has its basis in a conception of authenticity.

The notion of authenticity upon which I am relying has a complicated history. Its clearest explication occurs in a recent article by the Hegelian philosopher Robert Pippin. In that article, which is on 'Authenticity in painting', Pippin discusses the writings of the art historian Michael Fried (Pippin 2005). As is well known, Fried, across a range of books and articles (see Fried 1980, 1990, 1996,

1998) has advanced a theory of modernist painting based on a distinction between *absorption* and *theatricality*. (In his turn, Fried adopted these terms from the late eighteenth-century *philosophe* Denis Diderot.) Paintings that utilize modes of absorption belong to a tradition that culminates in modernism, while theatrical paintings are part of another tradition, a tradition that, for Fried, both precedes (with Rococo) and follows modernism (with postmodernism). I want to argue that Bazin's call for realism in the cinema is very similar in nature to Fried's advocacy of absorption in painting. In turn, following Pippin's lead, I want to suggest that modes of absorption in art are ones that rely on authenticity, and, thus, Bazin's call for realism in the cinema is also a plea for authenticity. Such a suggestion is not at all far-fetched, especially in the light of Fried's championing of various realist painters – Courbet, Eakins, Menzel (Fried 1988, 1990, 2002). Therefore, I am arguing that the kind of realism advocated by Bazin is one that is absorptive and authentic.

First of all, a counter-example. Pippin, in passing, makes a reference to Douglas Sirk in order to explain situations that are not absorptive. Such situations are, he writes, 'depictions of alienation, where virtually all aspects of a life come to be experienced as scripted with rules that have only a positive, external authority and where success at managing such a life amounts to an imitation of life, to recall Douglas Sirk's variation on just that theme' (Pippin 2005: 593). What I surmise from Pippin's suggestion is that the films of Douglas Sirk – say, *Imitation of Life* (1959), *Magnificent Obsession* (1954) or *Written on the Wind* (1957) – depict the stifling and restrictive social mores and rules of postwar American society, a society in which one's attitudes, thoughts, actions, hopes and dreams were not ones that were self-inspired or self-determined, but were wholly determined by codes, institutions and expectations that were given by others; where the conception of 'the right thing to do' (or, more simply, of 'what one does') was something that could not be decided by oneself, but rather was a decision imposed upon one by 'external authorities'.[22]

Against this alienated vision of the world, absorption is a mode in which one's attitudes, thoughts, actions, hopes and dreams can be determined by oneself. Absorption affirms, first of all then, a kind of self-determination, a determination that 'I can make decisions for myself'. Readers familiar with Bazin will know that the capacity to make decisions for oneself is one of the hallmarks of the realist cinema. In the films of William Wyler, for example, a filmmaker who can be usefully contrasted with Sirk here, Bazin claims that

'The frequency of depth-of-focus shots and the perfect sharpness of the backgrounds contribute enormously to reassuring the viewer and to giving him the opportunity to observe and to make a selection, and the length of the shots even allows him time to form an opinion' (Bazin 1997e: 9). That is one of the key aspects of realist cinema for Bazin: it allows spectators the freedom to judge and decide for themselves the meaning and significance of a scene.

Readers will possibly sense that this contrast between Sirk and Wyler does not really match up. Pippin invokes Sirk in order to make a point about the attitude of irony that exists in some modern and postmodern conceptions of the social world: the ironic attitude is a form of critique that emphasizes the false and phoney nature of social conventions in order that they be recognized as false and phoney. Bazin's comments on Wyler, on the other hand, make a different point which suggests how certain aesthetic techniques (depth of field, the long take) can allow spectators to make decisions about what they are viewing rather than having their viewing decisions determined *a priori* by 'manipulative' techniques (such as analytical editing). However, what I want to suggest throughout the remainder of this chapter is that the contrast between these two positions does match up and it is the question of their matching up that is crucial for understanding Bazin's conception of realism. My point is this: filmmaking techniques for Bazin are not simply a matter of an aesthetics that decides some forms of filmmaking are better than others because they allow spectators a 'freedom to decide'. Rather, what is also at stake for Bazin is a conception of the social world implied by such techniques. As we have seen a number of times already, 'The cinematic esthetic will be social', for Bazin, 'or cinema will have to do without an esthetic' (Bazin 1981: 37). The kind of world affirmed by the 'filmic reality' upon which Bazin insists is one in which people treat each other and their world in ways that are *authentic* and not in ways that are false or artificial. Such a conception is a long way away from merely trying to determine whether a film's aesthetic choices correspond with perceptual reality. It further implies that the way spectators watch and understand films can be considered a matter of authenticity too; Bazin wants a trip to the movies to be one where aspects of authenticity are at stake, not one conceived in terms of an escape into a world that is false and fake.

In what ways, therefore, might Sirk's films invoke 'filmic reality' and authenticity in the ways I am tentatively here ascribing to Bazin? I have argued in another context that Sirk's films – especially

Imitation of Life – are rigorously organized around distinction between actions that are authentic and those that are inauthentic (see Rushton 2007). Quite straightforwardly, in *Imitation of Life*, the actions of Lora Meredith (Lana Turner) and Sarah Jane (Susan Kohner) are designated inauthentic: they are 'imitations' of life, so many ways of turning away from life. Lora achieves this by a series of escapes into theatrical stardom, for her roles there ensure her that she can flee from her real life and commitments (in a manner directly contrary to the character of Camilla (Anna Magnani) in *The Golden Coach*, discussed above in the Introduction). Likewise, Sarah Jane's repeated repudiations of her mother, Annie (Juanita Moore), her attempts to pass as white and her eventual escape into a world of burlesque theatre, are inauthentic escapes from what Sirk explicitly regards as a 'real' life. Sirk's films are quite simply critiques of inauthenticity, critiques of the difficulty of living an authentic life in the contemporary world (that is, the world of the 1950s), but they nevertheless pose the possibility of living an authentic life, a life which would be 'true to life', as it were. He is critical of the anomie, despondency and despair of living a fake life, a life in which meaning is only ever determined by others, by forces external to the self (by those, in the case of Sarah Jane, who decide that humans with black skin are inferior to those with white complexions, for example). Far from being celebrations of artifice or of a universal inauthenticity – a universal illusionism – Sirk's films are a heartfelt defence of living an authentic life, of ways of discovering how to be true to oneself. Such a defence is one, I am trying to imply, of which Bazin would surely have approved.

From such a perspective, we might be able to see Bazin's approach to realism in the cinema as similar to Diderot's approach to the art of his day (the mid- to late eighteenth century). What Diderot criticized in art was the very same as what he criticized in the world at large. He thought it abysmal that people adopted airs and graces, that they acted only in ways designed to impress others and that they thus acted in ways that were not dictated by themselves, but which were dictated by the norms and attitudes of others. He referred to such people as 'theatrical' because their lives were lived in such a way that they were actors or performers, faking their lives to the best of their abilities in order to impress a social audience. It is precisely this attitude Diderot deplored in paintings as well. Works of art that were obviously trying to attract the attention of a viewer and that were going out of their way to ensure that they would conform to a viewer's expectations were, for Diderot, 'faking it',

falsifying themselves in order to impress an audience. Such paintings were thus theatrical in the very same way that people could be theatrical.

Against theatricality, Diderot posited absorption as the mode in which a person or a painting was not faking it. ('Absorption' is a term that, strictly speaking, Diderot did not use very often. Michael Fried has, however, argued very persuasively for its pertinence to Diderot's art criticism; see Fried 1980). The main criterion for absorption was that one should act without the need for an audience, act in such a way that one's actions did not need to be affirmed by others and thus did not have to pander to the tastes and expectations of others. Such a criterion was central for absorptive works of art too: a work of art should not in any way suggest that it is to be seen by an audience and should not artificially try to attract the eye of the spectator in such a way as to cower for that spectator's approval. This antitheatricality was, in fact, probably most pertinent for the theatre: to ensure an absorptive mode of presentation, an actor in the theatre should not in any way hint that he or she is performing for an audience, and he or she should most certainly never look at or speak directly to the audience. By the same token, in a painting the figures should never be painted in such a way as to be looking out towards or gesturing towards the viewer. Rather, they should be painted in such a way as to ignore the fact that they are going to be looked at. The reason figures in a painting should never do this is that, if they do, they will be seeking the approval of the onlooker, pleading that their actions be affirmed by the onlooker, rather than seeking that approval from within themselves. And that is what artworks should do: they should seek their own confidence from within themselves, not succumb to the codes or trends of the moment that could only provisionally and temporarily ensure their success.[23]

Does a similar distinction between absorption and theatricality hold for Bazin? I think it is fair to say that, by the end of the 1930s, according to the argument of one of Bazin's most influential articles, 'The evolution of the language of cinema', the cinema had fallen into a mode of production that was based on thoroughly conventional norms (Bazin 1967b). Following the demise of the avant-garde experiments of the 1920s and the end of the silent era, the sound film had found something like its median form.[24] Classical editing, according to this median form, was a matter of breaking the world up into usable 'bits', then putting these bits back together according to an analytical or dramatic definition of reality. (Bazin

gives a hypothetical example of a dinner scene made up of a series of 'bits'; 1967b: 31–2.) These techniques of classical editing served only to degrade the reality of films, for Bazin, and amounted to asserting the primacy of images over the sanctity of reality. It is this famous division between the kinds of directors or films who put their faith in images and those who put their faith in reality that can be compared with Diderot's distinction between theatricality and absorption: those who put their faith in images are making films that are theatrical, while those who put their faith in reality are following a mode of absorption (see Bazin 1967b: 24). Films that merely follow the codes and conventions of accepted filmmaking in order to pander to an audience, films that are made 'according to the rules', according to practices governed purely by 'external authorities'; such films will be delivering 'theatrical' images. Those other films and filmmakers, on the contrary, whose quest is to define an aesthetic on its own terms – a 'self-determined' aesthetic (and into such a category, for Bazin, we can place films made by Welles, Wyler, Renoir, the neorealists and others) – will be satisfying a quest for absorption.

A pivotal piece of criticism (Bazin 1971b), which focuses on two scenes from De Sica's *Umberto D* (1952), is, I think, of utmost importance for understanding the link between Bazin's realism and the notion of absorption. Bazin emphasizes two particular scenes from the film, the scene where Umberto goes to bed one night, and a second scene in which the young maid, Maria, awakens the following morning. Bazin praises the scenes for their lack of overt excitement. Rather than 'cutting to the chase', as a classical film would do, these two scenes linger on the minutiae of everyday life, the minor digressions, inconveniences, misfortunes and pleasures of human existence.

The two scenes are certainly undramatic. Indeed, Bazin praises the entire film as one that is free from the 'exaggerations of drama' (Bazin 1967d: 80). With this claim, Bazin immediately hints at the film's antitheatricality (and hence its quest for absorption), in so far as anything that is exaggerated would be seen as theatrical. But more explicitly, Bazin singles out the two scenes described above for particular attention. He writes that 'These two sequences undoubt-edly constitute the ultimate in "performance" of a certain kind of cinema, at the level of what one would call "the invisible subject", by which I mean the subject entirely dissolved in the fact to which it has given rise' (1971b: 77).[25] This concise sentence requires considerable unpacking.

Bazin's use of the word subject (*sujet*) here may be deliberately ambiguous and comes amid a quite extraordinary page or two of film criticism. Inasmuch as he equates the 'invisible subject' with a 'performance', Bazin would seem to be emphasizing something about the status of the human subject in these scenes. In these scenes, the human subject – Umberto, Maria – is 'entirely dissolved' in the facts of which it is part. The actions of the performers in these scenes would thus epitomize absorption: these characters are so absorbed in their own environments that there is absolutely no hint of theatricality – of an overt appeal to the spectator – in their actions. Rather, their actions are entirely part and parcel of their world, a world in which they are wholly absorbed (or 'dissolved', as Bazin claims).

But in using the term *sujet*, Bazin also seems to be referring to the notion of the film's content or story, as in when one asks 'what is the subject of the film?' And that is also Bazin's point: *Umberto D*, as exemplified by these two scenes, is *a film without a subject*, or, rather, a film whose subject (story) is invisible. What is important about *Umberto D* is not *what it is about*, not its story or subject, but something else. As Bazin argues,

> If I try to recount the film to someone who has not seen it – for example, what Umberto does in his room or the little servant Maria in the kitchen, what is there left for me to describe? An impalpable show of gestures without meaning, from which the person I am talking to cannot derive the slightest idea of the emotion that has gripped the viewer. (Bazin 1971b: 77)

The story or subject of the film is thus only important in so far as this subject virtually disappears and becomes synonymous with the scene, where all sense of a fabricated story fades away.

Such a position is, of course, both one of the cornerstones of neorealist theorizing (suffice it to recall the aim of Cesare Zavattani, scriptwriter of *Umberto D*, to make a film consisting of eighty minutes of a man's life without a cut; see Bazin 1971b: 67) and of Bazin's film criticism (especially with regard to neorealism; see Bazin 1971e, 1971f). In focusing most especially on the scene of Maria in the kitchen from *Umberto D*, Bazin emphasizes the lack of 'story' that underpins his notion of realism. Realism, for him, relies not on a form of story that is based on causal relations but on one which is episodic, and which thus gives rise to a different kind of meaning. Bazin describes the contrast between the way a classical film would depict Maria in the kitchen and the way that De Sica portrays it:

[T]he unit event in a classical film would be 'the maid's getting out of bed'; two or three brief shots would suffice to show this. De Sica [on the contrary] replaces this narrative unit with a series of 'smaller' events: she wakes up; she crosses the hall; she drowns the ants; and so on. We see how the grinding of the coffee is divided in turn into a series of independent moments; for example, when she shuts the door with the tip of her outstretched foot. As it goes in on her the camera follows the movement of her leg so that the image finally concentrates on her toes feeling the surface of the door. (Bazin 1971b: 76)

It is very easy to see in this method of portrayal what subsequently became known as the 'reality effect', an emphasis, derived from nineteenth-century literature, on small, seemingly insignificant details which grant veracity to the fictional environs of the real. For Bazin, however, it was not enough merely to gesture towards a 'reality effect'. Yes, part of the realism of films relies on their picking up the details of a 'life time' (Bazin 1971b: 76) that other kinds of films may pass over (see also Bazin 1971d: 81–2). But if that is all realism consists of, then Bazin's theory of realism would find itself restricted once again to a correspondence theory, a theory in which the realism of cinema was defined by its ability to capture and reproduce as accurately as possible the fabric of the reality placed in front of it. This is clearly, however, not entirely what Bazin wants to argue. What is perhaps so crucial about the scenes he highlights from *Umberto D* is that they do not actually fit with the usual conception of Bazinian realism: there is little here that can be categorized in terms of *profondeur de champ*, and the scenes, even if they do linger on banal scenes of everyday life, are composed for the most part by editing patterns that are not too dissimilar from those of classical editing. And nor is there very much of the necessary ambiguity of reality that Bazin praises in depth of field and the long take; these scenes could easily be interpreted as being quite manipulative in so far as they persuade viewers to feel pity for Umberto and Maria (Umberto is suffering from angina; Maria has become pregnant out of wedlock). Particularly noteworthy is the clear editing 'trick' of Maria's tears (one moment she is not crying, then immediately following a cut her cheeks are suddenly wet with tears) and the editing in which she uses her foot to close the kitchen door is straightforwardly classical. None of this seems to be at all consistent with the notion of realism typically ascribed to Bazin.

How can sense be made of this potential anomaly in Bazin's criticism? I think it is at least reasonable to suggest that the realism of the traditional Bazin – that which posits a correspondence

between films and perceptual reality – cannot define what is most important about Bazin's theorization of realism. In order to determine just what he is getting at, it is worth examining his further comments on the maid's scene in *Umberto D*, for it is here that Bazin eventually comes full circle on the notion of the *subject*:

> At the scenario level, this kind of behaviour corresponds, reciprocally, to the scenario based entirely on the behaviour of the actor. Since the real time of the narrative is not that of the drama but the concrete duration of the character, this objectiveness can only be transformed into a *mise en scène* (scenario and action) in terms of something totally subjective. I mean by this that the film is identical with what the actor is doing and with this alone. (Bazin 1971b: 77)

The story or subject of the film – what the film is about – thus becomes 'something totally subjective', something bound up with the life of a human subject. And this human subject is engaging with the world in a mode of absorption. This subject is not adopting airs and graces, she is not exaggerating her plight in the hope of obtaining a surplus of sympathy from a crowd of beholders. She is not even 'acting', for her actions are ones that flow directly from a 'life'; the 'complete replica of a life', as Bazin states (Bazin 1971b: 77). This 'complete replica of a life', the 'life time' of a human subject, stands diametrically opposed to the fabrications of a theatrical performance, the kind of actor's performance which, in Bazin's words, relies 'on a system of generally accepted dramatic conventions which are learned in conservatories' (ibid.). Any such reliance on dramatic conventions would be a concession to theatricality, the adoption of accepted modes of 'acting' designed to impress audiences. Bazin, for his part, wants none of this; for his realism, the performance of the actor is one in which 'the subject [is] entirely dissolved in the fact to which it has given rise' (ibid.).

The presentation of the character of Maria in *Umberto D* is in fact strikingly similar to the way in which certain subjects were presented in paintings by Jean Baptiste Greuze (1725–1805), one of the key figures in the genesis of the antitheatrical tradition for Diderot and Fried. Some of the key paintings might be *A Young Girl Weeping for Her Dead Bird* (1765), *The Broken Mirror* (1763) and *The Broken Jug* (1785). (I am certainly not suggesting that De Sica was in some way influenced by Greuze's paintings, merely that there is a correlation between the subject matter and mode of absorption in Greuze's paintings and the maid's scene from *Umberto D*.) Fried describes these paintings by Greuze as ones that 'represent female figures

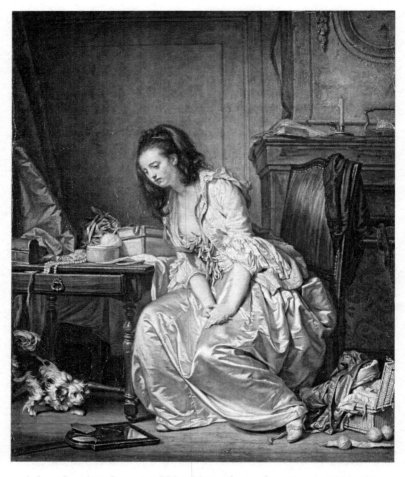

4 Jean-Baptiste Greuze (1725–1805), *The Broken Mirror* (1762–63).
Oil on canvas, 56 × 45.6 cm.

wholly absorbed in extreme states and oblivious to all else' (Fried 1980: 57). As such, they fulfil the prerequisites of absorptive art; they offer the 'persuasive representation of a particular state or condition, which each figure in the painting appeared to exemplify in his or her own way, i.e., the state or condition of rapt attention, of being completely occupied or engrossed or (as I prefer to say) absorbed in what he or she is doing, hearing, thinking, feeling' (ibid.: 10; Fried's comments here refer to another of Greuze's paintings, *The Village*

Betrothal (1761)). These same qualities are present while Maria is engaged in her chores in the kitchen, though she is less absorbed in her chores than she is absorbed in her own thoughts, her concern for her plight as a potentially unmarried mother, and thus her concern for her existence as such.[26]

If one agrees that what is stake in the filmic reality I am invoking for Bazin, and that this reality is closely tied to the artistic tradition of absorption, then in what ways might this absorption be said to be equivalent in some way to a notion of authenticity? As I indicated near the beginning of this chapter, the notion of realism as authenticity that I am trying to tease out of Bazin's writings is one in which realism is not a matter of being true to perceptual reality and therefore not a theory of realism's correspondence with reality, but one in which realism is a matter of being true to life. I realize that these are grossly inadequate words, for what on earth can it mean to be 'true to life'? Because it is to Robert Pippin's understanding of authenticity that I am referring, it is perhaps best if he is given the opportunity to define this concept.

Pippin considers that his understanding of authenticity can be hinted at by a number of terms: to be authentic means to be genuine, honest or true. But for Pippin this is not a matter of scientific veracity; for example, I imagine, if he were examining the maid's scene from *Umberto D*, then the genuineness or truth of the scene could in no way be determined by counting the number of shots in the scene and deciding whether such shots 'genuinely' qualify as ones that utilize depth of field and the long take.[27] This is not the kind of authenticity which interests Pippin, and it is likewise not the kind of authenticity which I am attributing to Bazin. As Pippin argues, 'I am interested in another kind of genuineness and fraudulence, the kind at issue when we say of a person that he or she is false, not genuine, inauthentic, lacks integrity, and, especially when we say he or she is playing to the crowd, playing for effect, or is a poseur' (Pippin 2005: 575).

It should be immediately clear that what Pippin means by authenticity is something very closely related to the antitheatrical tradition associated with Diderot. An authentic life is one that is predicated on modes of absorption, while an inauthentic or false life is a theatrical one, a life whose mode of being is determined by external authorities, by appeals and subordinations to the standards and dictates of others. Pippin thus offers an excellent description of the distinction between absorption and theatricality:

The former might be called (or at least I want to stress this dimension here) a complete identification of a subject with the role or activity undertaken, so much so that the subject can seem completely absorbed in the activity, self-forgetful, lost in reverie, and so on; the latter is what it would be to act without such identification, to perform an activity controlled and directed by an anticipation of what others expect to occur, as when subjects are posed in a painting in classic poses assumed to connote heroism or fidelity. (Pippin 2005: 578)

Absorption as 'a complete identification of a subject with the role or activity undertaken' resonates strongly with Bazin's notion of an 'invisible subject', an actor's complete identification with his or her performance such that it transcends the very notion of performance, and of a film that is identical with what an actor is doing. For Bazin, I would suggest, as for Pippin, an authentic life or work of art is one that is absorbed. Essential to Pippin's argument, then, is that the notion of an 'authentic life' is one that is related to the kinds of absorption Fried identifies in works of art by way of Diderot.

I would hope that a sense of how a painting or a film can be authentic or 'true to life' in this way is beginning to become apparent. This sense of an artwork's being 'true to life' has little to do with copying reality exactly, that is, it has little to do with notions of verisimilitude or of an artwork's realistic correspondence with perceptual reality. Rather, this notion of being 'true to life' is one that stresses a commitment to a certain mode of being or a certain way of life, a condition that amounts to something like, as Pippin argues, 'the realization of a condition necessary for any life to have *any* value for me – that it be *my* life' (Pippin 2005: 591). If such standards are extended to works of art, then one condition of an artwork's value is that it be *self-defining* (ibid.). Only on the basis that its mode of being is self-determined can an artwork be called authentic. Such a notion of authenticity is a long way away from notions of verisimilitude, a point Pippin emphasizes: 'It might seem odd', he claims, 'to say that paintings can be *true to life* in ways quite different from simple verisimilitude and so can be *false* in a way similar to the ways in which a person can be false' (Pippin 2005: 576). But even though it might seem odd, this is indeed what Pippin is arguing: true to life does not need to mean that something looks true, but instead can mean something which acts in a way that can be said to be true, genuine or honest.

Some of Pippin's statements need qualification. The notion that a life or an artwork can be entirely self-defining or self-determined is somewhat misleading. A life as much as a painting or a film requires

some degree of external verification and thus no life or artwork could ever be fully self-determining. An artwork, after all, is made to be beheld by someone or something external to it, and films are no exception. To say as much, however, is to say that issues like authenticity and absorption are not at all straightforward – as the writings of Fried make clear, the history of absorption in painting from the eighteenth to the twentieth centuries is one of absorption's increasing difficulty, if not impossibility.[28] Absorption, even if it is a mode where an attempt is made to ignore the presence of a beholder, is also, at one and the same time, a way of addressing the beholder (ignoring the beholder *is* absorption's way of addressing and eliciting a response from the beholder).[29] As an antitheatrical way of addressing the beholder, it is thus not a way of addressing the beholder that demands or aspires to the beholder's complicity. Rather, absorption's mode of address is one that treats the beholder as an equal, which asks nothing of the beholder except that she or he give her/himself to the work. Such too is the mode of an authentic life, a life of 'mutually affirming free subjectivity'.[30]

Pippin (following Fried) advocates modes of absorption that are a 'way of life' (or '*mode of life*'; see Pippin 2005: 592). This position is one that is, I think, very close to Bazin's, in so far as Bazin advocates a cinema of the 'life time', a cinema of 'the succession of concrete instances of life' (Bazin 1971d: 81). The cinematic experience, for Bazin, is not one that requires a split, doubled or reflexive consciousness that is then capable of turning back on itself. Rather, the cinema requires a consciousness that is at one with the world. This notion of being at one with the world goes to the heart of Bazin's realism.

It is likewise the status of 'worldliness' that is at stake for Fried's realism. As Pippin argues,

> The underlying philosophical problem is the problem of Fried's *realism* ... As we have been noting, no one should be misled by the 'supreme fiction' of absent beholders to think that realism amounts to the fulfilment of the fantasy of the world viewed as it would be without a viewer. The deep, even corporeal inseparability of beholder and world is quite a different sort of realism, one wherein the intelligible world is not built up or constructed out of impressions or any succession of momentary mental states, nor just there as an object-to-be-viewed. What is real is this corporeally inseparable original whole of bodies at work in space and moving in time in a shared natural and cultural world, the intelligibility of which is illuminated in terms of these practices, corporeal positions, empathic projections, and

practical motion. Absent any of the latter, *there is no world*, not some putatively truly real world. (Pippin 2005: 589–90)

For Pippin as much as for Fried and, I would suggest, for Bazin as well, the problem of realism is thus less one of representing the world than of being-in-the-world.[31] The inspired passage above focuses on the distinction between a realism of verisimilitude and one that is based on a 'shared world'. The realism of Fried – and of Bazin – is not one that fosters an illusion of reality or of a represented world that looks like reality (along the lines of Alberti – as Pippin writes, of 'the world viewed without a viewer'). This realism is, then, not one of verisimilitude. If this reality is not a matter of looking like reality, then perhaps it is a matter of feeling like reality. What Fried's (and Bazin's) notion of realism delivers is a corporeal reality that is spatially and temporally involving, one that engages a beholder as part of his or her shared world. I think this is without question what Bazin affirms: a cinematic universe where the integrity of space and duration are maintained, not chopped up and reassembled. Such conceptions lead to straightforwardly profound statements from Bazin: 'For a time, a film is the Universe, the world, or if you like, Nature' (Bazin 1967e: 109).

Another way of approaching this point (the primacy of being-in-the-world) is by way of Bazin's comments on theatre and cinema. Indeed, by focusing on these comments, a greater understanding of the relation between theatre and theatricality becomes available. Bazin is in no way opposed to 'filmed theatre', but there are differences between the two artforms that need to be identified. He makes a fundamental distinction between theatre and cinema in the following way: 'Let's just say that the word in the theatre is abstract, that, like all of theatre, is itself a convention: in this case, of converting action into words. By contrast, the word in film is a concrete reality: at the least, if not at most, it exists by and for itself' (Bazin 1997b: 54). In the theatre, therefore, an actor is merely reproducing words whose real (or ideal) existence is elsewhere: on the dramatist's page. Othello or Nora – as Panofsky pointed out in a similar argument, in ways also taken up by Stanley Cavell (Panofsky 1995; Cavell 1979: 27) – are essentially figures on a page, whereas Rhett Butler's exclamation that 'Frankly, my dear, I don't give a damn', can be said only once, and then only by Clark Gable. To a certain degree, this state of affairs consigns theatre to a perpetual theatricality (as in Diderot's *Paradox of the Actor*; Diderot 1994: 98–158): the successful actor on the stage is the one

who most effectively transforms her/himself into someone else and who by necessity must act according to the dictates of an external authority (the script). In the cinema, on the contrary, the quest is for actor and role to become indistinguishable, to the extent that Rhett Butler is, and always will be, Clark Gable. With such views, it is little wonder Bazin favoured non-actors and, one might say, non-acting as well: the actor whose role was that of 'a life', and whose subjectivity was 'entirely dissolved in the fact to which it had given rise' (Bazin 1971b: 77). One of the ways that theatre is very different from cinema, for Bazin, is that in the cinema it is possible to believe that an actor is not acting; a spectator can imagine such actors as persons rather than actors, and furthermore, in the cinema, it is as persons that they matter, not as actors but as human beings.

Bazin bolsters this same argument elsewhere. Against the claim that in the theatre the audience is in the presence of the actor while at the cinema the actor is absent,[32] he responds with the claim that the audience *is* in the presence of the actor in the cinema. Bazin argues thus: '"To be in the presence of someone" is to recognize him as existing contemporaneously with us and to note that he comes within the actual range of our senses' (Bazin 1967d: 91). And is this not, Bazin implies, precisely what happens in the cinema? For in the cinema, he states, 'Everything takes place as if in the time-space perimeter which is the definition of presence' (Bazin 1967e: 98). While watching a film one is in the presence of corporeal bodies in space and time, bodies that give rise to all the indicators of a shared world. Bazin's perspective is thus echoed by Pippin's claim that realism in Fried's writings is one that involves a 'corporeally insepa-rable original whole of bodies at work in space and moving in time in a shared natural and cultural world'.[33] This kind of realism is a matter of authenticity, for Pippin as much as Fried and as much as for Bazin, I would argue; a matter of being in the presence of the authentic actions of persons absorbed in the world. It is not a matter of being 'duped' into believing in another world ('the fantasy of a world without a viewer'), but is matter of having faith in the authentic reality of *this* world. In Bazin's words: 'Alone, hidden in a dark room, we watch through half-open blinds a spectacle that is unaware of our existence and which is part of the universe. There is nothing to prevent us from identifying ourselves in imagination with the moving world before us, which becomes *the* world' (Bazin 1967e: 102).

The cinema, while I am there, and in ways that precipitate them-selves into my life afterwards, becomes the world. That, for Bazin

is the reality of film: a shared space and time, a space and time I share with others, and a space and time I share with the film I watch. That sharing is the space and time of a reality that can be called filmic and constitutes the co-ordinates of Bazin's approach to 'filmic reality'. Perhaps there is a reason Bazin titles one of his most famous essays 'an aesthetic of reality' rather than 'an aesthetic of realism'.

The importance of cinema for Bazin lies in its ability to produce worlds or visions of the world which we – as audiences – might be able to 'take' for reality. Not a perceptual or psychological reality but a shared, social reality dependent upon providing views of what we might be able to accept as being real. This is not perceptual or psychological, but deeply social and historical. It is one way of considering the reality of film. I hope I have indicated the potential for a new appreciation of Bazin, one for whom the realism of cinema is a matter of absorption and the authenticity of a way of life, not a realism of verisimilitude. This is a Bazin who claimed 'All that matters is that the spectator can say at one and the same time that the basic material of the film is authentic while the film is also truly cinema' (Bazin 1967f: 48). Perhaps the key point to be derived from Bazin's comments on the scene of Maria in the kitchen from *Umberto D* is that, as I put it earlier, 'all sense of a fabricated story fades away'. What this means from Bazin's perspective is not a belief in a perfect replica of reality, but rather a belief in the depiction of a way of life that matters. As I have tried to argue, a way of life that matters (for Bazin) is one that is absorptive and authentic. Such authenticity can pertain to fantasy films, such as *E.T.: The Extra-Terrestrial* as much as they can pertain to traditionally realist fare, such as *Umberto D*. Just because 'it is only a film' does not mean the only relationship we can have with a film is to dismiss it as an artifice or a construction, as DiIorio and Prince do. For Bazin, on the contrary, a film is something we can imbue with reality, accept as part of reality, as something which, for a time, becomes the world. For Bazin, that is the reality of film.

3 The imaginary as filmic reality

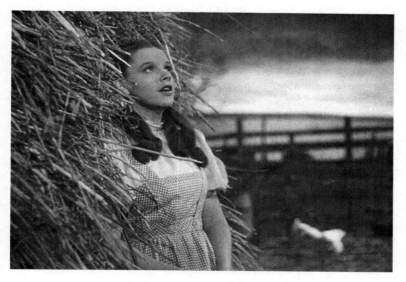

5 Over the rainbow: the imaginary of *The Wizard of Oz*
(Victor Fleming, 1939)

If 'filmic reality' for Bazin was a matter of authenticity and the establishment of 'social' forms of reality, as I argued in the preceding chapter, in what ways might Christian Metz provide a theory of 'filmic reality'? At first sight, 'reality' would appear to be a concept quite alien to Metz's conception of cinema. Certainly, he did once write an essay on the 'impression of reality' in the cinema (Metz 1974b), but *impressions* are precisely what separate themselves from reality: they are impressions of reality because they are not reality itself. Subsequently, Metz became a master at discerning cinematic codes, his *Grande Syntagmatique* being exemplary (see Metz 1974a). In doing so, surely again Metz clearly signalled the distance between cinema and reality, for the cinema was and continues to be symbolic, conventional, fabricated, obviously produced and false in ways that anything worthy of the

name 'reality' could never be. For isn't 'reality' – and I'm beginning to sense we might have heard this argument before – truly out there, untainted, pure, preserved, and devoid of codes, symbols, conventions and culture? As I have begun to outline already in this book, such arguments simply do not stand up to logical scrutiny, even if they have been defining arguments for film studies for many years. We can begin therefore to outline Metz's project: his project was not one which tries to place a pure and untainted reality in opposition to the symbolic, conventional illusions of cinema. Instead, his aim was to clarify what kinds of reality the cinema and films are capable of producing. Hence Metz's predilection for an overwhelming number of semiotic designations, categories and distinctions: he did not go to such lengths merely in order to affirm the illusionistic, conventional artifice of cinema. Rather, he was trying to define and explain what cinema's reality is (what cinema was, is or can be). We might take him to be asking: In what ways and by what means does cinema become a reality for us?

Metz, if I am right, must be one of the most misrepresented writers of recent times in any field. What one comes up again and again in commentaries on Metz is that word, *illusion*, as though the driving force of Metz's research was to expose, time and time again, the illusionistic workings of the cinema. What puzzles me so greatly is that I rarely manage to find such thoughts or views actually expressed in Metz's writings. In his most controversial and problematic essay – needless to say that it is this essay which I find to be the most rewarding – what emerges is a category of the imaginary. That essay is, of course, 'The imaginary signifier' (Metz 1982). But what is imaginary there, in Metz's essay, is not necessarily an *illusion*. Rather, one way of drawing the contours of the reality we call cinema, he seems to be saying, is by way of the imaginary: 'imagining' what the world is like by way of our cinematic experiences is part and parcel of working out and experiencing that world and its reality. We have already met with this notion once or twice in this book, mostly by way of Cornelius Castoriadis and his claim that what defines the human is imagination (Castoriadis 1997b: 159). And, as we shall see in what follows, what is imaginary is not necessarily Lacanian either, though most commentators seem to presume that Metz is Lacanian – or, at the very least they accuse him of deviating from the truth of Lacan's teaching (or that he is 'not Lacanian enough'; see McGowan 2004; Silverman 1996: 124). Against such misrepresentations, I argue in this chapter that the imaginary is, for Metz, the category which most accurately defines

cinema's reality. For Metz, 'filmic reality' is defined as imaginary. Furthermore, defining the reality of film as imaginary is not to damn the cinema to illusion or pretension. Rather, the imaginary reality of film is, for Metz, its most precious and rewarding attribute.

The imaginary and illusion

Discerning just what Metz is up to in 'The imaginary signifier' will take some unpacking. A good place to start is with one of the most astute refutations of the Metzian approach, as expressed by Richard Allen's notion of 'projective illusion' (Allen 1995). Allen designates a number of different approaches we can take to representational artworks, the chief of these being *reproductive illusion* – artworks in which we are aware that an object has been reproduced – and *projective illusion*, this latter being a state in which we entertain the notion of representational transparency; that is, that the artwork – or photograph or film or play – we see before us *is* indeed the real thing. At the same time, however, we are never in any doubt that such representations – whether they be reproductive or projective – are none the less *illusions*. Indeed, such is the delight of artworks: they tantalize us with their trickery; their illusions of reality are what make them so compelling and engaging.

With respect to painting and photography, Allen describes the process of 'projective illusion' in the following way:

> [W]hen we look at a representational painting ... [o]ur awareness of the painting as a painting may be eclipsed entirely, and we may imagine or visualize that the object of the painting is before us, unmediated by representation. When we entertain the painting in this fashion we do not think that the represented object is actually before us in the space of the real world, yet we visualize that the object in the painting is fully realized before us. We imagine that we inhabit the world of the painting in the manner of an internal observer. Likewise, a photograph can be experienced as a projective illusion: Instead of looking through a photo at the object depicted within it, we may perceive the object as one that is fully realized before us and be unaware of the fact that what we perceive is a photograph of something. (Allen 1995: 88)

And so it goes also and especially for films: we can believe we are more or less 'in' the space and time of the film without necessarily believing what we are 'in' is real in the same way that the 'real world' we perceive and feel is real. And yet, once again we bump up against the difficulty of this word: real. For Allen, projective illusion is just that: illusion. And there is a good reason why he thinks this,

for he thinks that there is a major factor which shall for ever sever paintings, photographs, films and theatrical plays from reality – they are representations. Such is his claim: 'The minimum condition for a picture or drama to be experienced as a projective illusion is simply that the form be representational, that is, it must contain pictorial elements that a spectator can recognize as standing for individuals or types of things' (Allen 1995: 88). Allen's approach is thereby unequivocally representational; plays, paintings and other pictures are representations, while, on the contrary, reality is not represented, it is.

Once again, therefore, as we were in the chapters of this book which have preceded this one, we are back putting cinema – and other representational forms – in second place: true things, those things which exist in a primary way (those things characterized by 'being'), are the things by which all else is judged. On this score, cinema can only ever re-present those primary things, it can offer only illusions, never 'things themselves'. Needless to say that the point of this book is to go beyond that logic. Allen's problem is here: that reality is something that can be seen or perceived, pointed to and designated, and furthermore, there are scientific – measurable, precise – ways of discerning what is really real over and above the subjective misapprehensions views of any one human being. In other words, for Allen, reality is out there, and the cinema is not a part of that reality. For Allen, what is characteristic of the cinema is not its reality but its illusions.

As we saw in Chapter 1, making the kinds of hard and fast distinctions between illusion and reality on the basis of the notion of 'representation' is something like a moral judgement between the right kinds of representations and the wrong kinds. (These points are made very keenly by Anne Kibbey's *Theory of the Image* (2005).) And it is indeed upon the terrain of moral judgement that Richard Allen's approach to 'projective illusion' falters, and by charting his account of fetishism and disavowal, an account which he explicitly places in opposition to Metz's account, we can begin to see some of the advantages of Metz's approach.

Some clarifications of fetishism and the cinema

Metz tackles the issue of psychoanalysis and cinema from a number of angles, but one of the more controversial avenues down which he goes is that of fetishism. He follows Freud in arguing that the existence of a fetish requires the simultaneous existence of contrary

beliefs. The starting point for this doubled belief concerns the child's belief in the mother's penis. For Freud, the male child has an innate ('primitive', 'mythical') understanding that all human beings have penises, so that, when the child actually sees that the mother does not have a penis, he is somewhat concerned and confused (I stress the 'he' here, for Freud's approach focuses on the experiences of the male child) (Freud 1977). One way of dealing with this concern is by inventing or imagining a substitute object – say a shoe or exotic furs. Such objects are fetish objects, and it is by means of such objects that the child's concern over the mother's lack of a penis can be alleviated. Such fetishes can continue throughout life as ways of coping or amending perceptual reality with the result that they make that reality existentially more palatable. Of course, such fetishes might become more of a hindrance than a help if they overtake the psyche to the extent that social functioning is severely compromised.

Of course, readers should not be mistaken here to believe that any of these fetishistic actions are in any way conscious.[34] Rather, Freud's theory of psychoanalysis is predicated on unconscious processes, so that the child's – or the adult's – belief in fetishes is an unconscious one. Or, more accurately, in so far as it impossible for the unconscious to 'believe', the fetish is stimulated or provoked by unconscious processes which allow the fetishist to be convinced of the effectiveness of the fetish object. The male fetishist will not consciously believe in the fetish – he will not pick up a stilettoed shoe and gasp at how such an object relieves his consternation over his mother's lack of a penis! Rather, such consequences play themselves out beneath consciousness (for example, while glancing at the stiletto, our fetishist will be able to maintain an erection and reach orgasm, and one assumes he will not be consciously invoking his mother at such moments).

It is perhaps more difficult to see where the cinema fits in with such theories. And Metz certainly does not argue that the cinema is in some way fetishistic: one does not go to the movies in order to be unconsciously compensated for one's mother's lack of a penis. Rather, Metz tries to bring out a somewhat stretched analogy, though I, for one, admire his audacity in having done so. His argument goes something like this: the kind of belief scenario entailed in processes of fetishism is akin to the kind of belief scenario entailed by watching a film. What Freud refers to in fetishism as the simultaneous existence of contrary beliefs Metz calls, in relation to the cinema, a doubling up of belief. (I should briefly add that, by way

of this analogy, Metz might conceivably escape charges of phollo-centrism: rather than fetishism *per se*, he is speaking of a particular structure of belief for which fetishism provides a model, a model which need not be, so far as I can discern, specific to males.)

Let's try to conceive of this in terms of fantasy, for that is indeed what Richard Allen does, and fantasy is a term which will be visited a number of times throughout this book. There is no doubt that the term 'fantasy' can be used in an enormous variety of ways and, on the back of Freud's writings especially, the term has taken on a number of quite complex and specialized meanings. The question I wish to ask here, however, is a rather general one: what is involved in my attempt to fantasize or imagine something; that is, what is involved in my attempt to conjure up something to my mind which does not materially or 'actually' exist in the objective, 'real' world before me? And it is perhaps to Freud that a fruitful answer to this question can be sought, partly by way of a small essay he wrote on 'Creative writers and daydreaming' (Freud 1990). He argues there that what is most important in the activity of consciously fantasizing or daydreaming is less that one is attempting to escape from reality in order to forget one's cares or to avoid having to face up to disappointments met with in reality. Rather, what fanta-sizing achieves is a way of negotiating or 'intersecting' with reality.[35] Fantasizing, from this perspective, is a way of wishing for a change in reality, of imagining the ways in which reality might be different from what it currently is.

Of course, when we have a fantasy in such a way, we know we are having a fantasy and, thus, we know where the line between fantasy and reality lies. This might be all well and good, but it raises the question of precisely how we manage to make such distinctions between fantasy and reality and further of whether such distinc-tions can be said to hold, from the perspective of psychoanalysis, for the unconscious. That is to say, someone falling under the sway of the fetish to a pathological degree is subject to the effects of the unconscious in ways that someone consciously fantasizing is not. So where can we draw the line between fantasy and reality? Richard Allen thinks he knows where the line between fantasy and reality lies, and he argues for a carefully tuned distinction between fantasy and reality by considering the problem in terms of fetishism and disavowal.

For Allen, fetishism is a form of fantasy, for the fantasized object – shoes or stockings, and so on – are imbued with a fantasy status that seemingly overrides their status in reality. In a sense, the fetish

object is imbued with an added quality that nullifies its 'real' quali-
ties: much like Marx's fetishism of the commodity, the Freudian
fetish is an ordinary object that becomes imbued with magical quali-
ties. In order to try to test where the fetish ends and where reality
begins, for it is this precise distinction he is after, Allen concentrates
on the notion of disavowal. Disavowal is typically understood as
a negation: to disavow something is to deny or reject it. In simple
terms, therefore, the fetishist disavows the real status of the fetish
object: the magical qualities of the fetish object will completely
nullify its 'real' qualities. In extremis, the fetishist is attempting to
disavow knowledge of the mother's lack of a penis, for the mother
in reality does not have a penis, while the fetish allows the fetishist
to believe that the mother in fantasy does have a penis. So far so
good. But Allen is convinced there are degrees of disavowal – that,
in fact, there can be a *normal* process of disavowal, where the line
between fantasy and reality is maintained, and a *pathological* form
of disavowal, where that line is crossed in such a way that fantasy
comes to replace reality. From this perspective, the normal fetishist
maintains contact with reality while, on the contrary, for the patho-
logical fetishist, reality no longer exists.

The rat man's fetishes

Again, so far so good, we might think. In order to ground his argu-
ment, Allen focuses on some of the details of Freud's case history of
the 'rat man' (Freud 1955). Precisely how does Allen denote the rat
man's pathology? He argues that, in cases like the rat man's, when
disavowal functions in a pathological way, the distinction between
the fetish and reality is dissolved. The result is that 'the part of the
mind that maintains contact with reality splits itself from the part
where belief has been swallowed up by desire' (Allen 1995: 138).
The process is thus a curious one in which reality is dissolved only
because it is 'tucked away' in a part of the mind where its influ-
ence will be negated (its influence will be 'disavowed'). One part of
the mind splits from the other and maintains contact with reality
– that is, it maintains contact by way of disavowal – while the other
part of the mind, under the sway of wishes and desires, disavows
reality and indulges entirely in the fantasy-fetish (Allen refers to
Freud's paper on the 'splitting of the ego'; Freud 1984). Reality is
both maintained and disavowed at the same time, for this is the
only way to make the fetish-fantasy acceptable or bearable. In other
words, it is this double act of both maintaining a belief in reality

while at the same time completely denying reality that is central to the 'trick' fetishism manages to play. This pathological form of the fantasy-fetish is therefore one in which contradictory beliefs are held in tandem. The logic here is thus one of 'both-and', for the pathological fetishist wants both reality and the fantasy to co-exist, for that is the only way in which the fetish can acceptably replace reality. For Allen, therefore, everything which Freud refers to as the simultaneous maintenance of contrary beliefs, or what Metz will come to call a doubling up of belief, is pathological.

What, then, by contrast, might normal disavowal be? Allen argues that normal disavowal is a process in which the distinction between reality and the fantasy-fetish is maintained. We might say that the normal fantasy follows a logic of 'either-or', for the fantasist will here understand that one can have either fantasy or reality, but not both. Here, Allen writes, 'the mind can continue to indulge in the pleasures of fantasy', all the while knowing that reality is intact, for this fantasy is precisely that, a 'mere' fantasy, not to be confused with reality (Allen 1995: 138). Normal disavowal thus entails the 'entertaining' of a distinction between fantasy and reality, all along believing that reality is what is real, while fantasies are a harmless or frivolous form of illusion. By contrast, the pathological fetishist maintains reality only in so far as that reality is disavowed.

Finally, therefore, we can locate Allen's criticism: when Metz describes cinema viewing in terms of fetishism and disavowal, what he is describing is *a pathological process in which reality is denied*: a spectator's ego is split, and viewers are hooked into fantasized beliefs and dreamworlds which bear no relation to reality whatsoever. Even more emphatically, the Metz we find in Allen's commentary is one who argues that cinema's function is precisely to deny reality, to escape it, to keep all spectators cut off from it. From Allen's perspective, then, if disavowal has anything to do with cinema it does so only in so far as it is pathological. The result is this (putting all the pieces together): Metz argues that cinema offers us illusions by operating a procedure of disavowal; the specific function of cinema is to deny reality.

Allen's argument is a strong one and is convincing within the remit it draws for itself. It is, none the less fundamentally misguided and misses the genuine innovation put in place by Metz, while at the same time undermining the complexity of Freud's conceptions. I want to state concisely why I think Allen is wrong, though the detailed reasoning of why I believe him to be mistaken will only unfold in the coming paragraphs. Briefly put, however, I can

state the following: where Allen goes wrong is in his earnestness
to keep the fetish-fantasy illusion quite distinct and separate from
reality. For Allen, only when illusions – or fantasies or fetishes –
are 'entertained' are they acceptable, because they don't tread
upon the terrain of reality. If fetishes, fantasies or illusions begin to
blend with reality, then the warning lights start flashing: the integ-
rity of 'reality' is put at stake, and that very reality itself begins to
crumble, as though the problem for Allen is that spectators will no
longer be able to separate the two. It is acceptable to 'entertain' the
blending of illusion and reality, so long as one always knows where
illusion ends and reality begins. According to Allen's reading, Metz
oversteps this mark by describing a mode of cinema spectatorship
in which illusion and reality do inexorably blend and, furthermore,
they blend in ways that make it difficult to draw an indisputable
dividing line between the two. Why, however, might this be a moral
distinction? It is so because reality – what can be counted as real,
as true and as existing – must, for Allen, be in no way sullied or
degraded by fantasy or illusion. His entire analysis rests on making
judgements between what can be counted as real and what cannot.
And, for Allen, cinema cannot be counted as real, for if cinema is
real, if there is such a thing as 'filmic reality', then that reality is, for
Allen, unquestionably dangerous, for it will entirely upset his own
judgements about what can be counted as real. In other words, for
Allen, the cinema does not and cannot belong to the category of
reality; it must for ever remain distinct from it, cordoned off in a
realm he calls 'illusion'.

But how does Allen get here? The example from Freud's 'rat man'
case upon which Allen briefly concentrates is one in which the rat
man repeatedly fantasizes, during one of the states of delirium to
which he was prone, that his long dead father is still alive. While
doing this, at the same time he exposes his genitals to himself in
a mirror. And yes, I can certainly admit that this might seem like
strange behaviour. But perhaps we shouldn't be quite so quick to
judge. Surely it's not too much of a stretch for a person to wish
a deceased close relative was still alive, and as for exposing one's
genitals, an activity which, for the rat man, was a precursor to
masturbation, we are more than willing nowadays to accept
masturbation as a common and not necessarily deviant occurrence.
So should we be so quick to condemn the rat man's behaviour here?

The point Allen tries to make in relation to the rat man is that he
confuses illusion and reality. It is merely an illusion that his father is
alive and the rat man's masturbatory behaviour is a by-product of

this illusion. If the illusion of the father is stopped, then so too will the masturbation cease: the rat man will return to reality. But, as we know all too well, the rat man *does* hallucinate his father's reincarnation, with the result that Allen consigns the rat man's behaviour to the realm of the pathological: the rat man's inability to separate illusions (his belief that his father is alive; his masturbation) from reality (his father is dead; masturbation will no longer be necessary) is deemed pathological.

It is the rat man's masturbatory activities that are most problematic, for it is not too difficult to conclude that his fantasy of his father is very much hallucinatory – it is a product of the mind – in a way that his masturbation is not. He is not having an illusion of masturbation. Rather, he is masturbating in 'reality'. Allen seems to imply that the rat man masturbates only because he is in a state of pathological delirium from which all reality has been banished. In other words, Allen implies that masturbation is, for the rat man, an illusion, part of his disavowal of reality. The implication is that the rat man would cease to masturbate if he could rid himself of the spell cast by his hallucinatory illusions. Just to be entirely clear as to what I am working towards here: for Allen, reality is defined on the basis that it is clearly separated from illusion (that distinction 'founds experience itself', he writes (1995: 140)), so that here, in his comments on the rat man, the fantasy of the father and masturbation are placed fairly and squarely on the side of illusion, while an acknowledgement that the father is dead along with a renunciation of masturbation would bring the rat man back to reality. Allen's diagnosis is based on maintaining, supporting and affirming the distinction between illusion and reality.

Freud, for his part, is not so swift in judgement. He is not so certain where the division between the normal and the pathological, between reality and illusion, lies in this case. Indeed, if we concentrate on Freud's approach to the masturbation problem, he seems disinclined to perceive much of a problem there at all. He writes:

> The fact that so many people can tolerate masturbation – that is, a certain amount of it – without injury merely shows that their sexual constitution and the course of development of their sexual life have been such as to allow them to exercise the sexual function within the limits of what is culturally permissible. (Freud 1955: 203)

The 'cultural permissibility' of such activities is precisely what is at stake in Freud's account, and not, as it is with Allen, an overarching demarcation between what is normal and what pathological. Allen

merely dismisses the rat man's behaviour as obviously pathological without considering the cultural or social dynamics of the rat man's predicament. Freud, by contrast, identifies the underlying conditions of the rat man's masturbatory activities as composed of, on the one hand, 'a prohibition', and, on the other, 'the defiance of a command' (Freud 1955: 204). The transgression is based upon a symbolic command and exists as a transgression only by first having been prohibited – that is, it is only because masturbation was prohibited by his father that the rat man now transgresses the prohibition in fantasy. Without the prohibition in the first place, there would be no defiance of the command. What the fantasy therefore fulfils is the transgression of a symbolic mandate. We might imagine the rat man's triumphal fantasy as involving a repudiation of the father's command: 'See father! You always told me I shouldn't do this! And look, I *am* doing it!'

Fantasy and reality

Where, then, is fantasy and where is reality in all of this? In one sense we can see the rat man's triumph as something that occurs only in fantasy, and not in reality. His father really is dead, and the fantasy can only be played out against the background of that reality. It is also true that the rat man had apparently refrained from masturbating while his father was alive: the death of the father is in this way decisive. Perhaps this fact is also what led Freud to declare that 'Our patient's behaviour in the matter of masturbation was most remarkable' (Freud 1955: 203). The fantasy situation is thus dependent on what Freud refers to, most specifically in relation to fetishism, as the simultaneous maintenance of contrary beliefs. On the one hand, in fantasy the rat man's father must be alive in order for him to transgress the father's prohibition, while on the other hand, it is only the father's death in reality that enables the act of transgression to be possible. Transgressing the father's death (fantasizing that he is still alive) is at the same time a transgression or repudiation (negation or disavowal (*Verneinung*), for Freud) of the father's prohibition against masturbation.

But can this be called pathological? And if it is called pathological, on what grounds is it so? Is it, as Allen thinks, that the rat man is clearly placing his belief in something that is unreal and illusory (that his father is alive) when clearly this is not the case (his father is dead)? Furthermore, it would appear that, from Allen's perspective, masturbation is simply wrong and pathological – it is unreal

and illusory – so that anyone who engages in such a practice must be deprived of a certain connection with reality and normality. If we adopt such a point of view, the rat man's behaviour is pathological because the fetish-fantasy overrides his relation to reality.

But is there another way we might be able to understand this pathology? Instead of seeing it in terms of hard and fast distinctions between fantasy and reality, might there be a more fundamental pathological structure involved? Might we be able to claim that the cause of or reason for the rat man's illness has more to do with the transgression of a prohibition than a clear-cut distinction between illusion and reality? And furthermore, might we gain more insight from Freud's own conclusions? What Freud argues is that the rat man's symptoms, tics and various fantasy procedures eventually caused him harm because they led to his withdrawal from social reality: his obsessions had the effect of 'isolating him from the world' (Freud 1955: 232).

It is here, in the rat man's 'isolation from the world', that the core of his pathology lies. And all of this has to do with what is 'culturally permissible', of what is prohibited and what is transgressed, and on what kind of reality the rat man fashions for himself in relation to other people. If society dismisses or condemns his behaviour – or correlatively, if his behaviour leads to his losing contact with other people; if he withdraws into himself – then it follows the rat man will be isolated from the world and from other people. And what is at stake there is *not* the rat man's tendency towards masturbation nor even his frequent fantasies of his father's reincarnation. Rather, I think the main question concerning the rat man should be put in the following way: does the fantasy-fetish allow one to more easily gain contact with the world, or does it effectively isolate one from the world? Does the rat man pursue fantasies that allow him to forge links with the world, or do those fantasies result in his isolation from the world? Clearly for the rat man, the latter is the case. His fantasy-fetishes have led to his detachment from the world, his withdrawal from other people, and his sense of isolation. It is not a hard and fast distinction between fantasy and reality which defines what is normal and what is pathological (which is what Allen tries to argue) but rather what can be decided upon as acceptable behaviour – of what is 'culturally permissible', of what resides in the territory of the transgression of a prohibition; in short, what actions the rat man engages in which allow him to function as a social being – that is, in terms of what others accept as being 'culturally permissible'. This is a very complex set of problems, and is not reducible

to eternal dictums, as Allen wishes to believe, about what is 'real' and what is 'fantasy'. For Freud, the distinction between the normal and the pathological is one that is socially formed: that is what the Oedipus complex, for example, is all about.

One or two other factors from the rat man case can lead us towards further clarifications. First, the rat man relates how, when in his twenties, he had wanted to marry a woman he loved but of whom his father disapproved. His father had in fact wanted him to marry another woman, a woman to whom the rat man was not much attracted. This conflict – between the rat man's wishes and his father's commands and prohibitions – therefore provided the stimulus for a rekindling of the earlier prohibition against masturbation and led to an intensification of the rat man's pathologies. The cause of his symptoms is therefore the crushing nature of his father's commands; the way in which the father's prohibitions thwart the rat man's wishes and desires at every turn. In other words, it is not any inability to distinguish between reality and illusion that is at the heart of the rat man's neurosis. Rather, it is a matter of a prohibition and its transgression.

Freud goes so far as to declare that 'We may regard the repression of his infantile hatred of his father as the event which brought his whole subsequent career under the dominion of neurosis' (Freud 1955: 238). Again it is a matter of the father's prohibition, the rat man's internalization of the father's command, that is at the root of his problem, the cause of his hatred and his eventual pathology. How is one to find one's way out of such a problem? By merely accepting the father's command? Can we imagine the advice for his cure to be something along the lines of 'accept your father's commands, stop masturbating and marry a woman you do not love, and then you will be happy'? Accept reality (your father's command) and renounce fantasy (the transgression of the command) – and then you will be cured! This does not seem anything like an acceptable solution, though it also seems to be the only possible solution if we adopt Allen's perspective on these affairs. For him, fantasy must be renounced in favour of reality: his advice seems to be to accept the dictates of reality or fall prey to neurotic illusions.

Against such a solution, psychoanalysis proposes another possibility. The cure in psychoanalysis is never a matter of getting rid of fantasies or illusions and surrendering to so-called reality as prescribed by symbolic mandates or paternal decrees. Rather, and quite the contrary, any psychoanalytic cure involves the necessity of fully exploring and developing the ramifications of one's

fantasies. Going through one's fantasies (what Lacanians call 'traversing the fantasy')[36] is a way of discovering a clarified reality, of understanding reality by means of one's fantasies, rather than as something opposed to reality. To run away from one's fantasies, in fact, is the worst thing one could do – needless to say such a course of action amounts to what psychoanalysis calls 'repression'. That Allen seems to be in favour of following that course goes a long way towards explaining why his approach to fetishism in the cinema is one I tend to call 'moral'.

Another event from the rat man's case is just as illuminating. Freud describes the episode as follows: 'When he was rather less than six, his mother had a stuffed bird from a hat, which he borrowed to play with. As he was running along with it in his hands, its wings moved. He was terrified that it had come to life again, and threw it down' (Freud 1955: 309). Freud finds a number of ways to interpret this event: (1) that it suggests an association with masturbation ('running along with it in his hands, it came to life', just as rubbing his penis with his hands makes it become erect); (2) following on from the first point, that masturbating cannot be dissociated from death – from the death of his father, on the one hand, but also from the death of a sister, on the other, for Freud details the connection between the rat man's masturbation and the death of his sister as a child (see Freud 1955: 284). I mention these interpretations because it demonstrates the way in which an illusion or hallucination gives rise to something we can call reality. That the stuffed bird moved was clearly an illusion for the rat man, but declaring that the bird did not move in reality, that it was only an illusion, does not get us very far. And nor is it even a matter of the rat man's having 'entertained' the illusion of the bird's movement, for its consequences were not consciously entertaining. Instead, surely it is more fruitful to declare that the rat man's illusion provides great insight into his reality, the reality within which he dwells, that even the most minor of seemingly illusory events actually has consequences and determinants that are deep seated in the reality of the rat man's experiences (his relationship to his father; his guilt at masturbating). In short, illusions, fantasies and fetishes cannot be placed in opposition to reality. Rather, they are ways of proposing reality, describing it, of fleshing it out.

Freud's concluding remarks on the rat man divide his personality in three ways: the unconscious part of his mind in which the repressed material is very strong; a first preconscious which is very likeable and amiable; and a second preconscious which is 'comprised chiefly

of reaction-formations against his repressed wishes' (Freud 1955: 249). The rat man's problem, his neurosis, is clearly located in the relationship between the first and third parts of his psyche, between the repressed material and his reactions against that material. His pathology is located not in the repressed material but rather in the way his psyche responded to that material. In other words, it was not his repressed wishes themselves (his hatred of his father; the sexual desire related in his masturbation fantasies) but rather his reactions against those materials that were the cause of his neurosis. In the terms set up by Freud's later triad (id, ego, superego), we can say that the rat man's problem was not one of an over-enthusiastic id – his cure could not be obtained by 'taming' the desires of the id. Rather, his problem was one of the superego's guilt and punishment against the id. (To complete the triad, we might say that his ego is the likeable, tame aspect of his psyche.) Transgression *per se* was not what caused the rat man's neurosis, but the prohibitions constantly reinforced against that transgression were.

We are finally in a position to clarify the logic which structures Freud's notion of fetishism by way of what he referred to as the simultaneous maintenance of contrary beliefs. These contrary beliefs are clearly displayed in the rat man's case: on the one hand there is an aspect of his personality that is perfectly pleasant and amiable (his ego), while alongside on the other hand is a disturbed and at times embittered, delusional fragment of his psyche (his superego – or, more precisely, the superego's quarrels with the id). The former aspect tends to claim that 'the world is all right' while the second aspect sets itself up against that world: the fetish sets up a challenge against the world. From here, we might begin to suggest that it is in this challenging of the world which develops from the rat man's superego, from that aspect of his personality which disavows reality, that ways of bringing into question his father's commands – and by association the symbolic structures of the world – and a potentially radical dimension of fetishism begins to emerge. Essential to that challenge is the discovery of ways of undermining or reinventing the world as such, just as the rat man manages to do in his masturbatory fantasies, for such fantasies are explicitly directed towards undermining his father's symbolic authority. At the same time, such risks might lead to one's being isolated from the world: there are no guarantees where one's fantasies are concerned. On the contrary, the quest to remake the world might lead to complete isolation.

For Metz, such is the great advantage of having called upon fetishism in his elaboration of an understanding of cinema. One of

the great triumphs of the cinema – and a testament to the logic of fetishism which it encourages – has been, instead of providing isolation or escape from the world, to instead provide ways of conceiving new and different worlds (whether these be the magical worlds of Méliès, Fellini, Oz or myriad other possibilities). It is here, finally, that we can begin to trace the contours of Metz's 'imaginary signifier': a signifier of the imaginary which challenges the symbolic, precisely because it is more fluid and less fixed than the more tightly controlled symbolic features of language and literature.

Returning to Metz

All the pieces are now in place for us to discern the precise nature of Metz's innovation in regard to psychoanalysis and cinema. In short, the point is this: does what Metz calls the 'imaginary signifier', by means of which the cinema functions, by virtue of the imaginary fantasies it sustains, enable one to form links with the world, or does it isolate one from the world? A crucial ingredient in finding an answer to this question is cinema's double nature, the 'both-and' logic it borrows from Freud's concept of fetishism; the Freudian maintenance of contrary beliefs which Metz translates for the cinema as a 'doubling up of belief'. For the cinema is both a socially sanctioned activity, quite 'culturally permissible', and a privately pursued activity, an activity hidden away in the dark, where one is allowed to look upon things that would typically – in terms of 'cultural permissibility' – be hidden from view (we are allowed to view intimate scenes of personal family life; we can gaze upon gross acts of cruelty and horror; we can witness the expression of the most private and personal emotions, and so on). Metz refers to this aspect of the cinema explicitly in terms of the unconscious as a hidden 'reserve' or 'enclosure':

> the cinema (rather like the dream in this) represents a kind of enclosure or 'reserve' which escapes the fully social aspect of life although it is accepted and fully prescribed by it: going to the cinema is one lawful activity among others with its place in the admissible pastimes of the day or the week, and yet that place is a 'hole' in the social cloth, a *loophole* opening onto something slightly more crazy, slightly less approved than what one does the rest of the time. (Metz 1982: 66)

The cinema is both a 'culturally permissible' pastime and a site where prohibited acts can be viewed with (relative) impunity. It is both an activity where 'reality' can be shut out at the door and one where fantasies can be indulged (of course, one's fantasies might also be

thwarted). It is both an activity where one can utterly believe in the fantasy present before one's eyes and one where a firm belief in the 'real world' beyond the cinema theatre can also be maintained. Indeed, this doubling up of belief is as crucial to the imaginary effect of cinema as it is to the structure of fetishism.

Does this doubling therefore automatically make the cinema into something pathological (remember this is the accusation Allen makes)? The only answer one can make to such a question is that the cinema definitely can be something pathological, but it need not be. And whether it is pathological has nothing to do with its status as a fantasy or illusion, fetish or 'imaginary signifier', in opposition to the real world's status as 'reality'. Rather, the lesson to be learned from Freud or Metz is that only social reality itself can provide a situation or environment in which its products will be considered 'normal' or 'pathological'. Indeed, this is the entire point of Metz's analysis: that, as a social construction, as a cultural invention, cinema's codes are not defined by its perceptual 'tricks' or a permanent set of inbuilt characteristics, techniques or methods – Metz is no apparatus theorist. Rather, the cinema is defined by codes that are socially and culturally produced, and such codes – at the time when Metz was writing, in the mid-1970s – reached, at that particular historical moment, a position whereby the characteristic way in which the cinema signifies for its audiences is imaginary. (I'm not at all convinced that the cinema has markedly changed since that time.) It is not as a result of its technologies, techniques or its apparatus, but rather because of the signification it has historically developed, that the cinema can be referred to, for Metz, as an 'imaginary signifier'. As he writes: '[T]he cinema exists as our product, the product of the society which consumes it, as an *orientation of consciousness*' (Metz 1982: 93).

For Metz, quite contrary to what Allen asserts, it is not the distinction between fantasy and reality – or between the imaginary and reality, or the imaginary and the symbolic, or between illusion and reality and so on – that is crucial. Instead, what is at stake for the cinema, what makes it what it is, is its curious and distinctive blending of fantasy and reality, somewhere on the border between the two, not purely and simply an illusion which we know to be an illusion, but also not simply a replica of the real which we take as a copy or replica of that real. For the reality of film *is* precisely that blend of half-believed fantasy and partially filled-in reality that presents us with a distinctive and precious reality all its own: the reality of film.

Where does this leave us? Perhaps once and for all we can try to alleviate the widespread fears present-day film scholars seem to have of Metz's notion of the 'imaginary signifier'. Torben Grodal has claimed that 'Metz and many others adopt Freud's sinister view of life by seeing symbolic phenomena as illusions and compensations for infantile traumas, not as symbolic software for active coping' (Grodal 1997: 27). This short dismissal of Metz is so stunningly misguided that it is difficult to know where to begin. First of all, Metz theorized an imaginary signifier precisely to designate that the cinematic signifier was not symbolic, at least not symbolic in the way that spoken and written languages are. To thus refer to Metz's approach in terms of 'symbolic phenomena' is an opening error. To then state that these phenomena are, for Metz, 'compensations for infantile traumas' is to skew Metz's position significantly. He certainly considers cinemagoing an activity associated with regression, but a strange kind of regression mediated by the viewer's already-implanted symbolic modes of awareness and understanding (see Metz 1982: 47–8). To declare that, for Metz, films are compensations for traumas offers a very poor explanation of his aims. Finally, against what he supposes is Metz's position, Grodal defends, against Metz, a position in which cinema offers forms of 'active coping'. Here, as was the case with Richard Allen, I can only apprehend the harsh hand of symbolic prohibitions, as though Grodal is convinced that the world is a cruel, harsh place and that films at least manage to ease the pain a little; films make the suffering we endure at the behest of the symbolic order somewhat more bearable. There is here no prospect of a challenge or revolt against the suffering inflicted by the symbolic, merely a submission to its commands, a posture of 'coping'. Grodal, in going against Metz, therefore ends up repeating the rationale proposed by Allen: illusions are bad for they merely divorce us from our experience and understanding of reality (they are mere 'compensations'). By contrast, to be true to reality, to eschew illusion, films must help us to 'cope' with reality. The prospect of changing reality or imagining other realities simply does not register as anything other than an illusion. Illusions are bad; the real is good.

The fetish and consensus

And yet many have claimed that the imaginary signifier does, in fact, designate a form of 'active coping': there is no possible way for the imaginary signifier to be radical or to discover ways of

challenging the world. Many – perhaps most film scholars today – would claim that Metz merely supports forms of passive coping: the imaginary signifier merely explains the ways in which spectators go to the cinema in order to have the same fantasy fulfilled over and over again. In doing so, it offers no conception of challenging the sameness of that fantasy. Quite the contrary, from this perspective, we go back to the cinema in order to be subjected to an experience of the same, to avoid experiences of difference, to evade any experience which might be challenging or problematic. We just want a repetition of the same, just as much as the fetishist wants that very same shoe again this time in order to reach orgasm. This repetition changes nothing, but is instead only a repetitive form of coping, of ensuring that nothing changes, of affirming the processes of the same over and over again.

As if this was not already enough: isn't the cosy doubling up of belief entailed by the imaginary signifier an evasion of the world and its reality? Surely the fetish and the imaginary signifier are merely ways of getting away from the world, ways of coping with the world by repudiating it instead of confronting or challenging it. Rather than offering a challenge to the world, isn't the imaginary signifier instead the offer of a cosy recluse from the world, a hideaway, 'hole' or 'loophole' in the social (as Metz himself claims) into which one can crawl while visiting the cinema precisely as an escape from the world and its realities?

The reader is no doubt aware that this is the typical way in which the fetishistic relation to the image has been conceived by film studies. Its most sophisticated articulation appeared many years ago – at almost the very same time at which Metz's own essay appeared – in an article by Stephen Heath. Heath's criticism (perhaps we can see it as a criticism of Metz *avant la lettre*) is that the viewer is duped by the fetishistic nature of cinematic representation. In an article published in 1974 on 'Lessons from Brecht', Heath derides the fetishistic nature of cinematic representation: the fetish is a guarantor of the spectator's coherence and of the coherence of that at which the spectator looks. That is to say, the fetish fixes the spectator into a locked structure, an imprisonment in fetishistic representation from which there is no escape. Against fetishism, therefore, Heath examines what he thinks are the strategies necessary for overcoming this supposed enslavement.

The fetish, Heath argues, in so far as it can be applied to the cinema, is predicated on the spectator's distance from that which is fetishized. In so far as the spectator is separated from the cinema

screen, then so is the diegetic space screened, screened in such a way as to allow the separation necessary for the operation of the fetish. Overcoming this separation, then, is one way of destroying the fetish, in such a way as to ensure that the spectators are no longer 'outside' the representational process, but rather are part of that process: 'The aim is no longer to fix the spectator apart as receiver of a representation but to pull the audience into an activity of reading; far from separating the spectator, this is a step towards his inclusion in the process' (Heath 1974: 110). In this way, Heath really does take lessons from Brecht: if the spectator is included in the process, then (to quote directly from Brecht's theories of theatre):

> it is also as spectator that the individual loses his epicentral role and disappears; he is no longer a private person 'present' at a spectacle organized by theatre people, appreciating a work he has shown to him; he is no longer a simple consumer, he must also produce. Without active participation on his part, the work would be incomplete … Included in the theatrical event, the spectator is 'theatralised'. (quoted in Heath 1974: 112)

Rather than passively submitting to the representational fetish, the Brechtian spectator is here actively producing her/his own relationship to the production. Instead of remaining apart from the spectacle, the spectator is now part of that spectacle: the spectator is 'theatralized'. This, for Heath, offers the subject an escape from the prison of the fetish.

Added to this conception of Brechtian theatralization, Heath calls on another figure of authority to drive home his argument: Louis Althusser. Also borrowing from Brecht, Althusser argues that if we accept the 'theatralization' of the spectator 'then the play is really the development, the production of a new consciousness in the spectator …; the play is really the production of a new spectator, an actor who starts where the performance ends, who only starts so as to complete it, but in life' (Althusser 1969: 150–1; Heath 1974: 115). Heath's Althusserian-Brechtian point here is that, contrary to the fetish, which for him provides an escape from the world, a representational zone that is cut off from the world, an escape which ensures the spectator will never challenge or confront the world, the theatralized spectator will start to produce a new self, and a new life beyond the performance. If we apply such a dictum to the cinema, then the cinematic situation will flow over into life, and in this way the spectator will be able to challenge, change and construct the world, 'in life', as it were, and not just in fantasy.

These statements from Heath's Marxian masters (Walter Benjamin also figures heavily in the article) still carry an extraordinary strength. And in many ways they are not at all unfamiliar. The reader might indeed think we have stumbled upon the same kind of dichotomy found in the preceding chapter. Is not Heath here supporting a notion of theatralization as a way of countering Metz's defence of 'absorption' in the cinema? This might indeed be the case, but I none the less believe Brechtian theatralization or distanciation is different in many important ways from the theatricality proposed by Fried (in ways that I do not have the space to go into here, and besides which I am also somewhat uncertain about).[37] Suffice it to say that Heath's argument here unfolds on different terrain from Fried's and that, from a Brechtian point of view, I would prefer to believe that strategies of theatralization or distanciation might indeed be part of the anti-theatrical tradition.

To continue: Heath's opposition begins with a viewer duped by the cinematic illusionism that fosters fetishistic representationalism in the spectator. Such a spectator is hermetically sealed off from the diegetic space of the representation and, as such, the cinema screens that representation for the spectator in a fetishistic way. The way to destroy this spectator's fetishistic enslavement is by way of theatralization, by breaking down the spectator's separation from the screened spectacle so as to ensure the spectator's inclusion in that spectacle.

Does Metz therefore deny the possibility that the cinema might take forms other than that of the fetishistic, imaginary signifier? Might it be possible, from Metz's point of view, to discover a 'theatralization' of the spectator in opposition to the fetish-loving spectators of the imaginary signifier? Some consideration of what might be called theatralization is considered by Metz and he also claims, in ways that could conceivably be associated with Heath's position, that any change in the nature of the cinema signifier would necessitate a transformation in the nature of the classical fiction cinema as it is currently constituted (Metz 1982: 142). In other words, for this to happen, the cinema would no longer be the cinema as we know it today; it would be something other than what we currently call 'cinema'.

The stakes are, however, somewhat complicated for Metz. As we know all too well, Metz famously coined the term 'imaginary signifier'. From that perspective, the illusory qualities of cinema are imaginary ones. And yet, for Metz, this is a cinematically specific imaginary, for he claims that 'What is characteristic of the cinema

is not the imaginary it may happen to represent, but that imaginary that it *is* from the start' (Metz 1982: 44). In other words, the cinema does not merely represent imaginary scenes and scenarios (indeed, the imaginariness of its scenes and scenarios is a secondary consideration). Rather, the cinema's acts of representing, its modes of portrayal, are themselves imaginary. With this claim one can easily believe Metz is charting the same terrain as any other scholar associated with political modernism: what is most characteristic of the cinema is its ability to hide its own technological operations – its 'work' (as Baudry put it (1985)) – and thus effortlessly and transparently to present a diegetic world that barely needs any decoding or interpreting. The diegesis merely presents itself to be seen: and as for me, to paraphrase Metz, I am there to look at it (see Metz 1982: 48).

Metz's all-important claim, however, is that in order for any fiction film to be made available for the viewer (and it is Metz's contention that only the most minute minority of films are truly non-fictional), the viewer must go through a process of accession to the imaginary. The spectator must accede to the imaginary 'contract' any film proposes,[38] and such a contract necessitates what Metz infamously calls primary cinematic identification: the spectator's identification with her/himself as the condition or precondition of viewing: 'the spectator *identifies with himself*, with himself as a pure act of perception (as wakefulness, alertness): as the condition of possibility of the perceived and hence as a kind of transcendental subject, which comes before every *there is*' (Metz 1982: 49). Primary cinematic identification is contrasted, as is well known, with secondary cinematic identification: an identification, built on the foundation of the primary identification, with the scenes, stories and people a film represents.

Metz goes on to argue that, if one does not disavow the apparatus, then one will disavow the diegesis, the scene of representation. In other words, instead of disavowing primary cinematic identification, one will instead disavow the secondary identifications. To disavow the secondary identifications, then, is to deny or reject the 'story' of a film. And this kind of a rejection of a film is typically what happens when a person claims that they don't like a certain film: they didn't like certain characters, or they didn't think the plot was very interesting and so on (Metz 192: 115). Metz does not see any problem with this sort of rejection, for they are part and parcel of the experience of movies; 'certain spectators do not like certain films', Metz unashamedly states (Metz 1982: 115).

But there is another twist to the tale. Metz argues that such rejections of secondary identifications often occur when spectators who are generally fond of popular, Hollywood-style films alter their habits and instead go to see an experimental or 'radical' film. He claims that quite often what will happen in these cases is that the spectator will be frustrated, perhaps even bored, and will simply leave the cinema, unable to accept the difficulty – or even the impossibility – of forming secondary identifications with such films. (We might consider that it is not just the cinematically unadventurous who are susceptible to such disappointments, for, as Jonathan Rosenbaum remarks, occasionally even the most progressive critics desire their own secondary gratifications. Jean-Luc Godard's *King Lear* (1984), according to Rosenbaum, is a deliberate attempt to frustrate its audiences, to block any potential secondary identifications, and to foreclose intentionally any possibility of spectatorial redemption: 'In other words', writes Rosenbaum, 'as an assault on the Cinematic Apparatus, [*King Lear*] actively works to make the critical community, including Godard's heartiest defenders, virtually tongue-tied' (Rosenbaum 1995: 187).

For Metz, then, 'The problem of the spectator walking out seems to be a very simple matter. Most people are simply bored and they walk out' (Metz 1979: 22). And this means that, for Metz, experimental cinema finds itself in a very tricky situation: 'I think you have a real, directly political problem with the radical films. If you try to shoot a radical film in the sense of inscribing the marks of enunciation with the enunciated, you have no audience. And so, in another sense, the film is not radical' (Metz 1979: 29). Where the apparatus (the 'marks of enunciation') is foregrounded, when oblique camera angles, or discontinuous editing, or de-dramatization, and so on, get in the way of a spectator's secondary identifications, then 'His secondary wishes and secondary expectations are strongly disappointed, and so he is no longer able to maintain his primary wish-fulfilment' (Metz 1979: 22). And that is that. Such a viewer will simply hope that the next movie s/he sees will provide her/him with better secondary identifications.

But there *are* other types of viewers, those viewers who, when confronted with a radical, experimental or 'difficult' film, are prepared to 'work' with it, as Metz remarks (Metz 1979: 22). This is clearly a different kind of spectator, 'another type of person', claims Metz, 'who is very enthusiastic about experimental cinema and does not have the same reaction' as the spectator who is enamoured of secondary identifications and expectations (Metz 1979: 22). It is

quite clear that Heath passionately desires a cinema which will attract spectators of this type, a spectator who is enthusiastic about films which try to block or break down secondary identifications. Nevertheless, Metz finds such spectators somewhat problematic and it is here that a critique of Heath's argument can be most appropriately located. '[F]or this second type of person', Metz remarks, 'there is this danger of what I call idealistic aestheticism' (Metz 1979: 22). This is certainly not an out and out objection, for Metz grants that such spectators are typically 'bright', even 'courageous' (Metz 1979: 28). But this does not mean they are not problematic. And there is a pertinent reason why such spectators are problematic, which Metz phrases in a very specific way: 'How is it possible', he asks, '– in our circumstances, now – to break down the secondary identification *without* falling in love with the apparatus itself, without reinforcing the stages of the apparatus as fetish?' (Metz 1979: 21). What Metz is arguing here is that, for this other type of spectator who is very keen on experimental films, far from there being an overcoming of a fetishistic relation to the cinema, there still exists a fetishism. Instead of being a fetishization of the diegesis and its secondary identifications, this falling in love with the apparatus fetishizes the primary cinematic identification; it is a fetishization of the apparatus. Instead of disavowing the apparatus, it is the diegesis that is disavowed (denied 'reality'). In other words, spectators of this kind will commonly declare that they don't like narrative cinema, that they don't like films that 'just tell stories'. Rather, they enjoy films which explore the nature of film as a medium, films that 'push the boundaries', that dispense with linear narratives and so on. In other words, they disavow the secondary identifications (the scenes, scenarios and characters) of cinema and fetishize the primary identifications, the apparatus itself.

Might we thus have to declare that Heath is a fetishist of the apparatus? I believe this is what Metz's position implies, so that Heath's critique of the fetishization of representation cannot result in anything other than a fetishization of the apparatus, a fetishism that Heath calls, after Brecht, theatralization. To stress the materiality of the apparatus, to foreground the filmmaking techniques, is precisely to stress the material reality of the cinema apparatus over and above its potential for transparency, its primary identifications over its secondary ones. Instead, therefore, of making the signifier of the cinema imaginary, such foregrounding pushes cinema towards the condition of theatre in which the signifier is materially real (properly 'symbolic' rather than imaginary). I can only contend

that Heath would concur with such statements: that cinema ought to be deprived of its imaginariness in favour of a properly symbolic aptitude.

And yet, even these binary oppositions are perhaps too extreme: the opposition between a fetishization of the apparatus and one of the diegesis tends to simplify matters rather too starkly. Metz's analysis is, in the final account, infinitely more subtle:

> The cinema fetishist is the person who is enchanted at what the machine is capable of, at the *theatre of shadows* as such. For the establishment of his full potency for cinematic enjoyment [*jouissance*] he must think at every moment (and above all *simultaneously*) of the force of presence the film has and of the absence on which this force is constructed.[39] He must constantly compare the result with the means deployed (and hence pay attention to the technique), for his pleasure lodges in the gap between the two. Of course, this attitude appears most clearly in the 'connoisseur', the cinephile, but it also occurs, as a particular component of cinematic pleasure, in those who just go to the cinema: if they do go it is partly in order to be carried away by the film (or the fiction, if there is one), but also in order to *appreciate* as such the machinery that is carrying them away: they will say, precisely when they have been carried away, that the film was a 'good' one, that it was 'well made'. (Metz 1982: 74–5)

Metz's position is thus one of calculated restraint. Cinema theorists like Heath (and the many who have come after him and repeated the terms of his arguments, as I noted in Chapter 1) are often too hasty in their willingness to construct scorecards of positive and negative types of films, good versus bad films, illusory films versus ones which put us in touch with reality. Metz convincingly argues that such scorekeeping simplifies the spectatorial situation in which competing tendencies often work in tandem and to each other's advantage, and to the ultimate benefit of the spectator's pleasure (or often, to be fair, to the spectator's distress and displeasure). Film spectators, whatever their 'type', are a sophisticated bunch, and their pleasures are assuredly worthwhile, even if those pleasures are fetishistic, imaginary, unreal and/or illusory.

Propositions, conclusions

The continuing relevance of oppositional paradigms in film studies needs to be, if one heeds Metz's words, 'profoundly questioned'. Film histories and theories have come up with a series of oppositional categories, all of which rely on the 'classical narrative cinema'

as the norm to which all 'other' cinemas are opposed: avant-garde, documentary, early cinema, post-classical cinema, spectacle cinema (e.g., the musical or the comedy as forms that constantly interrupt narrative), art cinema, political cinema – including feminist cinema – and there are surely many others. Even classical narrative cinema itself has been dialectically undone and opposed to itself.[40] I do not deny that I have a great deal of sympathy with these positions, for the study of 'new', 'other' and 'minor' cinemas has greatly diversified the field. Nevertheless, at the root of all these oppositions is the foundational opposition between illusion and reality: classical narrative cinema peddles illusions which must be rectified by the realities of those forms which oppose classical narrative. This opposition between cinema's illusions and its potential realities are all too clear in Heath's call for 'theatralization'. Yet, to reiterate again the claims of my opening chapter, it is this opposition between illusory films and ones which allow us access to reality that has been replayed again and again in film studies.

For his part, Metz posits that such 'non-classical' forms are not ones that are straightforwardly opposed to classical cinema, and nor, in the cinema, can illusion be straightforwardly opposed to realism. Rather, the reality of the cinema *is* illusory, and this is in fact its defining feature. And there is nothing wrong with that. The problem with each of the arguments put forward in this chapter in contrast to Metz – Allen's argument for 'projecting illusion' and Heath's call for 'theatralization' – is that each of these scholars constructs a system by means of which illusion is placed in opposition to reality. For Allen, the cinema is placed on the side of illusion so that, while at the cinema, spectators 'entertain' the reality of these illusions. At the same time, however, Allen argues that spectators never confuse those cinematic illusions with the reality that lies beyond those illusions: spectators only ever 'entertain' a confusion. Such, for Allen, are the great joys and pleasures of cinema. For Heath, on the contrary, that the joys and pleasures of cinema are illusory presents us with a directly political problem. What any political or radical cinema must do is to smash the illusions of cinema in order that spectators come face to face with reality. Only by eschewing illusion will the cinema be able to lay bare the nature of the real. Only then will spectators begin to change the world and create a new life.

Metz offers a position that is completely at odds with the arguments of both Allen and Heath. His position is one that denies the distinction between illusion and reality. Instead, he argues that the cinema

does indeed present us with illusions, but it is only by way of these illusions, by believing in them, by treating them *not* as illusions, that one can gain access to cinema's reality. Metz's argument therefore collapses the distinction between illusion and reality in the cinema: he advocates an imaginary illusionism at the heart of filmic reality. He argues quite explicitly that the cinema signifier is underpinned by a 'doubling up of belief' that provides an illusory reality (see Metz 1982: 70). Spectators do not mistake what they see on the screen for reality, rather they maintain a dual relation to the screen that is structured in a fetishistic manner. One part of the spectator's psyche which knows a film is merely a construct, a convention, a socially sanctioned pastime, but another part of the psyche disavows this constructed convention and assumes that this film is reality. Beyond Freud, we might even consider that Metz's position inherits Edgar Morin's marvellous theses on cinema's 'imaginary man': '*The cinema is the dialectical unity of the real and the unreal*' (Morin 2005: 169). By way of cinema's imaginary illusions, humans have the capacity to remake themselves, to reinvent themselves: '[Films] come back upon our waking life to mold it, to teach us how to live or not to live ... We must try to question them – that is, to reintegrate the imaginary in the reality of man' (ibid.: 218).

4 A reality beyond imagining

6 William Holden and Kim Novak promoting *Picnic*
(Joshua Logan, 1955)

Involvement

Stanely Cavell's most important consideration of the movies (as he likes to call them) is also the most straightforward: movies involve us. 'We involve the movies in us', he writes. 'They become further fragments of what happens to me, further cards in the shuffle of my memory, with no telling what place in the future' (Cavell 1979: 154). We go to the movies (or watch them on television); we talk with our friends about the movies; memorable moments from movies arise frequently in conversations (at least they do in my experience). Some of us may even fantasize about being in movies –

perhaps not so much of being movie stars, but rather of being like a character in a movie (on this latter point see Stacey 1994). In short, movies are a part of our lives, they form one aspect of how we live our lives, of how we choose to spend our time and perhaps, even, from time to time, they may influence the decisions we make about our lives.

Such is the place from which Cavell approaches movies: not only do movies involve us, but we involve ourselves in them. 'Why are movies important?' asks Cavell. In answering this question, he considers that the arts of music (I can only assume he means something akin to 'classical' music), painting, sculpture or poetry 'are not *generally* important' and even goes so far as to assert that 'These artists [those involved in music, painting, sculpture and poetry] have virtually no audiences any longer' (Cavell 1979: 4). But anyone who is in any way, shape or form involved in cultural pursuits (or 'artistic' pursuits may be more appropriate to Cavell's frame of mind), 'all care about movies, await them, respond to them, remember them, talk about them, hate some of them, are grateful for some of them' (Cavell 1979: 5). The classic arts today play a minor role in most people's lives, whereas movies are in various ways central to our existence, and most people have developed sophisticated ways of relating to them, ways that do not require any kind of expert knowledge, but which require seemingly 'natural' conditions of viewing, seeing, hearing and thinking.

An overarching question for Cavell is thus why do we involve movies in us? Our involvement in movies does not depend on some kind of expert knowledge (say, of the kind that is necessary for classical music, or painting, sculpture or poetry); even though many film scholars seem to have the impression that some kind of expert knowledge is essential for understanding films, this is not something that is at all important for Cavell. Rather, the question for him of what is necessary to our involvement in movies simply comes down to reflecting on what it is that we see and hear when we go to the movies, and then, ultimately, of engaging with what it is that films allow us to reflect upon. Therefore, what Cavell feels it important to grapple with in films comes down to what we take away with us from a film. At stake is how or why a film may (or may not) become active in one's memory, or whether a film continues to have meaning or to matter within, but also and especially beyond the conditions of its viewing. For Cavell, 'to take an interest in an object is to take an interest in one's experience of the object, so that to examine and defend my interest in these films is to examine and defend my

interest in my own experience, in the moments and passages of my life I have spent with them' (Cavell 1981: 7).

Checking

In order to trace the importance of these aspects of the film experience, Cavell invokes something he refers to as 'checking one's experience'. By 'checking one's experience', he writes,

> I mean the rubric to capture the sense at the same time of consulting one's experience and of subjecting it to examination and, beyond these, of momentarily stopping, turning yourself away from whatever your preoccupation and turning your experience away from its expected, habitual track, to find itself, its own track: coming to attention. The moral of this practice is to educate your experience sufficiently so that it is worthy of trust ... I think of this authority as the right to take an interest in your own experience ... Think of it as learning neither to impose your experience on the world nor have it imposed upon by the world. (Cavell 1981: 12)

To engage in this kind of 'checking' of our experience is something we do all the time. We may do it to ensure ourselves that our senses are not deceiving us or, more importantly for Cavell, to check that our experiences are not deceiving us. To check one's experiences is to simultaneously court the experiences of other people, of 'other minds', in relation to the senses we possess and the perceptions by way of which we perceive the world around us. Hence the importance of the Kantian impetus of Cavell's musings here: 'checking' is an activity of reason. Our experience of the world, therefore, is a product of checking our sensations of it and, for the Kant whom Cavell invokes, the checking reason induces is a matter of the 'necessity and universality apart from which we would have no access to the objective, no idea of a world' (Cavell 1981: 77).

To ask questions of ourselves, of the world and of others: that is what it means to 'check' one's experience. For Cavell, it is also what we do when we go to the movies; we judge them according to our experiences; we understand that a world is set up by a film and we are called upon to examine and question that world to see whether it fits with our conception of a world; and we understand that characters in films make certain decisions and that such decisions may be plausible or implausible, often both at the same time. *Groundhog Day* (a film we met briefly in Chapter 2) presents itself in this light, a light in which the lead character, Phil (Bill Murray) finds himself in the situation of questioning both his senses and his experience,

and thus engaging in an activity of 'checking'. On the one hand, his senses are called into question in so far as, throughout the film, he is sentenced to repeating the same day over and over again, which is to say that he finds himself beyond nature. On the other hand, he also calls his experiences into question and thus turns his experience away from its habitual track in order to follow a path down which he has never been. That is to say, he falls in love and decides to pursue this love, resulting in what Cavell contends is 'a deeply wonderful story of love' (Cavell 2005a: 222).

But, for the movies, there is much more to the notion of 'checking' than this: not only can it be declared that Phil's activities are ones of 'checking his experience', so too must we, as spectators of the film, 'check' our own experiences. When Phil finds himself stuck in a day that repeats itself, then we are forced to accept this as something that *Groundhog Day* makes possible in a manner that is beyond nature (we are forced to accept this if we are to find the film believable or plausible). We might accept that this is something that can never happen to us, and thus that it can never be part of our experience. But this does not prevent us from checking this experience or, more accurately, from checking our understanding of this experience, of trying to work out 'what is going on' that makes such an experience possible. In *Groundhog Day* Phil makes some decisions which could strike some viewers as unacceptable. For example, in order to free himself from the tyranny of a day that repeats itself, he decides to kill himself. And yet, even though he kills himself a number of times, he nevertheless, like an imperishable cartoon character, never fails to reawaken on the following morning, with the caveat that the following morning is, of course, the same day repeating itself once again. There may be any number of issues that a spectator might check here: is Phil's decision to kill himself really warranted? Is this the kind of decision I would make if faced with the same predicament? Or is this series of spectacular deaths merely another comic ruse *Groundhog Day* utilizes (along with its 'groundhog' plot device and the repeating day) in order to convince us that it does not, in fact, take its subject at all seriously? And, for that matter, can we really take the romance between Phil and Rita (Andie MacDowell) seriously, or is this too another of Hollywood's manipulating contrivances? All of these questions, whether one finds the film to be a positive or negative one, are aspects of 'checking one's experience', of questioning what one encounters, of 'consulting one's experience and of subjecting it to examination', as Cavell understands it.

The parameters of such questionings are ones that enable us, in Cavell's words, to 'educate' our experience. And perhaps this is the greatest achievement of films (or any artform), as it is in life: to allow us to educate our experience. All the same, we can never be certain that there is any kind of correct education; to put it as simply as possible, there is no way to prove that *Groundhog Day* is 'a deeply wonderful story of love', as Cavell thinks it is, rather than a disappointing, implausible or cynical one. But, as Cavell tries to argue, by checking one's experience and thus by educating it, one learns to begin to trust one's experience: such are the rewards of film, as much as the rewards of life.

Learning to articulate what one considers to matter in a film is the most important task for anyone writing on film, and criticism or interpretation is a task which Cavell acknowledges to be Kantian. The meaning or significance of films is rarely self-evident – and the same might be said for any art form or entertainment. Christian Metz once wrote that 'A film is difficult to explain because it is easy to understand' and what he means is that we typically understand films all too easily, such that we often fail to 'process' them in a way that enables them to be put into words or even recalled with any great accuracy (Metz 1974c: 72). At the same time, when confronted with a film there is always too much – it is impossible to account for every detail of a film (say, in the way that one can focus on a poem or a novel right down to most minute notations of their materials). The process of 'checking' one's experiences of film is therefore one of drawing boundaries and establishing the limits of what matters and thus of coming to terms with the reason films involve us.

The first obstacle Cavell faced when he began to teach film was the sheer difficulty of translating the experience of film into something that had the capacity to become a shared discourse. In other words, he had great difficulty articulating what it was that he thought mattered in films, and his students seemed to suffer from similar deficiencies. It was disheartening that, at what one may consider the very simplest level of articulating what a film is – at the level of description, at the level of trying to clearly describe 'what a film is about' or 'what happened' in a certain film – very straightforward inaccuracies were commonplace. Even more disheartening was a willingness among students to retreat into technicalities when confronted by the injunction to 'describe' a film. As Cavell puts it, 'words flowed about everything from low-angle shots to filters to timings and numbers of set-ups to deep focus and fast cutting', and so on (Cavell 1979: xxi). Articulating one's understanding of a film

has very little to do with clarifying the technical aspects of film craft. Rather, for Cavell, trying to come to grips with a film means paying attention to the film before your eyes. He claims, again with reference to the first years in which he was teaching film, that 'the only technical matters we found ourselves invoking, so far as they were relevant to the *experience* of particular films, which was our only business, are in front of your eyes' (ibid.). Cavell is simply affirming, and I think he is correct to do so, that this is quite simply how the majority of people see and experience films. Very few people, it seems to me, go to the movies in order to appreciate, say, Serge Leone's juxtapositions of close-up and long shot, or Spielberg's manipulations of focal length. Some people may believe that they go to the movies to be impressed by special effects, but being impressed by special effects means that such effects establish a sense of conviction. We may all know that the shark in *Jaws* is a mechanical one, but that does not prevent it from scaring us to death. We may know that Darth Vadar is an imaginary character from a galaxy far, far away, but that will not deter us from the surprise and suspense of discovering he is Luke Skywalker's father. And we may know that the land of Oz is a land of make-believe, but that world still allows us to care for Dorothy to the point that we are desperate to see her find her way home (see Cavell's comments, 1979: 196–8). And even the experiments of experimental filmmakers cannot solely define what is important in their films; the reliance of the Dogme 95 filmmakers on digital video cameras and a strict set of rules, for example, did not preclude them from making films that had the capacity to transcend the technical definitions they themselves set down; which is another way of saying that the Dogme 95 films were not defined by their technical aspects, but rather were defined by the subjects they filmed.

As Cavell argues, does it really matter how Hitchcock managed to get the stairwell to distort in *Vertigo* (1958)? That it does distort in a peculiar way is enough to know, while the effectiveness, meaning or significance of that distortion is what it is important to grapple with in coming to articulate what one thinks about the film (actually describing what one sees is far more important here than understanding whatever technique it was that Hitchcock utilized). If students or scholars seek refuge in these technical aspects of films, then what such a refuge displays is an avoidance of the film's experience, an inability to engage with what the film presents. Knowing how Hitchcock got the effect does little or nothing to our understanding of the effect and certainly cannot provide 'the key to the

experience', as Cavell suggests (Cavell 1979: xxii). To take this point of argument a step further, 'checking' that experience of what one sees against one's own experience provides something towards an understanding of *Vertigo*'s distortion effect. And surely one of the reasons the effect was so successful is that in some way it gives vision to an experience many will have felt (at least I know I have): the strangeness of a perspective on the world that is at odds with one's usual distance from the ground.

Subjectivity

That is the reality of film for Cavell. The experience of sitting in front of a movie screen and seeing the stairwell distort in *Vertigo* is a real experience. It is not a real*ism*, for how could one prove or even claim that the effect of the distorted stairwell is an accurate repro-duction of what one would see in the real world? And yet, all the same, it happens there in front of me on film when I watch *Vertigo* as a reality of the experience of watching that film (as something, in other words, that really does happen). It might be understandable, given his faith in photography's ability to capture reality and of the correlative ability of the world to exhibit itself on film, that Cavell has often been thought of as a realist. He goes to great pains to try to clarify his perspective on photography, but even then Cavell's thoughts are not entirely clear. Perhaps this is merely an outcome of what Roland Barthes referred to as the 'photographic paradox': that when we see a photograph of a thing, we see, at one and the same time, the photograph and the thing itself (Barthes 1977a). This is a far more difficult argument to accept than the one, even more common now than it was when Cavell was writing *The World Viewed*, that argues that the camera lies or that 'there is no way in which a photograph really represents a real object'. The logic of this kind of argument is one that stresses the ways in which a photograph can never be the same as reality or never really capture the realness of the real; in other words, photographs will always be removed from reality or a distortion of reality. Such arguments insist on the sanctity of a reality that is entirely separate from a photograph, which is to say that they insist upon the separation between the realm of representation and that of reality. To put it simply, this is an attitude we have come across again and again in this book: that films, as much as photographs, are 'only representa-tions'; they are illusions entirely distinct from the reality of a real that is 'out there'. Cavell's view is both more straightforward and

more difficult than such a dismissal: that in a photograph reality and representation are conjoined.

This photographic paradox does not mean that in a photograph we cannot distinguish between reality and its representation, it merely means that if we conceive of a photograph as a representation then that representation carries with it something of reality. Cavell is more or less content to call this a photograph's mystery; we cannot somehow explain away the mystery whereby a photograph of Napoleon's nephew ineluctably shows us 'the eyes that looked at the Emperor' (as Barthes so astonishingly puts it; 1981: 3). Cavell argues that 'the relation between photograph and subject does not fit our conception of representation, one thing standing for another, disconnected thing, or one forming a likeness of another'. In other words, a photograph does not give us a copy, reproduction or representation of its subject; the logic of representation simply does not work in the case of photography. He continues, 'When I see that child there in the photograph of the group of school children standing outside the country schoolhouse, the one standing just in front of their teacher Wittgenstein, I know that the child is not here, where I am; yet there he stands, his right arm slightly bent, his collar somewhat disarranged' (Cavell 2005b: 117). With this example, Cavell affirms the kinds of statements he made in *The World Viewed*, where he tried to fathom what it is that happens 'when we look at a photograph'. His answer is that 'we see things that are not present' (1979: 18). For Cavell, photographs are a presence from which I am absent.

Cavell's argument becomes more intriguing as it moves closer to what he wants to say about film. He writes that 'Photography maintains the presentness of the world by accepting our absence from it. The reality in a photograph is present to me while I am not present to it' (Cavell 1979: 23). Perhaps the best way to initially think of this is to say that, in a photograph, the world is there in front of me, but I cannot affect that world, I am cut off from it. It is this same point that Cavell emphasizes about movies: they are present to us, but we are absent from them. Because we cannot affect what happens in the world as presented to us by a movie (or by a photograph), then the world is freed to exhibit itself; it is freed from my impositions and interventions. In short, it is freed from my subjectivity.

The world has the capacity to exhibit itself on film (though Cavell is not entirely convinced by the word 'exhibit'; he eventually prefers 'project' or 'screen'): this is one of Cavell's fundamental claims. But

given that, for Cavell, in reality, the world also exhibits itself, then the relation between the way the world exhibits itself on film and the way it does so in reality is crucial. Again it is important to stress that this has nothing to do with the way that films reproduce or represent the world, while it has much more to do with the way in which the world produces itself on film. Cavell's approach is thus less one of realism, which is to say that his question is not one of how films represent the real, than it is one of reality – that is, of what kinds of realities are produced by movies.

Cavell asserts that films screen the world. 'The world of the moving picture is screened', he writes. 'It screens me from the world ... And it screens that world from me' (Cavell 1979: 24). We might think of this in a least three ways. First, films put the world on to a screen (the world is transcribed or transfigured on to the cinema screen).[41] Second, films place a barrier between us and the world, which means that films block us from the world. Third, by screening the world films are also selecting the 'bits' of the world that are put on to the screen (as in when a firm 'screens' a host of candidates for their suitability for an available job). These are all ways in which movies can screen the world. But primarily what Cavell means when he writes that movies screen the world is that they make explicit *the ways in which we ourselves are imprisoned by our subjectivity*. Films emphasize and thus make explicit the conditions of our subjectivity. Movies present us with a world that we are not a part of; we are outside them. We view those worlds unseen. The worlds produced by movies are ones that make me invisible (see Cavell 1979: 24). Movies present us with the world, 'but by permitting us to view it unseen' (ibid.: 40).

Strangely, perhaps, Cavell does not then go on to argue that this is what makes films different from reality. One might imagine that he could have argued that, in reality I am present to the world, whereas when watching a film I am absent from the world. On the contrary, Cavell wants to stress that films actually demonstrate the way in which our normal or typical relation to the world is one in which we are absent. Thus he claims that 'In viewing films, the sense of invisibility is an expression of modern privacy or anonymity' (ibid.: 40).

The way in which films screen the world make explicit the modern condition of subjectivity. Cavell argues that at some point in the history of the West – the key instances of its emergence are the plays of Shakespeare, the Protestant Reformation and the philosophy of Descartes – humans became imprisoned within their own

subjectivity. This is one of the founding assumptions of Cavell's philosophy, which is to a large extent devoted to problems of scepticism, of what it is possible to know of ourselves, of others and of the world from within the confines of our own subjectivity. But it also points to the centrality of the movies for Cavell's approaches to scepticism. In *The World Viewed* he argues that 'At some point the unhinging of our consciousness from the world interposed our subjectivity between us and our presentness to the world. Then our subjectivity became what is present to us, individuality became isolation' (ibid.: 22). William Rothman and Marian Keane, in their commentary on Cavell's book, expand on this point:

> We now feel isolated by our subjectivity. It is our subjectivity, not a world we objectively apprehend, that appears present to us. Nor do we objectively apprehend our own subjectivity; our subjectivity, too, appears present to us only subjectively, as if our consciousness has become unhinged from our subjectivity no less than from the world. (Rothman and Keane 2000: 64)

Part of our modern condition, then, is that we feel cut off from the world; we can trust only our own senses and our own thoughts, but even these are difficult to trust, for we lack the objective criteria by virtue of which we might be able to trust even our own senses. Hence the importance of movies: movies screen reality in much the same way as reality itself, for reality, from our modern perspective, is always already screened.

Our modern relation to the world is described in the simplest of ways by Cavell, for he argues that, under the conditions of modern subjectivity, 'we do not so much look at the world as look *out at* it, from behind the self' (1979: 102). At the movies we view the world unseen, but so too in reality we have become accustomed to viewing the world as if unseen (and humans became accustomed to this long before anything like movies were around). This is a line of thought that is central to Cavell's conception of filmic reality: the reality of films is not one that relies upon representations of the world or notions of verisimilitude or indexicality. Rather, the reality that films make explicit is the reality of humankind's modern relation to the world, of the reality that the world is itself screened in a way very similar to the way in which films screen the world, and that this process of screening is one in which subjects are made to withdraw into themselves, so that their relation to the world is one in which they hide behind themselves and view the world unseen.

Fantasy

Cavell's notion of being trapped behind our own subjectivity means that we are accustomed to retreating into our private worlds – such is the lot of modern privacy. He thus reckons that this same privacy applies to our fantasies as well; our fantasies are those things that we keep locked up within ourselves as part of our 'internal world' in contrast with the realities that we have to deal with in the 'external world': the internal world is subjective while the external world is objective. One of the conditions of modernity is that we are discouraged from making public our innermost wishes – fantasies are things that are tied up with and reducible to subjectivity; they are not open to objectivity.

Cavell explains this condition in the following way: 'Our condition has become one in which our natural mode of perception is to view, feeling unseen ... It is our fantasies, now all but completely thwarted and out of hand, which are unseen and must be kept unseen' (Cavell 1979: 102). Why does he think this? Why is he convinced that our fantasies have been privatized, as it were? And what becomes of fantasies if they are made public? If they are made public, are they still fantasies? Of course, our fantasies *are* always privatized, but at the same time, what is the point of fantasies if they remain restricted to our inner worlds? Is not our interaction with the world one in which, in one way or another, we would hope to give voice to our fantasies, that we may realize our fantasies? What value is a world in which our fantasies are for ever nullified? These are themes which Cavell follows in his writings.

Cavell thus stresses, as I have already noted, that 'It is our fantasies, now all but completely thwarted and out of hand, which are unseen and must be kept unseen. As if we could no longer hope that anyone might share them ... So we are less than ever in a position to marry them to the world' (1979: 102). Of central importance is that we marry our fantasies to the world, or at least what is important is that the potential for such a marriage remains open. And it is movies, for Cavell, that open up the potential space of fantasy, not, as he argues, 'because they are escapes into fantasy, but', he continues, 'because they are reliefs from private fantasy and its responsibilities' (ibid.).

Films are not escapes into fantasy for the simple reason that no film can ever be *my* fantasy. Films are not expressions of my own fantasies or subjectivity. Rather, they are someone else's fantasies, the fantasies of a subjectivity outside my own: whether we associate

this fantasy with a scriptwriter, a director, with a character from a film or with some other subjectivity, I am at least certain that this subjectivity that is expressed or fantasized on film is not my own. This takes us to precisely what is at stake for Cavell: that on the one hand films allow us a refuge from our own fantasies, but that on the other they also correspondingly demonstrate that other people have fantasies too; which is to say that they make explicit the fact that other people as well as myself are trapped inside their own subjectivity. By virtue of the fact that, while watching a movie, I can become involved in another's fantasy and that another's fantasy can become involved in me, is something of a verification that we can overcome our state of being trapped in our subjectivity, that someone else's fantasies can matter to us, and therefore that our own fantasies might be able to matter to someone else. If films make explicit that we are trapped in our subjectivity then they also have the potential to demonstrate the way (or ways) that we might overcome and break free from being trapped in that subjectivity.

Picnic

Joshua Logan's melodrama *Picnic* (1955) provides an excellent example of the ways in which one's subjectivity is often successfully married to the world, but it also demonstrates some of the ways in which this attempted marriage can also fail. *Picnic*'s primary plot centres on the romance of Madge Owens (Kim Novak) and Hal Carter (William Holden) in a small town in Kansas. Hal had lived in this town when he was younger, but had left in search of fame and fortune. He is now returning as a failed man, without a penny to his name. Hal meets up with his boyhood friend, Alan Benson (Cliff Robertson), the wealthy owner of the town's major business which he inherited from his father. Alan offers Hal a job, for Hal is now determined to forgo his dreams and to settle down to live a normal, stable life. Hal soon meets Madge, for she is betrothed to Alan. Madge has done well for herself, as her fatherless family has had to struggle for many years. Her marriage to the town's most eligible bachelor will guarantee her security and comfort for the rest of her life.

Nevertheless, Madge finds it impossible to resist the temptations of the untamed Hal; it is during the company's yearly picnic (hence the film's title), when Madge and Hal dance together, that the couple find it impossible to conceal their love for each other. Naturally, this leads to a serious conflict between Alan and Hal, the

upshot of which is that Hal must now once again leave the town, his quest for stability and normality in ruins. What, then, is Madge now to do? She can live securely and comfortably with Alan, or she can follow her love, with the genuine possibility that she might be consigning herself to a life of penury and misery. In the film's wonderfully melodramatic climax, she indeed decides to follow her love, and quickly packs a suitcase to follow Hal.

The choice Madge has to make is one that carries the full weight of Cavell's understanding of how one might try to marry one's fantasies to the world. Should Madge have followed the easy choice and married Alan, so that her life would be secure, even if she would ultimately be forgoing any possibility of true love? In other words, should she have given up on her fantasies? Should she have admitted that her fantasies could not be married to the world? It is as clear for us as it clear for Madge herself that she does not love Alan, but she has done all the right things and played all the correct cards that could ensure her union with him. But Madge's relationship with Alan is predicated on her renouncing her own dreams, of accepting the fate of being trapped within her own subjectivity, of deciding that she will never be able to share her fantasies with another, and thus marry them to the world.

It is with Hal that Madge learns to express her wishes: she acknowledges Hal's wishes, but crucially, Hal also recognizes hers. More than anything else for Cavell, this is the great American invention: the invention of a version of love (and marriage) that hinges on 'a mutual acknowledgment of equality' between the partners (on this point see Rothman 2003: 212). Madge may not end up happily ever after with Hal, but that she is willing to risk it, to put her own dreams at risk, to engage in the risk of marrying her dreams with Hal's and thus of achieving the kind of self-understanding central to Cavell's conception of selfhood – this is, I think, what makes Madge's decision precisely a decision worth making. To have married Alan would have resulted in her withdrawing her dreams within herself and thus of trapping herself within her own subjectivity, so that her experience of selfhood would never be realized. And that, for Cavell, is what modern subjectivity is typically like: we have learned to give up on the chance of marrying our dreams to the world and instead keep our dreams locked within ourselves. The choices we typically make are those that are determined by forces external to us, which is to say they are decisions made by conventions, by social authorities, or by conceptions of 'the right thing to do'. Madge rejects such conventional decisions and decides

instead to follow the path that might allow her to marry her dreams to the world.

Madge is thus an exemplary Cavellian subject: not only does she demonstrate how modern subjectivity is trapped within itself but she also suggests the ways in which this isolation can be overcome. Of course, her overcoming of her subjectivity is predicated not merely on having her dreams acknowledged by Hal but also on the basis of her recognition of Hal's dreams. Hal's return to the town and his taking of an office job are a sure sign that he too has withdrawn into his subjectivity, renounced his dreams, given up on his fantasies, and subjected himself to conventional notions of 'the right thing to do'. Madge's acknowledgement of Hal – of his romance, of his humanness – is an acknowledgement of his fantasies, and thus an acknowledgement that other people besides herself have fantasies. The bargain Madge then strikes with the world, by following Hal, is one in which she hopes that she and Hal can marry their fantasies with one another and thus together marry their fantasies to the world. As Rothman and Keane stress, 'In Cavell's view, self-knowledge cannot be achieved apart from the acknowledgment of others' (Rothman and Keane 2000: 10–11). Therefore, Madge's acknowledgement of Hal, and his acknowledgement of her, are ways to self-knowledge. Rothman and Keane further stress the importance of this conception of 'acknowledgement' for Cavell:

> Without following our own thinking, we cannot know the minds of others. And without following the thinking of others, we cannot know our own minds, cannot have conviction in our thoughts, cannot claim them as our own. That the achievement of selfhood requires the simultaneous acknowledgment of others is a guiding philosophical principle for Cavell. (Rothman and Keane 2000)[42]

Thus far, however, I have merely outlined how subjectivity and the overcoming of subjectivity function in the narrative of *Picnic*. In a sense, it may be more or less clear why Madge's overcoming of her subjectivity is important to *her*, but in what way is it important to *us*, as viewers of the film? What is important for us is our acknowledgement of Madge's fantasies, our recognition that she does not want to be trapped in a convenient but loveless marriage in much the same ways as we too would not wish to be trapped in loveless marriages. And we can also recognize her ability to break free from the stranglehold of her own subjectivity, that she does not need to forgo her fantasies. This recognition that we make, as viewers of the

film, is a function of 'checking' our experience, a matter of asking ourselves what we would do if confronted with a similar situation. The point of doing this, of checking our experience, is clear: if Madge has the capacity to overcome her subjectivity and achieve selfhood – potentially, at least; for that is the risk she takes by following Hal – then perhaps such risks are worth taking, perhaps we too can break free from our own subjective prisons.

A film like *Picnic* certainly allows me a refuge from my own fantasies, for there is no way that Madge's or Hal's fantasies are mine: they are fantasies made by Madge and Hal. But by acknowledging these fantasies, I am acknowledging that other people besides myself have fantasies and that I can become involved in those fantasies and thus, that I can involve another's fantasies in me. (Of course, there is nothing to stop me from rejecting such fantasies: that too is a function of 'checking' one's experience.) These are steps along the way to overcoming subjectivity and achieving selfhood.

There is also a secondary plot in *Picnic*. Madge's aunt, the brash and world-weary schoolteacher, Rosemary (Rosalind Russell), is an elderly spinster who desperately wishes to be married. Throughout the film she longs for her feelings for the fidgety but contented bachelor, Howard (Arthur O'Connell), to be reciprocated, but he fails to provide the recognition for which she so openly yearns. His dreams are not ones that can be married to hers, even when Rosemary insists that they should or must. Rosemary and Howard do eventually get married – it is as though Rosemary bullies him into a ceremony to which he clumsily complies. But we know this union is doomed; that its dreams are destined to falter, that its couple's pleas to be married to each other and to the world are so many strategies in keeping both of them absent from the world. Rosemary and Howard thus provide examples of subjects who fail to marry their fantasies with the world, the outcome of which, in this instance, is akin to tragedy. There are risks involved in pursuing one's fantasies: they can end in tragedy (on this point see Cavell 1969). Cavell finds, for the most part, I think, that those risks are ones worth taking, for they are ones where what it is to be human is at stake.

Imagination

There is an especially inspired passage in Rothman and Keane's commentary on *The World Viewed*. The passage is ostensibly about Hitchcock's *Vertigo*, but it is also about the capacity for film to give

volume to subjective fantasies such that they can make images out of that which is even beyond imagining.

> Reality that is past imagining is not beyond the reach of film ... Because it is reality itself, not a stand-in for reality, that appears to us on film, reality does not have to be imagined, or even imaginable, to be filmed. For us to accept at the climax of *Vertigo* that the human something on the screen is at once the eminently immanent Judy and the transcendent Madeleine, we must acknowledge at once film's capacity to transform a reality beyond imagining into a world that seems naturally to present itself to us. (Rothman and Keane 2000: 155)

This is a difficult passage. I think, however, that what Rothman and Keane are trying to point out with regard to *Vertigo*, is that, at least at on one level, to imagine that Judy really is Madeleine initially appears to be 'a reality beyond imagining'. I still very clearly remember the first time I saw *Vertigo*: I steadfastly refused to believe that Judy was Madeleine; I thought Scottie had merely found a lesser imitation. Thus, I remember being astonished when Judy confessed that she *was* Madeleine. Furthermore, even now, having seen the film many times, I am still utterly astonished when, as though by some miracle of transubstantiation, Judy emerges as Madeleine. Judy's transformation is, for me, something that is beyond imagining, and yet Hitchcock's film manages to allow that transformation to really happen, right before my eyes.

Rothman and Keane thus want to stress that Judy's transformation is exemplary of the reality of film: 'reality does not have to be imagined, or even imaginable, to be filmed'. Again this is to stress that, for Cavell, films are to be seen not as real*ist* products but rather as products of real*ity*: 'it is reality itself, not a stand-in for reality, that appears to us on film'. Scottie's transformation of Judy is thus akin to cinema's transformations of reality: the making real – or realization – of fantasies beyond our imagining. For Scottie, of course, the realization of this fantasy comes at a terrible price. But there are no guarantees when it comes to realizing our fantasies.

Some fantasies, however, are surely one worth pursuing – and Hollywood movies endlessly try to reassure us of this. For Cavell, this is the extraordinary achievement of Hollywood: that it has been able to give body and reality to the most remarkable fantasies and dreams and, furthermore, that those fantasies and dreams are often worth taking seriously. They are worth taking seriously because no other artform has managed such an endeavour. To deny the validity and seriousness of Hollywood's dreamworlds is to deny

something that, for Cavell, has been one of the great successes of the medium of film.

The first of Cavell's two books on Hollywood genres is on what he calls the 'comedies of remarriage'. The film of that genre which most clearly plays out many of the themes I have been tracing throughout this chapter is Frank Capra's seminal *It Happened One Night* (1934), the film that gives birth to the genre of remarriage comedies. Cavell's reading of the film centres on the role of the famous blanket that divides the film's yet-to-be-married couple, Peter (Clark Gable) and Ellie (Claudette Colbert), as they spend a night together in a motel. Cavell's reasons for focusing on the function of the blanket are manifold. The blanket acts as a screen which is analogous to the movie screen, but it also exemplifies the way that Peter and Ellie block themselves from each other. In other words, the blanket offers a demonstration of the way that the characters remain withdrawn into their own subjectivities, and thus screen their fantasies from each other. Therefore, when the blanket is removed, the screen's role as a realizer of fantasies reaches its destiny. Just as in cinema *per se*, for Cavell, the screen emphasizes both how we are trapped in our subjectivity and also how we might find our way out of this trap, so too does the blanket in *It Happened One Night* emphasize that Peter and Ellie are hiding behind their subjectivities while also offering them a way beyond this hiddenness. In the marriage of the couple (or remarriage, as Cavell likes to stress), their union is also evidence that they have married their fantasies with each other – each has learned to acknowledge the other's fantasies – and thus married their fantasies to the world.

One might see this as being all a bit too neat and tidy, but there are a number of exceptional moments and situations that guide Cavell's reading of *It Happened One Night*. Ellie begins the film on a hunger strike (as a protest against her father), and Cavell takes this to mean that she is starved of love. Thus he argues that 'The film can be said to be about what it is people really hunger for, or anyway about the fact that there really is something people hunger for' (1981: 95–6). Ultimately what people really hunger for is acknowledgement from others and, reciprocally, to acknowledge others. Thus, when Peter exclaims 'Boy, if I could ever find a girl who's hungry ...' one begins to sense that Ellie may be just the right kind of girl for him.

A key moment occurs when Peter, alone with Ellie, enters into one of the rhapsodical dream-statements that are characteristic of remarriage comedies. Ellie asks him if he has ever been in love, and he replies by claiming how difficult it is to find the right girl. 'Where

are you going to find her', he asks, 'somebody that's real, somebody that's alive?' After ruminating on the possibility of discovering such a girl and living happily ever after with her, he opines in a tone that suggests a mixture of hopefulness and hopelessness, 'Boy, if I could ever find a girl who's hungry for those things'. In confessing his wish to find a girl who might be able to share his dreams, he is also openly confessing those dreams to Ellie; in a sense, he is asking Ellie if she is hungry for those things. When one considers that earlier in the film, at a point of extreme hunger, Ellie had eaten a carrot she found in Peter's coat pocket, then perhaps this demonstrates that she is a woman of hunger, and that she could be hungry for 'those things' Peter suggests.

Indeed, Ellie *is* hungry for those things. Immediately following Peter's dream-statement, a speech he makes while they are separated by the blanket that screens each of them from the other, the following occurs (this is Cavell's description):

> we cut to her just coming toward him around the blanket. She pauses, holds on to the blanket's edge, and we reframe to a tighter close-up of her in soft focus, the visual field blurred as if through a mist of happiness, or a trance of it. Then she approaches his bedside, falls to her knees, throws her arms around his neck, asks him to take her with him, and declares her love for him. (Cavell 1981: 97)

Ellie declares her love for Peter, but he is dumbstruck; he dismisses her and tells her to get back to her bed. It is only now that the full weight of Ellie's declaration strikes him; he too realizes that he loves her, only he had not realized it until now. He effectively declares his love for her, only to find she has fallen asleep.

And perhaps he realizes that they had been playacting at being married all along. Ellie is the daughter of a millionaire father from whom she has run away. A wealthy and eligible daughter on the run is a big news story, especially considering that her father has offered a substantial reward for her safe return. Peter, on the other hand, is a newspaper reporter who is disillusioned with his job. When he happens to come across Ellie, he intimates that he's stumbled upon one of the biggest scoops imaginable. To turn it into a great news story, he is determined to stay with Ellie for a few days in order that he discover the real story and the real person behind the story.

Thus, when, on their first morning after having spent the night together – together, that is, while separated by the blanket-barrier – they are confronted by two detectives searching for Ellie, the couple become aware that they must immediately adopt disguises. They

thus disguise themselves as a married couple. Cavell comments that 'since in taking the cabin together they were already pretending to be man and wife ..., we might say they are giving a charade of marriage' (Cavell 1981: 86). The mode of charade they adopt is as central to remarriage comedies as it is to philosophy: 'The pair mean the charade to convince hardened, suspicious observers on the spot that they are a seasoned couple, and their knockdown proof is to bicker and scream at each other' (ibid.). Hence the humour of the scene; what it means to behave 'just like a married couple' is to bicker and argue. This proves, for Cavell, that arguments are as essential to marriage as they are to philosophy; only by way of argument and conversation can acknowledgement be achieved.

But what Ellie and Peter's charade further makes evident is that, in order to break free of their own subjectivities, to break free from the subjective barriers behind which they have remained hidden, what is required is the discovery of another subjectivity; that is, it requires pushing one's subjectivity beyond itself, 'projecting' it somewhere else. It is only by becoming something or someone else that Peter and Ellie truly begin to recognize themselves, to acknowledge each other and find their way to selfhood. As Cavell points out at the end of *Pursuits of Happiness*, remarriage 'requires a passage, as it were, from one world (of imagination) to another, as from dreaming to waking' (1981: 261–2). Going through the imaginary charade of being married is, for this couple, one step through dreaming on the way to waking.

When Ellie steps out from behind the blanket she is taking another step through dreaming towards waking. Cavell argues that 'The woman believed she was walking into the man's dream [that is why she is depicted in soft focus]. So she was, and it woke him up, or brought him to' (1981: 99). Unlike Ellie at this point of the story, Peter does not go through the dream towards waking – that is something he will not achieve until the very end of the film. Rather, his dream is interrupted when Ellie breaks through the blanket-barrier. Peter is so used to keeping his dreams to himself, in having his dreams blocked, confounded and disappointed, that he refuses to believe his dream could be married to the world in the form of Ellie. He immediately resorts to hiding himself behind the blanket-barrier, he folds back into himself, retrieves his dream back into private fantasy, to the anonymity that is a trademark of modern subjectivity.

Needless to say, the film's exuberant and triumphant ending, in which the happy couple is married (or remarried, as it were),

demonstrates that Peter was indeed able to overcome his subjec-
tivity, as Ellie had broken free of hers, and acknowledge her, as she
had acknowledged him, so that both, together, find themselves on
the way to discovering a sense of selfhood. Cavell ends his reading
of *It Happened One Night* on a philosophical note as he finally
sums up what he wants to say about the blanket-barrier-screen:

> What it censors is the man's knowledge of the human being 'on
> the other side'. The picture is that the existence of other minds is
> something of which we are unconscious, a piece of knowledge we
> repress, about which we draw a blank. This does violence to others,
> it separates their bodies from their souls, makes monsters of them;
> and presumably we do it because we feel that others are doing this
> violence to us. The release from this circle of vengeance is something I
> call acknowledgment. (1981: 109)

Peter does eventually manage to release himself from this 'circle
of vengeance'; he discovers that his dream of Ellie, the dream that
Ellie steps into, is also her reality, that she is in fact the incarna-
tion, in flesh and blood, of his dream; she is 'somebody that's real,
somebody that's alive'. But this too is the reality of films for Cavell:
that they make real the possibility that dreams can be married to
reality; that fantasy and reality need not inhabit distinct domains.
Such is the reality of film for Cavell:

> It is a poor idea of fantasy which takes it to be a world apart from
> reality, a world clearly showing its unreality. Fantasy is precisely what
> reality can be confused with. It is through fantasy that our conviction
> of the worth of reality is established; to forgo our fantasies would be
> to forgo our touch with the world. (Cavell 1979: 85)

I might even be tempted to go so far as to say that film is one of
the modes of fantasy that can reveal to us the worth of reality: the
reality of film is that it presents us with worlds that make reality
itself worthwhile. And yes, that fantasy and that film are what
reality can be confused with, but out of that confusion a world
itself is formed. For Cavell to have made such claims sets him at a
great distance from the discourse of political modernism and the
majority of discourses by means of which film studies has primarily
defined itself. But Cavell's claims are a defence of the reality of film,
a defence of the kinds of fantasies which constitute that reality as
much as any fantasy contributes to what it is that we call 'reality'.
Cavell is one of the most important theorists of the reality of film.

5 Cinema produces reality

7 Cinema produces reality: David Hemmings in *Blow Up*
(Michelangelo Antonioni, 1966)

Interpretations of Gilles Deleuze's books on cinema have tended to concentrate on his distinction between the movement-image and the time-image. In focusing on this distinction, authors have also tended to accentuate the virtues of the time-image while denigrating the shortcomings of the movement-image: the movement-image is the relic of a past mode of cinema that has been surpassed by the superior mode of the time-image (see, for example, Rodowick 1997; Olkowski 1999; Martin-Jones 2006). Commentators have done this even in the face of Deleuze's explicit statement, in the Preface to the English translation of *Cinema 1*, that the establishment of such hierarchies was not at all his concern:

It is not a matter of saying that the modern cinema of the time-image is 'more valuable' than the classical cinema of the movement-image. We are talking only of masterpieces to which no hierarchy of value applies. The cinema is always as perfect as it can be, taking into account the images and signs which it invents and which it has at its disposal. (Deleuze 1986: x)

Deleuze's study of cinema is thus one that avoids establishing hierarchies of value. Rather, his aim is to specify precisely what it is that films do, to identify and classify the perceptions and meanings films produce, their images and signs. While I think it is important to consider Deleuze's notion of the time-image as an extraordinary contribution to understanding the nature and possibilities of the cinematic medium, the movement-image is no less extraordinary. In many ways, it is via the movement-image that Deleuze puts forward a general theory of cinema, and it is only on the basis of having established the notion of the movement-image that the time-image then becomes possible. (The most sustained defence of Deleuze's notion of the movement-image is provided by Paola Marrati (2008).)

My argument in this chapter therefore has little to do with affirming the richness of the time-image against the poverty of the movement-image. Rather, I want to identify something more fundamental in Deleuze's approach to cinema. This chapter therefore has a number of aims. First of all, after examining the ambiguous nature of Deleuze's use of the terms 'real' and 'reality', I reconstruct and defend Deleuze's theses on the nature of the movement-image. At the end of the chapter, I make some tentative remarks on the importance of the time-image's relation to the movement-image. Throughout the chapter I remain focused on avoiding the kind of hierarchical judgement which automatically assumes the superiority of the time-image over the movement-image. Contrary to such judgement, which seems to assert that the time-image 'better' while the movement-image is 'worse,' I assert that both types of images are neither better nor worse, but real.

I think it is worthwhile figuring out how Deleuze fits with the other film scholars discussed in this book. Often the task of an academic work is to pit one thinker against others, and by and large this has been true of studies of Deleuze: to demonstrate how Deleuze's approach is superior to other approaches. It is even true of Deleuze himself, for he explicitly positions his arguments against those of Bazin and Metz, for example. To pit the superiority of one conception of film over others is not the aim of the present book, however. Rather, I am examining the ways in which a number of

theorists offer a perspective on film I have called 'filmic reality'. All the same, Deleuze's criticism that Bazin remains too dependent on reality must certainly raise questions for my own argument, for my claim is that both of these writers are theorists of the 'reality' of film. In what ways, then, can Deleuze be defended as a theorist of filmic reality in a manner that can be distinguished from, but also related to Bazin's notion of filmic reality?

A similar question necessarily emerges for Metz. Deleuze is quite dismissive of Metz's reliance on linguistics and semiology for, according to Deleuze's argument, the cinema has nothing to do with models of meaning derived from language. Rather, cinema's signs are specific to cinema, and most of Deleuze's cinema project is devoted to charting the nature of cinematic signs in ways that are explicitly opposed to linguistic formulations. Again, therefore, if I am to defend both Metz and Deleuze as theorists of filmic reality, in what ways can Deleuze be defended as a theorist of filmic reality in a manner that can be distinguished from, but also related to Metz's notion of filmic reality?

The convergence or divergence between Cavell's and Deleuze's approaches to the cinema is somewhat more complex, for each emerges from a different tradition and, to some extent, each pursues his enquiry in a different way. But a similar question still holds: can Deleuze be defended as a theorist of filmic reality in a manner that can be distinguished from, but also related to Cavell's notion of filmic reality?[43]

With these questions in mind, I think it is probably time to sketch some of the major differences between the ways in which the authors discussed in this book approach the notion of filmic reality. In the most straightforward terms, the theories can be divided in the following way:

- For Bazin, filmic reality means ways of *socially* defining what reality has the possibility to be.
- For Metz, filmic reality means ways of *imaginarily* defining what reality has the possibility to be.
- For Cavell, filmic reality means ways of defining *in fantasy* what reality has the possibility to be.
- For Deleuze, filmic reality means ways of *perceptually* defining what reality has the possibility to be.

The central concept of this chapter might therefore be said to be cinematic perception. Deleuze's concern in the cinema books is to map out several of the ways in which we perceive films. But

his aim is also slightly more complicated than this. In addition to considering how human beings might perceive cinematic images and signs he is also interested in trying to discern how the cinema itself perceives. How does cinema perceive? How do films see and hear in ways that might be similar to, or which might diverge from the ways that humans perceive? Therefore, this chapter focuses on one overarching concern: What is the difference between the reality we naturally perceive and the reality we perceive on film? In other words, what is the difference between natural perception and what Deleuze refers to as 'cinematographic perception'?

Traditionally, natural perception is what is taken to be real – we perceive reality – whereas what is presented to us on screen is taken to be a degradation of reality, a copy, representation or reproduction. We have come across this conception time and time again throughout this book under the guise of 'political modernism': in the cinema we do not perceive reality, we perceive representations, constructions, fabrications. Deleuze utterly dismisses such conceptions. For him, natural perception constructs reality in much the same way as cinematographic perception does, so why would cinematic reality be any less real than reality itself? Deleuze argues that the cinema creates or synthesizes reality in much the same way as our own faculties create or synthesize reality and, as such, the cinema may even be seen as a prime example of the way that perception itself works. Therefore, the reality we perceive in the cinema is perceived in much the same way as the reality we naturally perceive. In fact, Deleuze's position is even more audacious: he claims that the cinema demonstrates a superior perception; the perceptions that the film camera-projector provides for us are more accomplished than our own, human, capacities for perception. Deleuze writes that cinematic consciousness can provide realities that are beyond a merely human reality, for cinema consciousness is 'the camera, now human, now inhuman, or super-human' (Deleuze 1986: 20).

Real, unreal, imaginary

The point from which I will set out is that of a remark made by Deleuze, in what is surely a reference to Metz's notion of the 'imaginary signifier', in a short interview on the time-image. There he states that 'It's questionable whether the notion of "the imaginary" ... has any bearing on cinema; cinema produces reality' (Deleuze 1995b: 58). Deleuze's statement immediately introduces a few terms that cannot fail to cause difficulty. What, in the first place, does he mean

by 'the imaginary', and second, what does he mean by 'reality'? And third, what can it mean to claim that cinema *produces* reality? The concept of the imaginary may be one that has been somewhat over-theorized in film theory, but I think what Deleuze means by it here is actually quite straightforward. He merely means that the cinema does not produce imaginary things; it does not produce fantasies or illusions. Rather, what the cinema produces is undeniably real. I could be tempted to reiterate here many of the arguments that have dominated this book: the cinema is not a secondary being, it is not a representation, a copy or illusion. On the contrary, films are primary beings. But that is not the whole story.

In another short article in which he questions the status of 'the imaginary' in theories of cinema, Deleuze goes to great lengths to explain the relation between the imaginary and the real:

> There's actually a real philosophical problem here: is 'the imaginary' a good concept? We might begin with the terms *real* and *unreal* …: reality as connection according to laws, the ongoing linkage of actualities, and unreality as what appears suddenly and discontinu-ously to consciousness, a virtuality in the process of becoming actual-ized. Then there's another pair of terms, *true* and *false*. The real and the unreal are always distinct, but the distinction between them isn't always discernible: you get falsity when the distinction between real and unreal becomes indiscernible. But then, where there's falsity, truth itself becomes undecidable. (Deleuze 1995a: 65)

Again here Deleuze introduces a baffling number of terms: imagi-nary, real, unreal, true, false, actual, virtual. All of these are central to Deleuze's theorization of film, especially to his notion of the time-image. But unlike the example previously cited in which the imaginary was contrasted with reality, here, what Deleuze calls the real is instead contrasted with the unreal. Instead of an opposition between the real and the imaginary, he now presents an opposition between the real and the unreal.

Then finally, in the same article, Deleuze reintroduces the concept of the imaginary: 'The imaginary isn't the unreal; it's the indiscern-ibility of real and unreal' (Deleuze 1995a: 67). Here, the real is opposed neither to the unreal nor to the imaginary, but is posited as one side of a duality of indiscernibility, an indiscernibility which is now designated as imaginary. I think readers have every right to be confused here: Is reality to be contrasted with the imaginary, or is it to be distinguished from unreality? Is the imaginary the same thing as unreality, or is the imaginary something that signifies the indistinguishability of the real and the unreal? And even if all these

terms can be clarified, what can be made of Deleuze's claim that 'cinema produces reality'?

There is only one way out of this confusion: Deleuze is writing about two different things. In the first example, when he declares that 'cinema produces reality', he is referring to the cinema in its entirety: *all films produce reality*. This position is fundamental for Deleuze: cinema images are not culturally constructed in the same way that languages are, cinema images are reality. As one commentator has argued, 'The question of "reality" in the cinema is usually deferred in favor of examinations of the inevitable cultural constructedness of cinematic images' (Beasley-Murray 1997: 37), an argument that remains constant in film studies as we have seen throughout this book. But Deleuze, against such deferrals, tackles the question of cinema's reality. Cinema does not produce things that are imaginary, it produces reality.

In the second example, when Deleuze declares that the imaginary is the indiscernibility of real and unreal, he is referring to the specific mode of cinema designated as the time-image. With the emergence of the time-image, real and unreal are no longer subject to the same divisions as they were for the movement-image. But the divisions or lack of divisions a film makes between reality and unreality does not in any way reduce the reality of a film itself.

It is the break between the movement-image and time-image which makes Deleuze's jumbling up of terms more than a little confusing. The difficulty arises because the films of the movement-image *do* posit distinctions between the real and the unreal, whereas those of the time-image do not. The cinema of the time-image gives rise to a real and an unreal that can no longer be clearly separated, whereas the cinema of the movement-image does posit a real that is set against an unreal. The movement-image, which Deleuze also describes as an 'organic' regime, thus functions in the following way: 'In an organic description, the real that is assumed is recognizable ... It is clear that this system includes the unreal ... but as contrast' (Deleuze 1989: 126–7). Thus, Deleuze argues that films of the movement-image make clear distinctions between the real and the unreal. With the time-image, however, the straightforwardness of this contrast breaks down. 'The two modes of existence [i.e., the real and the unreal] are now combined in a circuit where the real and the imaginary, the actual and the virtual, chase after each other, exchange their roles and become indiscernible' (Deleuze 1989: 127). In films of the time-image, there are no longer clear distinctions between what is real and what is unreal. In this sense it can be

argued that the films of the movement-image produce realities that are clearly distinguished from unrealities, whereas, on the contrary, films of the time-image produce indiscernibilities between reality and unreality.

To claim therefore, that some films, in their form or content, make distinctions between reality and unreality is to make a claim about the different kinds of possibilities one finds in different kinds of films. On the other hand, to say that *all films produce realities* is to make an ontological claim about cinema as such. When Deleuze claims that 'cinema produces reality' this is a completely different thing from declaring that the movement-image produces contrasts between reality and unreality. Cinema produces a host of different kinds of realities, such that the realities produced by the movement-image posit a distinction between reality and unreality, while the realities produced by the time-image are ones that posit an indiscernibility between reality and unreality. Needless to say, both regimes of the image produce reality, while the main difference between them is that they produce different types of reality.

Some examples should make this point clear. Frank Capra's *Mr Smith Goes to Washington* (1939), as an example of the movement-image, posits a true love between Jefferson Smith (James Stewart) and Clarissa Saunders (Jean Arthur), while clearly demonstrating to us the falsity of the passion between Smith and Susan Paine (Astryd Allwyn), the senator's daughter. Smith's love for Clarissa is thus 'real' while his affections for the senator's daughter eventuate as 'unreal'. The true and the false, the real and the unreal are clear-cut and *Mr Smith* is, on these grounds, an example of the movement-image. Alain Resnais's *Muriel, ou Le Temps d'un retour* (1963), on the contrary, makes it impossible to tell whether Hélène's love for Alphonse is real or unreal, true or untrue. Does Hélène love Alphonse? Does Alphonse love Hélène? Or does he love Françoise, the younger woman whom he tries to pass off as his niece? Or does he in fact love Simone, from whom he has supposedly fled and whose brother, Ernest, has now come to track him down? Did Hélène once love Alphonse in a past she cannot forget? Or was it in fact Ernest who had tried to meet up with her at the café all those years ago? Or might it be that she in fact loves Roland (the property developer)? In whatever ways love is rendered problematic in *Muriel*, the impossibility of discovering a distinction between real and unreal love delivers an example of the time-image: the distinction between real and the unreal becomes indiscernible. All the same, both of these films produce 'reality'. Smith certainly posits

a clear distinction between a real love and an unreal one, but that is the reality it is proclaiming: some loves are real, some are not. At some points in history such a proclamation could certainly bear the burden of reality. *Muriel*, on the contrary, tries to make a different point: it declares that it is very difficult to discern the difference between a love that is real and one that is unreal, one that is present and one that is past. *Muriel* posits a world and a different point in history in which the rules of love have changed. The reality of *Smith* is that it posits a distinction between real and unreal; the reality of *Muriel* is that of an indiscernibility between real and unreal. What is real and what is reality thus unfold on two distinct levels; all films produce reality, but only some posit a real which is opposed to the unreal.

Movement

For the remainder of this chapter, I discuss the movement-image, a Deleuzian concept that is far from being simple, fixed, straight-forward or even linear or rational. I have already argued that the movement-image provides a reality in which the real is clearly separated from the unreal. But it is on the basis of the movement-image that Deleuze's cinematic semiotics is constructed. Therefore, I want to examine more closely the make-up of the movement-image with the particular aim of designating its processes of producing reality. It is, after all, only on the basis of first of all establishing that 'cinema produces reality' that Deleuze's account of cinema is constructed.

The realities of which films are capable are derived, according to Deleuze, from the nature of movement. Deleuze's understanding of movement is itself derived from the philosophy of Henri Bergson. In his Preface to the French edition of *Cinema 1*, Deleuze sums up what is most fundamental to Bergson's account of movement. His discovery was that 'Movement, as physical reality in the external world, and the image, as psychic reality of consciousness, could no longer be opposed' (Deleuze 1986: xiv). Such is the great discovery of *Matter and Memory*: movement as matter can no longer be opposed to consciousness as memory; the physical world cannot be opposed to the psychical one; and the external world cannot be opposed to an internal one (see Bergson 1996). Ultimately, the image, so far as Bergson conceives it, cannot be opposed to physical reality. There are no images *of* reality: images *are* reality. Ronald Bogue has emphasized these points in his discussion of Deleuze's

theory of film: 'There is no divide between an external, expanded material world and an internal, unextended mental reality, no split between *being* and *being perceived*' (Bogue 2003: 32).

These are devastating and contentious claims to make, for we are accustomed to thinking of the world in terms of an opposition between its objective reality and our subjective views of that reality. In other words, the reality of the world is distinguished from and opposed to the images we subjectively have of it. The representation of the world that is 'in our minds' is supposed to be fundamentally different from the world that is 'out there' – this is how we commonly conceive of reality. Bergson, for his part, wants none of this. Rather, he wants to argue that the images we have of reality *are* that reality. Deleuze defends Bergson's claim in an unambiguous fashion. At one point, for example he claims that 'an image does not represent some prior reality; it has its own reality' (Deleuze 2006a: 215).

It will take some effort to disentangle the implications of this position, so first of all it will be necessary to lay down some points of reference. Deleuze begins the cinema books with an account of Bergson's theses on movement. The first of these is the most fundamental, but it is also the most important: 'Movement is distinct from the space covered' (Deleuze 1986: 1). Bergson is adamant that movement is not something that can be measured. Movement is something that happens, a process, and it can be fast or slow, intense or relaxed. But it is not something that can be measured in terms of space (distance covered) or time (time elapsed). Thus if I say, 'It takes ten seconds to move from A to B', or 'it takes thirty metres to move from A to B', then I am not considering movement *per se*. Rather, I am creating measurements of distance. In creating such measurements, I am measuring both time and space wherein a movement is calculated as 'thirty metres' or 'ten seconds'.

In fact, Bergson contends that any notion of time as a measurement avoids what is essential to time. Unlike time, space can be measured, because it is immobile. Space can be defined in terms of its ability to be measured: distance, area, volume. But any measurement of time, for Bergson, is merely arbitrary and abstract. To break up time into measurable bits – e.g., ten seconds – is to conceive of time as though it were the same kind of thing as space – e.g., ten seconds = thirty metres. One of Bergson's primary philosophical beliefs is that time cannot be measured. Time, like movement, is something that happens; it is a process, a flow.

Any-instant-whatevers

All of this is necessary for understanding Bergson's second thesis on movement: movement is made up of instants, of what Deleuze calls immobile sections or 'any-instant-whatevers' (*instants quelconques*). Movement is composed of instants; surely this must be a difficult position to defend? Bergson has just claimed that what is essential to movement is that it moves, whereas now he is claiming that movement is made up of series of fixed instants – snapshots, immobile sections. Bergson, nevertheless, according to Deleuze's argument, sees something to be gained from conceiving of movement in terms of time, and thus, to claim that 'it takes ten seconds to get from A to B' may ultimately be of some value.

For Bergson, to begin to consider movement as movement, one cannot merely focus on the points A and B. Such points are only privileged instants and, as such, they break up the reality of movement into abstract points. On the other hand, if one begins to conceive of the movement from A to B in terms of its constitutent parts, then one is beginning to think of this process as one that is genuinely in motion. Instead of conceiving of the movement from A to B in terms of the privileged instants, A and B, one can conceive of it in terms of a series of equidistant steps from A to B: A, A', A'', A''', etc … B. If one does this, then the movement from A to B is mapped as a series of 'any-instant-whatevers', instants that are generalized equivalent points rather than privileged ones. By doing this, one gets closer to accurately charting what a movement is.

Cinema, quite obviously, exemplifies this view of movement. And this certainly goes a long way towards explaining Deleuze's reasoning here. In a film, a series of equidistant instants – film frames – are linked together to form a flow of movement. Deleuze thus writes that 'It is in this sense that the cinema is the system which reproduces movement as a function of any-instant-whatever that is, as a function of equidistant instants, selected so as to create an impression of continuity' (Deleuze 1986: 5). And yet, this leads Deleuze to another point: the instants of which movement is composed are not instantaneous in the sense of being fixed or frozen. The privileged instants of A and B, if considered in isolation, are frozen, but the any-instant-whatevers that link them (A, A', A'', A'''...) are instants that are in movement. Deleuze tries to explain this in terms of cinema, this time with reference to animation. 'This is clear', he writes,

> when one attempts to define the cartoon film; if it belongs fully to the cinema, this is because the drawing no longer constitutes a pose or a completed figure, but the description of a figure which is always in the process of being formed or dissolving through the movement of lines and points taken at any-instant-whatevers of their course. (Deleuze 1986: 5)

From this perspective, the cels of animation or the frames of live action cinema are not fixed snapshots, but are rather snapshots in movement, moments which are in transition from that which came before and that which will follow.

This explanation may be all well and good so far as the cinema is concerned, for films really are broken up into equidistant frames – twenty-four frames per second. But the reality of real movement is surely nothing like this, for I do not perceive reality as a series of frames per second. And this is probably the most contentious of Deleuze's interpretations of Bergson, for Bergson explicitly criticized what he called the cinematographic approach to reality. This cinematographic approach to reality, Bergson argued, is one that divides reality into a series of abstract instants and results in what he derides as the 'cinematographic illusion' (see Bergson 1911: 296–402). Deleuze, however, is adamant that Bergson has misunderstood the implications of his own theory, and there is a very simple reason why this is so. The reason is that when we go to the movies to see a film what we in fact see is movement. Even though technically or scientifically we know the images being projected before us are snapshots unfolding at twenty-four frames per second, that is not what we see. What we see are not snapshots or immobile sections. Rather, what we see is movement itself, what Deleuze calls mobile sections. And this, for Deleuze, is the true destiny of Bergson's argument: 'In fact, says Bergson, when the cinema reconstitutes movement with mobile sections, it is merely doing … what natural perception does' (Deleuze 1986: 1–2). In other words, the cinematographic mechanism is really just doing what natural perception does anyway.

D.N. Rodowick, in his exposition of the *Cinema* books, tries to figure out Deleuze's argument here. He writes that 'The apprehension of reality requires an interior "*cinematographe*": a selective sampling and organization, a series of snapshots preserving only those features relevant for our immediate needs whose inherent discontinuity is mentally suppressed' (Rodowick 1997: 22). Indeed, Rodowick goes so far as to claim that Deleuze's position hinges on the belief that 'the actual cinematographic apparatus is better than

the one turning inside our heads' (ibid.). The implication of this position is that the cinematographic apparatus provides us with a way of understanding how natural perception functions.

A crucial point in Deleuze's exposition of the image in cinema has been reached. What, if anything, is the difference between the image as it applies to cinema and the image as it applies to the perception of reality? If cinema images are broken down into a series of snapshots, of any-instant-whatevers, then does the same process of breaking up apply for reality itself? If the world is conceived of as being broken up into a number of any-instant-whatevers, then is not this an illusory abstraction, whether one applies it to cinema or to reality? Deleuze tries to tackle this problem when he asks, 'Does this mean that for Bergson the cinema is only the projection, the reproduction of a constant, universal illusion?' His answer is a long one:

> [I]s not the reproduction of the illusion in a certain sense also its correction? Can we conclude that the result is artificial because the means are artificial? Cinema proceeds with photogrammes – that is, with immobile sections – twenty-four images per second (or eighteen at the outset). But it has often been noted that what it gives us is not the photogramme: it is an intermediate image, to which movement is not appended or added; the movement on the contrary belongs to the intermediate image as its immediate given. It might be said that the position of natural perception is the same. But there the illusion is corrected 'above' perception by the conditions that make perception possible in the subject. In the cinema, however, it is corrected at the same time as the image appears for a spectator without conditions. (Deleuze 1986: 2)

Deleuze makes a series of claims here on the relation between cinematic perception and natural perception, not all of which are self-evident. First, he agrees with Bergson that the fragmenting of reality into snapshots or immobile sections is indeed an illusion. But he further argues that this illusion is necessary: only by in some way simplifying the constant stream of sense-perceptions can reality be presented to us in such a way as to be capable of being perceived. This point is perhaps even more Kantian than Bergsonian, for Deleuze is claiming that there are certain 'conditions which make perception possible in the subject' (Kant would call such conditions 'schemas'). Those conditions are ones of, in the first instance, selecting and preliminarily organizing our sense-perceptions so as to make it possible for us to synthesize those perceptions. Such a selecting and organizing is strictly speaking artificial or illusory,

but the artefacts created by this process are then 'corrected', claims Deleuze, by way of the faculties that are 'above' perception – to invoke Kant again, the Understanding is the cognitive faculty that 'corrects' or makes sense out of perceptions.

If Bergson's approach is considered in this Kantian way, it is possible to concentrate more clearly on the limitations of perception. We cannot and do not perceive everything (dogs, for example, can perceive sounds of higher frequencies than can humans), and what would it mean anyway to perceive everything? Rather, we perceive what concerns us, what is important to us. Perception is a matter of refining that which is given to the senses, of selecting and organizing (as Rodowick puts it). As Deleuze claims when discussing his notion of the perception-image, perception functions according to the following rule: 'We perceive the thing, minus that which does not interest us as a function of our needs' (Deleuze 1986: 63). Perception thus subtracts from the chaotic manifold of sense-perceptions so as to provide us with perceptions that we can do something with; in other words, it provides us with perceptions that we have the potential to make sense of.

Bergson and Deleuze certainly make their points in different ways from Kant, but the result is much the same: our perceptions of reality are limited, but at the same time those perceptions provide us with access to the only reality we are capable of experiencing. Bogue has again succinctly characterized the way Deleuze unfolds this problematic:

> [W]e may say that an object ... emits light and that some rays pass through unnoticed, while others are reflected back onto the object. Our representation of that object consists of the light rays we ignore or do not reflect, that is, the object's total number of rays minus the rays we ignore or do not reflect. An organ of perception functions as the mirror that reflects the rays that interest us and that serve our future actions. (Bogue 2003: 31)

The light rays we reflect are the rays that are significant for us in some way, and these are the ones we subtract from the infinite manifold of light rays in order that we can derive a little bit of order out of chaos.[44]

And is this not also what the cinema does? The camera selects and organizes, it 'cuts out' or subtracts slices of perception from the world. Consider the magnificent opening shot of *The Conversation* (Francis Ford Coppola, 1974): what is initially a vast, panoramic point of view with no centre of interest slowly condenses into a few selected and organized objects, to finally land on the figure of

the film's hero, Harry Caul (Gene Hackman). The film can accomplish these feats of floating and zooming and picking things out in ways that are similar to human perception. But the cinema also has the ability to take us beyond what is possible for 'ordinary' human perception. What this scene from *The Conversation* does – and the same might be said of any scene in any film – is to make us perceive what the film perceives, unencumbered by the limitations of 'ordinary' human perception. I think what Deleuze wants to say, even if he does not quite say it explicitly, it that a film allows us, as viewers, to perceive what the film itself perceives. Our eyes and ears themselves become filmic, 'now human, now inhuman or superhuman' (Deleuze 1986: 20).

From another perspective, Antonioni's *Blow Up* (1966) also offers an example of this perceptual selectivity. The film's main protagonist, Thomas (David Hemmings), takes a snapshot of reality, and this one particular snapshot appears to provide evidence of a crime. Once all of the surrounding data is removed from the scene, this snapshot, an immobile section, allows the significance of this reality to shine through. The protagonist even begins to make this snapshot properly cinematic: by way of a series of 'blow ups' in which the snapshot is further and further enlarged, there is created a series of equidistant frames, of any-instant-whatevers. Nevertheless, one of the film's great ironies is that the hero of the film lacks the mechanism by which these any-instant-whatevers can be made properly cinematic; they remain as immobile sections rather than mobile ones. As a result, the images cannot be endowed with perceptual reality, for they have been deprived of movement: they are not movement-images. The snapshot, therefore, does not provide reality; it provides only its arrested illusion. The frame's denial of movement is simultaneously a denial of its reality: the crime remains unsolved to the point where it can no longer even be said to exist. *Blow Up* might be considered an exemplarily Bergsonian film.

Thus, perception does not take place at the level of immobile sections. The reduction of sense perceptions to the level of immobile sections, like the reduction of cinema's images to individual frames, provides us with a level where the perceptual field is simplified for us to the degree where they become capable of being perceived. But where perception as such occurs is when these immobile sections are synthesized above perception, as Deleuze contends, so that they become mobile. And this is precisely what the cinematographic apparatus does: by synthesizing the any-instant-whatevers, a movement-image is produced.

The brain is the screen

All of this leads me to the point of re-asking one of my original questions: What is the difference between the reality we naturally perceive and the reality we perceive on film? Deleuze writes that, for natural perception, the illusions of any-instant-whatevers are synthesized above perception so that we can make sense of the things we perceive. For the cinema, on the contrary, the synthesis of any-instant-whatevers is built into the mechanism. As humans, we have to add the focusing, selecting and editing procedures to our perceptions to make reality perceptible, whereas all of these techniques are already there in the cinema.

Deleuze's position is certainly a contentious one and it is not without substantial ambiguities. First of all, it is clear that his position diverges significantly from phenomenological approaches to the image. D.N. Rodowick has emphasized this point: 'Because of the mobility of point of view – an eye distinct from any weighted body – the cinema breaks with the conditions for "natural" perception upon which phenomenology is based' (Rodowick 1997: 22). Rodowick is correct to point out that both Deleuze's and Bergson's approaches to perception are based on the capacities of an already mobile subject and not a subject that is stable or fixed, the latter being associated with a phenomenological perspective. One can thus certainly claim that the model of perception informing the *Cinema* books is non-phenomenological, but still the question of the relation between natural and cinematic perception has not been clarified. Rodowick persists by claiming that 'it is certainly false to suggest that there is no cognitive correction for movement in the perception of cinematic images. But it would be equally false', he continues, 'to conclude against Deleuze that cinematic perception and quotidian perception are therefore equivalent' (ibid.).

In raising these issues, Rodowick prises open a very fuzzy area of Deleuze's cinematic philosophy. Does not Deleuze claim at one point that 'It might be said that the position of natural perception is the same [as that of cinematic perception]' (Deleuze 1986: 2), so why is Rodowick against the suggestion of their equivalence? Perhaps another question needs to be asked: when Deleuze writes of 'cinematographic perception' does he mean the perceptions that *we* – as an audience of spectators – experience while at the cinema, or is he referring to the perceptible data that are provided by the cinema, by the 'camera eye', as it were? In other words, is cinematographic perception what we see (and hear) when we go

to the movies, or what the *film itself* sees (and hears) by way of its own camera eye (and ear)? If it is the former – what *we* see – then surely, as Rodowick argues, the spectator's eye must provide some correction 'above' sense-perception in order to be able to perceive cinematic images. But if it is the latter, if cinematographic perception is what the film-camera-apparatus perceives (what it makes perceptible) then the correction is indeed built into the apparatus.

This point is essential for Deleuze's approach to cinema: he makes no distinction between *what a spectator perceives* in a film and *what the film presents*. Rather, the cinema is a symbiotic conglomeration of spectator and screen. For Deleuze there is no division between a spectator and a screen, for the spectator is fused with the screen in such a way as to be indistinguishable from it. To this degree, the cinematic situation in which a viewer watches images and sounds projected on a screen is a combination of spectator and apparatus in which no neat distinction between spectator and screen can be made.[45] As Deleuze obliquely puts it at another point, 'the brain is the screen' (Deleuze 2006b).[46]

If Deleuze's conception of the movement-image is to remain consistent, derived as it is from Bergson's notion of the image, then the spectator can be conceived in no other way. As Deleuze explains, Bergson's understanding of consciousness is radically different from that of phenomenology. For phenomenology, 'consciousness is consciousness *of* something', whereas for Bergson, 'consciousness *is* something' (see Rodowick 1997: 32). Thus, phenomenology proposes an anchoring of the subject of perception. Such a subject is one that is placed above or outside what it perceives in so far as this subject attempts to obtain an objective perception of that which it surveys. In this way, this phenomenological subject, clearly separated as it is from that which it perceives, will be able to form a 'consciousness of ...' what it perceives, so that these perceptions become possessions of the subject. As Rodowick argues, 'If consciousness is consciousness *of* something, then it must be considered an intentionality that projects an illuminating beam of light into the world' (1997: 32).

Against this phenomenological conception, Bergson proposes something very different: that consciousness and things are similar substances; that consciousness *is* something. Against the phenomenological account, matter is not deposited as a copy or representation of itself into the mind's eye. Rather, the mind's eye is intrinsically part of that which it perceives. It is the act or action of my perception that makes matter available for me, and recipro-

cally the action of matter upon my perceptual faculties that initiates perception. There is not *my perception of an object* on the one hand and *the object* on the other; rather, the object *is* my consciousness. Just as my relation to the object is formed by the implantations of my consciousness, so too is my consciousness reciprocally formed by the implantations of the object. As Bogue puts it, 'Visual perception, then, is truly *in* things, both in the sense that perception takes place at the perceived object and that the perceiver itself is an emergent configuration of light'. Bogue adds to this Deleuze's claim that 'the eye is in things, in the luminous images themselves' (Bogue 2003: 34; Deleuze 1986: 60).

Likewise, for Deleuze, there is no spectatorship *of* a film, no spectator situated outside the film. Rather, the film is itself the process of the spectator's watching it; the film does not exist independently of the effects it has on the spectator: for a film is a combination of subject and screen; a subject created by the screen and a reciprocal screen created by the spectator subject. The spectator in the cinema functions in precisely the same way as does the subject in reality: there is no split between being and being perceived.

And yet, there is still one more point: the perceptions produced by the film-camera are the kinds of perceptions to which ordinary perception can aspire. In this sense, cinematic perception is indeed better than ordinary perception. To reiterate Rodowick's claim: 'the actual cinematographic apparatus is better than the one turning inside our heads' (1997: 22). Deleuze himself is even more emphatic on this point, for he describes the cinema as not merely 'the perfected apparatus of the oldest illusion, but, on the contrary, the organ for perfecting the new reality' (Deleuze 1986: 8).

From these statements only one conclusion can be drawn: cinematic perception and quotidian perception function in precisely the same way, only cinematic perception achieves more effectively that to which ordinary perception aspires. This may be Deleuze's fundamental thesis on the nature of the relation between natural perception and cinematic perception: cinematic perception demonstrates how natural perception works, only it does so more effectively. Cinema shows us the humans we can become; it is 'the organ for perfecting a new reality'.

What, finally, can be made of Bergson's second thesis on movement, of his notion that reality is composed of any-instant-whatevers that are synthesized by perception in such a way as to always be in movement (they are 'immobile sections of movement', as Deleuze refers to them at one point; 1986: 11)? This thesis

reveals the extraordinary nature of Bergson's philosophy and of Deleuze's appropriation of it. It effectively declares that the only reality available to us is the reality that is synthesized by our perceptions. One may wish to call this empiricism or to emphasize the *a posteriori* nature of this reality. Any reality posited beyond this perceivable reality is mere illusion, the illusion characterized by Bergson and Deleuze as 'immobile sections + abstract time', the illusion of a reality from which movement is extracted so that the world is frozen, embalmed, abstracted. The reality we experience is the reality that is made available to our perceptions.

It is in this fundamental sense that Deleuze's claim that 'cinema produces reality' can be understood: that which is perceived in cinema is not something that can broken down into a beyond that resides outside the perceptible matter of the film itself. We cannot know the truth of a film, for example, by breaking that film down into its separate frames (and Deleuze famously declined to include film stills in the *Cinema* books). In this way Deleuze comes very close to affirming Stanley Cavell's claim that all you need in order to know, understand and experience a film is 'right there in front of your eyes' – it is not outside, behind, underneath or beyond that which one sees on the screen.

But Deleuze's position also crucially counters any suggestion that cinema's role is to *represent* the real. Rather, the cinema synthesizes fragments of matter in such a way as to endow them with reality. Deleuze's position calls into question the notion that there is a 'real reality' that is objectively out there which can be opposed to a secondary or unreal reality which is provided by films. All films produce reality; they do not produce unreality or things that are imaginary, false or illusory.

It is in this way that Deleuze's approach to cinema is indebted to Bergson, for just as Bergson declared that, for him, physical and psychical reality could no longer be opposed, so too for Deleuze, in the cinema, filmic reality and objective reality can no longer be opposed. There is no beyond of filmic reality that is hidden from it, and reading or watching films is not a matter of decoding its symbols in order that a truer reality be uncovered (a reality that is more real than the film itself). Any such readings would be akin to freezing the movement of the world or of cinema so that these frozen moments can be analysed in terms of immobile sections, a series of ideal poses. It is any wonder, therefore, that Deleuze was critical of linguistic approaches to film?

Bergson's third thesis on movement and the time-image

Bergson's third thesis on movement, in so far as it is interpreted by Deleuze, is the one that most clearly characterizes the movement-image as a regime that can be differentiated from the time-image. The thesis is that *movement consists of a change in duration*. This is another way of saying that movement occurs through time; moving takes time and cannot exist without duration. Yet, according to Deleuze's well-known argument, when this thesis is applied to the movement-image, movement as change in duration delivers only an indirect image of time. The image of time is here indirect because, for the movement-image, duration is determined by and subordinated to movement. For the time-image, on the other hand, duration gains the upper hand: time is imaged directly in so far as it is no longer subordinated to movement. Bergson's third thesis is thus the crucial one for differentiating the movement-image from the time-image.

As I have already argued at length, a major distinction between the movement-image and the time-image is that the former makes clear distinctions between the real and the unreal, while the latter asserts an indiscernibility between real and unreal. But this in no way alters the fact that both regimes of the image produce realities (as I have already claimed). The difference between the two regimes is not a matter of declaring that one is more real than the other, or that one is better than the other. Rather, the two regimes define the different ways in which film images have functioned during the short history of the cinema (at least, that history up until Deleuze's books were written).

Finally, I want to choose two brief examples to clarify the distinction between the movement-image and the time-image. The movement-image presents a whole that is ordered, one in which 'everything is in its place'. The objects which the movement-image shows are certainly open to duration (this is Bergson's third thesis), but only in so far as that duration is subjected to movement, and, thus, to a determination of a temporality in which the past contributes to present events in such a way as to ensure that the past is definitively tucked away as 'past'. This can be very simply conceived by way of Hollywood's most enduring narrative techniques: the use of deadlines. Everything is designed so that time is an achievement that is accomplished by movement (by 'action'); time is regulated by its capacity to be conquered by movement such that a point in the narrative is reached (the climax) in which everything is put in its place. At those climactic endings, what is real is also clearly differ-

entiated from that which is unreal, most clearly signalled by the distinction between the hero (who is affirmed as real) and the villain (who is condemned, in the final account, as unreal, an unreality typically marked by defeat or even death).

Another example will serve to embellish this understanding of the movement-image. The present action of *Mildred Pierce* (Michael Curtiz, 1945) is set in a police station where the film's protagonist, Mildred Pierce (Joan Crawford), has just confessed to the murder of her second husband, Monty Beragon (Zacharay Scott). Much of the film then unfolds as a series of flashbacks detailing the events that led up to the murder. Thus we are presented with a clear distinction between the past, which is unreal in the sense that it is not happening 'now', but is instead situated as a memory from the past, and a present which is real. In other words, that which is designated as having happened in the past is framed in such a way as to be determinedly located 'in' the past. This past unfolds in a linear fashion that brings the narrative up to the present time, a present in which Mildred's daughter, Veda (Ann Blyth), confesses to the crime. Thus the film's final result is that Mildred's original confession is designated as 'unreal' while Veda's is the real or true one. *Mildred Pierce* is thus an exemplary movement-image: everything is in its place; time is submitted to the regularization of an unceasing flow that goes from the past through the present to the future.

In films governed by a logic of the time-image, time is no longer subordinated to movement. *Hiroshima, mon amour* (Alain Resnais, 1959), the story of a love affair between a French actress and a Japanese architect, is one such film and it is one that can be usefully contrasted with *Mildred Pierce*. While discussing *Hiroshima, mon amour* in the context of the time-image, Claire Colebrook focuses on what she considers the film's key moment:

> The key moment in the film occurs when the actress views the Japanese man's hands in slight movement; the film 'irrationally' (without order or sequence) cuts back to another hand also moving slightly. This turns out to be the remembered hand of the actress's former lover who had died a traumatic death. This intervention of a past-image does not take the form of a flashback; it has no narrative sequence ... Now, the point of this as a time-image lies in the following: when we see actions linked up into an ordered sequence, then time is tamed, ordered and spatialised – but when, as in *Hiroshima, mon amour*, an image of the past disrupts the present sequence of images, we see time not as an ordered sequence of images but as a virtual whole ... In the time-image cinema allows for past perceptions to cut into the present,

displaying the very potential of time: time as disruption of what is (the actual) by difference. (Colebrook 2002: 158–9)

Colebrook's characterization of the time-image is a succinct one: the movement-image subjects time to a linear order whereas the time-image brings to the fore a non-linear disorder.

But is this in fact what happens in *Hiroshima, mon amour*? Why does Colebrook claim that the interrupting image 'turns out to be the remembered hand of the actress's former lover' while at the same time claiming that the juxtaposition of the two hands 'has no narrative sequence'? Surely a remembered hand is a hand from the past, and thus the hands can be positioned in terms of their narrative sequentiality: the remembered hand is of an event that occurred before the Japanese man's hand. What Colebrook fails to emphasize is that this remembered hand is no ordinary remembrance – it is not a flashback in the same way that the memories of *Mildred Pierce* are flashbacks. On the contrary, this remembered hand erupts as a memory from the past, but as a memory that carries the full force of the present. As such, it is less a remembered hand that is remotely contained *in* the past (as in *Mildred Pierce*'s flashbacks) than a fragment of the past that is encountered *as if for the first time*. This fragment of the past emerges with a force and presence that it had never had before; it emerges as *new*, as a piece of the past that is now being experienced *in the present*, as something being experienced for the first time.

As such, this hand certainly has a narrative sequence: it is simultaneously past and present, a shard of the past that is experienced in the present. From this perspective, Colebrook must also be mistaken to affirm that the time-image's significance is one that displays 'time as the disruption of what is (the actual)' because for the time-image *what is* is never just the actual, but is rather *the convergence of virtual and actual*, of past and present. Again, one can assert that the virtual past is unreal while the actual present is real, but only in so far as these remain indistinct for the time-image. No one can be certain in this key moment from *Hiroshima, mon amour* precisely where the virtual begins or where the actual ends and thus there can be no clear demarcation between the real and the unreal. Such is the reality of which the time-image is capable.

Deleuze's approach to cinema affirms the reality of film. Not just the reality of some films over other films which lack reality, but rather the reality of all films. The conception of reality that films have the

capacity to produce is furthermore a conception of reality to which natural, human perception aspires. The techniques of framing, editing and above all of synthesizing any-instant-whatevers so that they form movement-images is a reality which is intrinsic to the cinema apparatus and the realities it makes perceptible. These same mechanisms are extrinsic to human perception, performed, so to speak, 'above' perception. It is in this way that cinematic perception is one to which natural perception aspires.

Cinematic perception has its own aspirations and is capable of its own modes of perceiving. For the movement-image the modes of perceiving are ones that depend upon a clear distinction between the real and the unreal, where, in the final account, everything is found to be in its place. The time-image, on the other hand, presents a different type of reality, one which acknowledges the presence of the past and the ways that the past is enveloped in the present. This is another way of saying that the time-image presents an indistinguishability between the real (present) and the unreal (past). Some writers claim that this is a more realistic mode of imaging: 'a melange that clearly approximates the structure of everyday experience in which memories, meaningful or not, constantly interpose themselves among events, meaningful or not' (Monaco 1978: 85). But whether such images are more realistic or not is of no concern to Deleuze, for his aim is not to determine the realism of films. Rather, his aim is to determine their reality.

6 Filmic reality and ideological fantasy

8 Ideological reality: *Independence Day*
(Roland Emmerich, 1995)

For film studies, the key insight that can be derived from the writings of Slavoj Žižek is that *reality cannot be separated from fantasy*. Films do not occupy a domain of fantasy that can be straightforwardly distinguished from reality; films do not provide audiences with fantasy escapes from reality; films do not provide us with illusions of reality. Rather, if films are fantastic, then they are fantastic in the same way that reality itself is fantastic. One of Žižek's key arguments concerns this: that it is only by way of fantasy that we can come to experience reality in the first place. We have already come across this notion of fantasy's role in the constitution of reality in this book: in the chapter on Christian Metz, where the fantasy-fetish structuring of the cinema signifier was deemed central to filmic reality, as well as by way of Stanley Cavell's understanding of the key role fantasy plays in the fleshing out of any reality, especially the realities of film.

Our key point in this chapter might therefore be: if Žižek too subscribes to a logic of fantasy's central role in the constitution of reality (and filmic reality), then in what ways does he differ from or add to the analyses of Metz and Cavell? Žižek brings to the table a concept central to the discourse of political modernism (and

perhaps a term that has been underplayed somewhat in this book): *ideology*. From Žižek's perspective, reality is inherently ideological; it is only by way of ideological fantasy that reality is structured, defined and experienced. One of Žižek's major claims – indeed, I believe it to be his major longstanding achievement – is to have conceived of ideology in such a way that there can be no position one can take that is somehow outside or beyond ideology. As such, all reality is ideological.

There are, all the same, experiences and manifestations that are beyond ideology, but such experiences, events or things cannot be imbued with reality; we cannot point to such things and confidently state that they are part of reality. This excess, this 'stuff' which has no place in reality is, for Žižek, what is meant by the Lacanian category of the *Real*: the Real is occupied by those things which are beyond reality as we know it, and therefore beyond ideology as well. The Real is beyond reality and exceeds ideology because, strictly speaking, it is impossible: an encounter with or experience of the Real cannot be cognized, registered or symbolized in a way that can make it part of what we call reality. The Real provides the limit for reality.

The arguments of this chapter revolve around these two central claims: first, in accordance with Žižek's Lacanian conceptions, that *reality* is something quite distinct from the *Real*; and, second, that reality is always defined as being ideological in one way or another. Each of these ways of specifying what reality is has ramifications for understanding what filmic reality is from Žižek's perspective. Filmic reality is always already ideological – there is no way of identifying a reality of film that might reside beyond ideology – and filmic reality is itself separated from the Real. This means that if there is a Real of film, then this is not something that can be specified, identified or spoken about. Rather, a Real of film is something that can only be alluded to by way of filmic reality. The aim of this chapter is to clarify these points in some detail.

Ideological determinants

Žižek's reinvention of the theory of ideology is central for reconsidering approaches to ideology in film studies. Elizabeth Cowie, in a discussion of fetishism and ideology in the cinema, successfully isolates one of the crucial interventions made by Žižek. She argues that classic film theory of the 1970s and 1980s conceived of ideology in terms of a spectator's imaginary relation to the film text.

Implicated in this imaginary relation was the spectator's misrecognition in or with the film, a mistaken identification that sent such spectators along a path of ideological self-delusion. (I should point out that this notion of the imaginary is quite different from the imaginary I have attributed to Christian Metz: his imaginary, so far as I'm concerned, is not the imaginary commonly associated with film studies.) The main currents of film studies (again one can point to Stephen Heath for an elaboration of these points) argued that the cinema apparatus constructed the spectator as unified or complete: the work of ideology meant that spectators misrecognized themselves, by way of film, as unified. In doing so, the spectator was 'duped', deluded and utterly ideological in a negative way. Beyond this deluded, unified spectator, there was none the less posited the possibility of a different kind of spectator who could be produced by a different kind of film; that is, alternative or radical cinema practices could, so it was believed, produce spectators who would transcend the unified delusions of traditional films and thus emerge as true or liberated subjects.

Yet, as Cowie argues, this conception of a mistakenly unified spectator was clearly at odds with what Lacan theorized as the subject's imaginary relations. She explains that

> Lacan's concept of the imaginary cannot be used to support a theory of ideology as misrepresentation and as mask, covering and hiding a truth and reality lying elsewhere behind the (mis)representation, a reality which would be revealed by peeling away the distorting mask of ideology. (Cowie 1997: 285)

Rather, according to Žižek's appropriation of Lacan (and of Cowie's interpretations here), the spectator's imaginary relation to the screen is ideological. This relation is not ideological in a way that masks a true, non-ideological reality. Rather, if one denies the imaginary and if one denies ideology, then one must simultaneously deny reality as well. The subject first gains access to reality by developing an imaginary relation to it, a point forcefully argued in Lacan's theory of the mirror stage.

It is by upholding Lacan's theory of the imaginary as constitutive rather than delusional that Žižek takes a decisive step for film theory. His discussion of Lacan thoroughly overturns much that had been achieved during the 1970s and 1980s under the name of Lacan. For Žižek it is only by way of fantasy – that is, it is only by constructing an imaginary relation to the real – that humans can have access to reality in the first place. The imaginary constructions

of fantasy do not constitute a departure from reality, they constitute reality itself because they grant reality a modicum of consistency. As Žižek argues at one point with reference to Lacan, '"reality" is always framed by fantasy, i.e., for something real to be experienced as part of "reality", it must fit the pre-ordained coordinates of our fantasy-space' (Žižek 1993: 43).

What this means – and readers should be aware by now that this has been a constant theme of this book – is that humans do not have direct access to the world. On the contrary, our experience of the world is always refracted by fantasy. For Žižek, ideological fantasy is thus not a distortion of reality, but is constitutive of reality: 'ideology is not simply a "false consciousness,", an illusory representation of reality, it is rather this reality itself which is already to be conceived as "ideological"' (Žižek 1989: 21). The only contact humans have with reality is inherently ideological, it is mediated by ideology. As such, humans have no direct or immediate contact with the world, and humans are mistaken if they believe that contact with the world can be established beyond the framework of ideological fantasy. Indeed, in what amounts to a reversal of the notion of ideological misrecognition, Žižek claims that the most deluded of misrecognitions are ones that posit themselves as being somehow beyond ideology; one can be certain that as soon as someone claims to be speaking from a position that is supposedly devoid of ideology that one can be most assuredly in the presence of the most ideological of discourses. Žižek, for his part, aims such a criticism at David Bordwell and other 'post-theorists' in film studies: in their quest to define trans-cultural universals that are beyond the ideology debates of 'Theory', these scholars commit the grave error of assuming a position beyond ideology. Quite to the contrary, such scholars should be dismissed as thoroughly ideological. For Bordwell's insistence that the 'problem-solving' directives upon which his work has focused are in important ways 'universal' for the cinema, Žižek responds with the claim that 'one should ... insist that the procedures of posing problems and finding solutions to them always and by definition occur within a certain ideological context that determines which problems are crucial and which solutions acceptable' (Žižek 2001: 17). In other words, Bordwell's claim that his work is free from ideological imperatives should not blind us to the fact that they are steeped in ideology (an ideology which, I should add, has now been uncritically accepted by a generation of US film scholars).

As Žižek points out many times in his writings, his position is not one that is especially novel. Indeed, even more so than the Hegel

whom he dearly invokes, it is Kant who is Žižek's great precursor. The Kantian distinction between phenomena and noumena is analogous to Žižek's split between the ideological and that which is beyond ideology. Like Kantian noumena, that which is beyond ideology is beyond the capacity of human experience; humans cannot come into contact with noumena, for they are thoughts (or the forms of thought) that lie beyond the realm of appearances and which therefore cannot be objects of experience (see Kant 1929: 269–70). Only phenomena can be said to be experienced in 'reality'. And yet, noumena can nevertheless be thought. As Žižek argues:

> we know and can prove that the phenomenal universe is not reality in itself, that there is 'something beyond'; but neither Reason ... nor Intuition ... can provide access to this beyond. All we can do is delineate its empty place, constraining the domain of the phenomena without in any way extending our knowledge to the noumenal domain. (Žižek 1993: 89)

We cannot know noumena as objects of empirical experience; rather, as Kant puts it, we can 'think them only under the title of an unknown something' (Kant 1929: 273).

For Lacan and Žižek, this 'unknown something' beyond phenomenal reality is called the Real; it is that which cannot be symbolized or represented and is thus beyond the realms of the imaginary and the symbolic. If the Real is that which is beyond experience, it can still be encountered, but encountered in such a way as to be impossible to incorporate into experience. In short, if we encounter the Real, we do not know what to make of it.

Perhaps the finest example of such an encounter with the Real – of someone who is caught in and enveloped by the Real – occurs in Lacan's first seminar when he discusses Melanie Klein's case of 'Little Dick'. As Klein herself describes, Dick, a four-year-old boy, has thus far failed to make sense of the phenomenal world, the world of objects; his reality is in no way symbolized. Klein argues that 'Adaptation to reality and emotional relations to his environment were almost entirely lacking' (Klein 1986: 98). He did not seem to relate to humans or objects at all and had only the most rudimentary grasp of language. Lacan's statements on the case are illuminating. He remarks that this patient, Dick, 'is completely in reality, in the pure state, unconstituted' (Lacan 1988: 68). Dick's world is one in which he is in *immediate contact with reality* – not a reality that is symbolized or constituted by ideological fantasy, but rather he is face to face with *reality-in-itself*, reality as *unconstituted*.

In short, his world unfolds for him entirely at the level of what Lacan will come to designate as the Real. 'In this respect', Lacan comments, 'Dick lives in a non-human world', a world deprived of human co-ordinates (ibid.). 'He is', continues Lacan, 'paradoxical as it may seem, eyeball to eyeball with reality ... He is immediately in a reality that knows no development' (Lacan 1988: 68–9). It is as though Dick has direct contact with noumena, with things-in-themselves, the consequence of which is that his world remains entirely de-signified, without the least amount of sense or significance.

Such is the case of a human subject who has direct access to the Real, and it is this kind of situation in which one is 'eyeball to eyeball with reality' that Lacan will later call the Real; which is to say, the Real is that which is drained of its fantasy-frame and thus of any relation to reality. The Real should not in any way be confused with reality. Because Dick has not developed a fanta-sized relation to the Real in such a way that would constitute a navigable reality, then reality *per se*, along with memory and an understanding of the consistency of 'things', do not exist for Dick; he inhabits a 'non-human world'. What is necessary for reality to exist for him, according to Lacan, is that, for each of the objects he comes into contact with, he finds 'a series of imaginary equivalents which diversify his world' (Lacan 1988: 69). In short, he must pass through the mirror stage.

What this means is that, rather than continuing as a non-human or a non-subject, Dick, in order to establish a relation to reality, must rise to the challenge of the split that the mirror stage induces. As Cowie emphasizes (we have mentioned it above), the subject who accedes to the imaginary in the mirror stage is not unified. Rather, the subject produced by the imaginary is irreversibly split. The split which occurs is one between reality and the Real: the only way for Dick to dig himself out of the Real is to develop an imaginary relation to reality; to establish his relation to reality *as* imaginary.

Does this then mean that, for Žižek, reality is always, in the first instance, irreducibly imaginary, always constitutively ideological, in so far as any relation to reality is constituted only in an imaginary way by fantasy? This is indeed precisely what Žižek argues:

> Ideology is not a dreamlike illusion that we build to escape insupport-able reality; in its basic dimension it is a fantasy-construction which serves as a support for 'reality' itself: an illusion which structures our effective, real social relations and thereby masks some insupportable, real, impossible kernel. (1989: 45)

Žižek thus posits a fundamental split between reality and the Real: the Real is that which can never be articulated, phenomenalized or shared (a 'real, impossible kernel'), while reality is precisely that which can be recognized, shared and articulated as *what is*. Reality, in so far as it is established and supported by the fantasy-constructions of ideology, is itself split from a Real which cannot be articulated, shared or symbolized (it is 'insupportable').

Imaginary, symbolic etc.

One of Žižek's clearest explanations of the way fantasy provides a support for reality occurs in an example, apparently borrowed from Freud, of eating a strawberry cake. He explains by way of this example that fantasy is not merely a form of imagining or hallucinating an object, so that when I fantasize about eating a strawberry cake I imagine or hallucinate a cake that does not really exist. Rather, what fantasy does is to constitute my desire for a strawberry cake in the first place; that is, fantasy puts in place for me a framework of reality in which eating a strawberry cake is an activity worth pursuing (in much the same way as 'problem solving' is determined as an activity worth pursuing for film viewers, according to David Bordwell). So what, then, is the split between reality and the Real involved here? Out of the myriad possibilities that are available in the Real (I could eat a chocolate cake, or drink some beer, or go for a walk and so on ad infinitum), fantasy manages to isolate an object of significance and importance that gives substance to the reality I inhabit. This distinction between reality and the Real is not a matter of opposing a fantasized reality ('I desire a strawberry cake') with a true reality (with the fact that a strawberry cake does or does not exist here and now, or that I really should be drinking beer rather than eating a strawberry cake). Rather, the imaginary fantasy here *creates* the reality, the reality in which, here and now, I desire a strawberry cake.

Žižek adds another important dimension to his discussion by taking into account Freud's description of eating a strawberry cake. The extension of this example is of utmost importance in so far as, by way of it, Žižek introduces the dimension of intersubjectivity and, thus, of the Symbolic: fantasy does not unfold merely at the level of the imaginary; it also necessarily has symbolic constituents. The imaginary, strictly speaking, involves a relation between a subject and her/his image, but a subject's image is always inserted into symbolic discourses that are crucial for upholding that image

in the imaginary. Žižek explains that, by way of the example of a young girl eating a strawberry cake – for it is purportedly Freud's daughter who provides the crucial example – what is at stake is not just the relation between this young girl and her imaginary fantasy of eating a strawberry cake. Rather, what emerges as vitally important is the way that this fantasy attracts the interest of others, of the girl's parents. As Žižek puts it,

> the crucial feature here is that while she was voraciously eating a strawberry cake, the little girl noticed how her parents were deeply satisfied by this spectacle, by seeing her fully enjoying it – so what the fantasy of eating a strawberry cake is really about is her attempt to form an identity (of the one who fully enjoys eating a cake given by the parents) that would satisfy her parents, would make her the object of their desire. (Žižek 1997: 9)

What then is the status of reality *vis-à-vis* the Real in this example? In what is very much an Althusserian framework, the young girl is here 'hailed' by her parents, interpellated by them as a subject who enjoys eating strawberry cake; her reality is constituted by her parents' desire to see her enjoy (see Althusser 1971). This, in turn, gives her a feeling of pleasure at having been recognized by them. The episode thus creates a social reality that is significant for the daughter. In contrast to Klein's patient, Dick, who had not grasped any sense of intersubjective relations – of what he may mean to others or what they may mean to him – the girl eating strawberry cake has identified an activity or experience in which sense is exchanged intersubjectively (between the girl and her parents via the strawberry cake).

Once again this example demonstrates the need to stress that the fantasy of eating a cake – and it is indeed the fantasy that is important here, for it is the eating of the cake that allows the fantasy structure to emerge – is not a distorted, mistaken rendering of an otherwise true reality, but rather that the fantasy of eating a strawberry cake is constitutive of reality itself. Thus it is not a matter of declaring that, deep down, the young girl does not really want a strawberry cake, that she merely deludes herself into believing she wants a strawberry cake because that is what her parents want her to desire. Rather, her parents' desire for her desire, as given substance by the strawberry cake, creates between the girl and her parents an articulable, shared relation, precisely the kind of articulation and sharing that constitute reality as such (the reality of a social world defined by intersubjectivity). This introduces a properly symbolic

register into proceedings: along the imaginary axis is the child and her relation to the image of the 'child eating the strawberry cake', while along the symbolic axis lies the admiring gaze of the parents who give social significance to the child's experience.

A further determinant in this story of the strawberry cake is one of the most misunderstood terms in film studies: the gaze. The kind of matrix in which the young girl is caught while eating the strawberry cake is what Lacan referred to as the *gaze*. The gaze always establishes an imaginary object in a field of vision that is constituted by the symbolic. In this example, the imaginary object (the strawberry cake) is caught in the symbolic matrix established between the young girl and her parents. What it is important to clarify here is that gaze here has nothing to do with what the child *sees*, rather it has to do with the place where *she imagines she is being seen* by her parents. The gaze is thus not what the child sees but the way that the child imagines herself being seen by the parents. The child's imaginary relation – the relation between the child and the imagined image of her 'eating a strawberry cake' – is thus caught in the matrix of the symbolic: the image of her 'eating strawberry cake' is one that is sanctified and buttressed by her parents' approval of it. Such is the significance of the gaze, a point succinctly explained by Elizabeth Cowie:

> The gaze is not the look, for to look is merely to see, whereas the gaze is to be posed by oneself in a field of vision. The pleasure of the scopic drive is first and foremost passive – the wish to be seen … In order to solicit the gaze of the Other, of the mother, the child comes to posit itself as an object for the Other's gaze – precisely in the same way that the child's look at and identification with its own image in the mirror produces a structure whereby the child sees from a place which is other than the place (the mirror) where it sees itself. The child's look is essentially alienated and hence is constituted as the 'gaze' in Lacan's terms. (Cowie 1997: 288)

Cowie very successfully maps the Lacanian gaze here on to the determinants of the mirror stage: the child's identification with itself in the mirror is an identification with someone (*moi* = ego = *Ich*) who is looked at. What is crucial in Lacan's account of the mirror stage is that I see myself as someone who is being looked at: the establishment of the ego is at the same time its projection outside my body (the 'projection of a surface' as Freud claimed; 1961: 26). Hence, as Cowie emphasizes, 'the child's look is essentially alienated', for the place from where the child looks (its body) is different from the place where it imagines itself to be (in the mirror). What the

parents of the young girl eating the strawberry cake are affirming is thus the imaginary child ('the child who enjoys eating strawberry cake') in so far as this imaginary projection of the place where the child desires to be (of what the child desires to be like) is fundamentally split off from the originary child of the Real (the 'unknown something' that is beyond experience). What occurs when the child makes the transition to the determinants of reality – that is, when the co-ordinates of reality are constituted by way of imaginary and symbolic processes (what Žižek calls 'ideological fantasy') – is that the child is irrevocably cut off from the Real.

Reality and its objects

Again, it is a matter of stressing what can be symbolized, articulated or imagined as reality against that which cannot be known in any definitive way – that is, the 'unknown something' of the Real. The emergence of the strawberry cake as an articulable dimension of reality necessitates the exclusion of an 'unknown something' in the Real against which the cake obtains its phenomenal resonance. This fundamental exclusion of the Real from reality is one that, for Žižek as much as Lacan, 'haunts' all meaning in the imaginary and the symbolic registers. This fundamental assumption of Lacanian thought is akin to Kant's fundamental exclusion of noumena from the realm of phenomena. If the strawberry cake is meaningful for the young girl, then it is meaningful only in so far as it is posited against a background of meaninglessness, a background which is beyond meaning: the Real. The Real is that which cannot be incorporated into the imaginary or the symbolic (it cannot be imagined, it cannot be symbolized) – in other words, it is everything that is excluded from the human world (thus when Dick is 'eyeball to eyeball with reality' he is in a non-human domain of the Real). Therefore, if the strawberry cake is meaningful for the young girl it is meaningful only against a background of meaninglessness: reality defines itself against the backdrop of the Real.

This ultimately means, for Lacan as much as for Žižek, that humans do not have direct access to reality; the reality that humans have the capacity to experience is always mediated. According to this logic it is possible to *think* the difference between reality and the Real and thus one can certainly posit an 'unknown something' that exists beyond phenomenal reality. If reality is a fantasized, illusory realm, then it is possible to posit a real that is beyond this 'fictional' reality, a Real that is free from fantasy and illusion. But

it is none the less not possible to *know* or *experience* such a reality beyond the fictional reality to which we have access. '[A]s soon as we renounce fiction and illusion', Žižek stresses, 'we lose reality itself; *the moment we subtract fictions from reality, reality itself loses its discursive-logical consistency*' (Žižek 1993: 88).

Before this discussion can turn to matters more closely allied with film theory as such, it will be necessary to put in place a final piece of Žižek's Lacanian puzzle: the *objet petit a*. The young girl's fantasy of eating strawberry cake certainly constitutes an articulable reality, but it is a reality marked for her by the circuit of desire. Her parents' desire for her to desire a strawberry cake is also a signal or message which indicates to her that by eating the cake she will attain a form of supreme fulfilment (*jouissance*); by achieving and complying with her parents' desire she will be in some way ultimately fulfilled. In what is again one of the fundamental assumptions of Lacanian thought, the Real is not merely that which is irrevocably cut off from reality, it is also the realm of the unknown 'beyond' which hides something that, if only it could be articulated and made real, promises to bring about some kind of supreme fulfilment for the subject (this, for Kant, was the failed dream of metaphysics: to chart the contours of the noumenal beyond). As one writer suggests, it is a 'familiar Lacanian theme that human subjectivity is constituted through giving up the ultimate in satisfaction' (Lee 1991: 141–2). The *objet a* is a representative of this potentially ultimate satisfaction; it is an object that in some way promises fulfilment. Again a Kantian analogy is worth while: what such a fulfilment in the Real would amount to would be a transcending of our human lot so that we reach a point of divine knowledge in the sense of experiencing or knowing what God himself experiences and knows (see Lacan 1992: 167–240; Lacan 1998: 64–77).

For Žižek (in his interpretation of Lacan), what is implied by such a promise of fulfilment is not the satisfaction of desire but, on the contrary, the satisfaction of *drive*. Desire is always situated on a plane of articulability in the imaginary or the symbolic, which is to say that desire latches on to objects that have a phenomenal existence, as in the example of the young girl's strawberry cake. Drive, on the other hand, exists only as a function of the Real, of bodily functions that are inarticulable, of encounters which function beyond those desires predicated on human objects of pleasure – that is, 'beyond the pleasure principle' as such. The *objet petit a* is thus the representative of drive that manifests itself (Žižek calls such manifestations 'spectral fantasies') by attaching itself to objects which have

a phenomenal reality. The strawberry cake is, for the young girl, not simply and straightforwardly just a strawberry cake. Rather, it emerges for her as something more, as the promise of a kind of ultimate achievement, of a supreme satisfaction of drive in the Real, a satisfaction for which Lacan famously adopted the term *jouissance*.

Fantasy still has a central role to play here inasmuch as, according to Žižek, '*fantasy is the very screen that separates desire from drive*' (Žižek 1997: 32). Fantasy is the framework or setting of desire, while the *objet a* is represented by objects which exist in reality (and can thus be registered as part of an ideological fantasy) but which also holds forth promises of the ultimate satisfaction of the drive. Any object can become a representative of the *objet a* – as the strawberry cake is for the young girl – and, as such, desire is always metonymical; it has the capacity to shift from one object to another and then to another, and so on. But the shifting from one object to another will none the less be held in place by a fantasy framework, the way in which a subject desires. As Žižek makes clear, even though our desire may be sparked by any number of objects, 'desire none the less retains a minimum of formal consistency, a set of phantasmatic features which, when they are encountered in a positive object, make us desire this object' (Žižek 1997: 39). He further adds that the '*objet petit a* as the cause of this desire is nothing other than this formal frame of consistency' (ibid.). Ultimately, then, Žižek contends, 'It is the famous Lacanian *object petit a* that mediates between the incompatible domains of desire and *jouissance*'; the *objet a* is the Real's messenger in reality, a 'little bit of the Real' that can be perceived in reality (ibid.). The *objet a* is a 'taster', a chimera that that stimulates desire in reality, but only in so far as it simultaneously tempts desire with the promise of a satisfaction beyond pleasure: a *jouissance* of drive in the Real.

Filmic reality and the Real

Finally, we can put all these pieces of Žižek's Lacanian puzzle together in a discussion of a particular film, one to which Žižek himself devotes considerable time and effort: Krzysztof Kieślowski's *Three Colours: Blue* (1993). Following the death of her husband and daughter in a car crash, Julie (Juliette Binoche), the central character in *Blue*, withdraws into the domain of the Real – that is, she cuts her ties with reality as such, and revels in an abstract nothingness brilliantly portrayed in the film by her plunges into the womb-like deep blue of a swimming pool's water. Žižek singles out one episode

of the film for its particular evocation of the Real. Having moved to a new apartment, in a broom cupboard Julie discovers a mouse that has given birth to a large litter of babies. Julie is disgusted by this occurrence, and Žižek argues that the reason for her disgust is that she cannot comprehend it as part of reality, she cannot fit it within an ideological fantasy frame where it might be said to make sense. Instead, her experience of the mice is understandable only in terms of an encounter with the Real. Žižek explains:

> Nothing renders [Julie's] subjective stance better at this moment than this aversion of hers, which bears witness to the lack of the fantas-matic frame that would mediate between her subjectivity and the raw Real of the life-substance: life becomes disgusting when the fantasy that mediates our access to it disintegrates, so that we are directly confronted with the Real. (Žižek 2001: 169)

How, then, does Julie find a way out of this immediate contact with the Real? Žižek answers: 'what Julie succeeds in doing at the end of the film is precisely to restitute her fantasy frame' (ibid.). Žižek argues that, at the very end of the film, Julie finally re-establishes contact with the social world. *Blue*'s bravura closing montage maps the reconnections Julie has made, for she has re-created a world for herself from the intersubjective connections made with various people throughout the film. Žižek claims that the final montage can be best understood by contrast with another scene from very early in the film: an extreme close-up of Julie's eye just as she has regained consciousness following the car crash in which the other members of her family were killed. This close-up, according to Žižek's analysis, stands for Julie's symbolic death, 'not her real (biological) death, but the suspension of her links with the symbolic environment' (Žižek 2001: 171). It is here, then, that Julie effectively descends into the Real – one might even claim that the close-up reveals her state as similar to that of Klein's patient, Dick: she is 'eyeball to eyeball with reality'.

In marked contrast to this journey through the Real, the film's closing scenes reassert the fabric of reality: 'the final shot stands for the reassertion of life', Žižek declares. He goes even further than this and makes a claim that is of central importance to under-standing *Blue*:

> The two shots thus stage the two opposed aspects of freedom, the 'abstract' freedom of pure, self-relating negativity, withdrawal-into-self, cutting the links with reality, and the concrete 'freedom' of the loving acceptance of others, of experiencing oneself as free and finding full realisation in relating to others (Žižek 2001: 171).

What *Blue* presents, therefore, is a succinct separation between the domain of the Real ('cutting links with reality') and the ideologically framed fantasy space of reality ('the loving acceptance of others').

The effectiveness of Lévi-Strauss

For the reader who remains unconvinced of this argument, it can be framed in another way. Given Žižek's fondness for the works of Claude Lévi-Strauss,[47] it seems quite appropriate to refer to one of his analyses. In an essay on 'The sorcerer and his magic', Lévi-Strauss relates the story of a famous shaman, Quesalid, from a North American Indian tribe.[48] Even though originally sceptical about the magic involved in shamanism, Quesalid is nevertheless impressed by the fact that its methods are actually successful. Indeed, within a short time, Quesalid becomes the most successful shaman of the region. The secret of the success of his method lies in the following, as described by Lévi-Strauss:

> The shaman hides a little tuft of down in the corner of his mouth, and he throws it up, covered with blood, at the proper moment – after having bitten his tongue or made his gums bleed – and solemnly presents it to his patient and the onlookers as the pathological foreign body extracted as a result of his sucking and manipulations. (Lévi-Strauss 1963b: 175)

By way of this majestic performance, the shaman thus 'sucks out' the sickness from his patient and, in doing so, the patient is miraculously cured. The piece of bloody down is, within a Žižekian–Lacanian framework, the *objet a*, a representative of the Real that has an objective existence in reality, but which simultaneously evokes something beyond reality, namely the illness from which the patient is suffering. The illness is, of course, impossible to understand – it is an 'unknown something' of the Real; repressed, pathological, inarticulable. However, by performing the cure, the shaman brings into being something which is not merely crucial to the survival of the patient, but also something which goes to the heart of the entire community: he allows the community to cope with forces it cannot understand; the shaman's cure allows the community to reconcile what it understands in reality with what it cannot understand in the Real.

Lévi-Strauss explains the significance of this symbolic, social function in terms of a distinction between the normal and the pathological:

In a universe which it strives to understand but whose dynamics it cannot fully control, normal thought continually seeks the meaning of things which refuse to reveal their significance. So-called pathological thought, on the other hand, overflows with emotional interpretations and overtones, in order to supplant an otherwise deficient reality ... Through collective participation in shamanistic curing, a balance is established between these two complementary situations. Normal thought cannot fathom the problem of illness, and so the group calls upon the neurotic to furnish a wealth of emotion heretofore lacking a focus. (Lévi-Strauss 1963b: 181)

The shaman – whom Lévi-Strauss refers to here as a 'neurotic' – allows the realms of the normal and the pathological to be reconciled, and, in doing so, he allows the domains of reality and the Real to be reconciled as well: if normal thought is that mode of thinking which has its basis in reality (in codified language, in symbolized customs and so on) but which is undermined by aspects of the universe it cannot understand – the pathological illnesses of the Real – then such normal thought can at least be reconciled with the pathological by way of the shamanistic ritual: the shaman knows the process of healing is a 'made up', completely fictional performance, but nevertheless, by way of this fiction a relationship to reality is established, and a whole community's fear of the Real is alleviated.

There is one final point to acknowledge: social cohesion. Quesalid's cures are effective primarily for the reason that the society in which they are performed has *made it so*. The reason Quesalid has become the most successful shaman of the region is quite simply that he is recognized as being such. Failure and success in this regard, Lévi-Strauss explains, are outcomes of the social: the community accepts the fiction provided by Quesalid to be definitive of a real cure and, as such, it functions as a cure in reality.

Lévi-Strauss's example is a quite perfect expression of the way ideology functions: if a community agrees that something is real and has real effects, then for all intents and purposes, that something *is* real. The agreement of that community as to 'the way things are' is precisely what can be called an ideology. The argument put forward by Lévi-Strauss can also be mapped on to Kieślowski's *Three Colours: Blue*. Julie's experience of the normal world is completely dismantled by the death of her husband and daughter – it is an occurrence that is utterly pathological for her, an evocation of the Real. However, by the end of the film, the normal and the pathological, reality and the Real, are brought back into an alignment.

And how is that achieved? It is achieved primarily by way of love. Does not love – the neurosis *par excellence* – function in *Blue* in precisely the same way as the Shaman's cure? By becoming aware that the process of love does function in a way that is supported by a social consensus, Julie re-establishes her ties with the social world and thus with reality itself. Her friendship with Lucille (the night-club stripper), her relationship with Olivier, her love of music and, perhaps most of all, her willing acceptance of Sandrine's pregnancy (for she is pregnant with the child of Julie's deceased husband) – that is, Julie's acceptance that her husband had loved Sandrine in a way he had not loved her – are all signs of an ideology of love by means of which Julie is cured of her illness. Love might well be an ideology, but it is by means of such an ideology that Julie makes her return to reality.

We are still, however, a long way from defining what filmic reality might be in Žižek's terms. We have learnt that reality is ideological and also that it is to be distinguished from the Real. But we have not considered how this relates to the reality of film. For this to be possible, an additional theoretical manoeuvre is necessary, and this manoeuvre is not one that is provided by Žižek. In a discussion of 'The death and resurrection of the theory of ideology', a sometime Žižek ally (though now, perhaps more famously, an acrimonious rival),[49] Ernesto Laclau, identifies a number of the ways in which Žižek's work has been exceptional in defining a new role for ideological analysis. First of all, Laclau reiterates that a new role for ideology is established on the basis that there is no *beyond* of ideology. But Laclau's most important intervention is to assign ideology a function: any ideology is an attempt to discern what a perfect community would be like. He explains this point in the following way:

> Let us suppose that at some point, in a Third World country, nation-alisation of the basic industries is proposed as an economic panacea. Now, this is just a technical way of running the economy and if it remains so it will never become an *ideology*. How does the transformation into the latter take place? Only if the particularity of the economic measure starts incarnating something more and different from itself: for instance, the emancipation from foreign domination, the elimination of capitalist waste, the possibility of social justice for excluded sections of the population, etc. In sum: the possibility of constituting the community as a coherent whole. That impossible object – the fullness of the community – appears here as depending on a particular set of transformations at the economic level. This is

> the ideological effect *stricto sensu*: the belief that there is a particular
> social arrangement which can bring about the closure and transpar-
> ency of the community. (Laclau 1997: 303)

Although Laclau argues that ideology is an effect of the belief that
a community might become full, unified and perfected, he also
argues that the fullness of society is something that could never
occur in reality. Rather, the fullness of society is an impossible goal.
Again we can see such an arrangement at work in Lévi-Strauss's
analysis: as ideological, the shaman's magic is one means by which
the fullness of the community is made possible; that is, it is a means
by which the so-called 'pathological' is to some degree reconciled
with the 'normal'. But the community as such could never reach
'full' harmony and transparency, for even if the pathological is
brought under some kind of control, it is nevertheless still beyond
understanding. Harmony is possible only on the basis of 'covering
over' the pathological 'foreign body' that cannot be understood
or integrated into the community. And likewise, in *Three Colours:
Blue*, love is the ideology by means of which the community can be
imagined in its fullness, an ideology which is given divine emphasis
by way of the excerpts from the Book of Corinthians at the film's
end – 'If I have not love, I am nothing' – not to mention the inclu-
sion of these excerpts in the film's 'Concerto for European Unifica-
tion'. Love is the signifier through which Europe – the community
– might attain its fullness.

There is one other important point to glean from Laclau: if the
fullness of the community is deemed impossible, then the register
of this impossible fullness is none other than the Lacanian Real.
Just as, for the individual subject, the *objet a* presents the promise
of an excess of enjoyment, of some sort of ultimate but impos-
sible satisfaction (as was discussed earlier in our 'strawberry cake'
example), then so too, at the level of the social, the Real offers a
promise of ultimate satisfaction: the fullness of the community. The
shaman's bloody tuft of down is the *objet a* in which not only is
the patient's cure contained but within which is also contained the
promise of the fullness of the community. So too, with Julie in *Blue*,
the empirical examples of love which she experiences are so many
objets a which point, for her, towards the potential fullness of the
community (again, a fullness given added weight by the 'Concerto
for European Unification').

The fetish and ideology

Our detours through Lévi-Strauss and Laclau allow us to approach one of Žižek's more recent formulations. Additionally, it allows us to link his position with that articulated in Chapter 3 by way of Christian Metz. Žižek has recently begun to argue in favour of a fetishistic mode of ideology by way of contrast with the more traditionally accepted (Althusserian) symptomal mode of ideology. The latter is a mode of ideology critique associated with 'political modernism' that we have encountered a number of times throughout this book. The task for political modernism was to rid the dominant cinema of its illusions – to rid it of its symptoms, of the things which make that type of cinema 'sick' – so that a truer reality could reveal itself, freed from symptomatic distortion. Of course, a freedom from symptomatic distortion would also signal a freedom from ideology: the illusions of ideology could finally be replaced by the true and real discourse of science.

Žižek rejects this symptomatic approach to ideology. Instead, he proposes a fetishistic approach to ideology:

> The fetish is effectively a kind of *envers* of the symptom. That is to say, the symptom is the exception which disturbs the surface of false appearances, the point at which the repressed Other Scene erupts, while the fetish is the embodiment of the lie which enables us to sustain the unbearable truth. Let us take the case of the death of a beloved person: in the case of a 'symptom', I repress this death, I try not to think about it, but the repressed trauma returns in the symptom; in the case of a fetish, on the contrary, I 'rationally' fully accept this death, and yet I cling to some feature that embodies for me the disavowal of this death. In this sense, a fetish can play a very constructive role by allowing us to cope with the harsh reality. Fetishists are not dreamers lost in their private worlds, they are thoroughly 'realist', able to accept the way things effectively are. (Žižek 2008: 296)[50]

Finally, then, we can locate Žižek's formidable contribution to ideology critique: that the ideological fantasy-fetish is not something we should be aiming to go beyond. We should not cling to the conviction that there is something beyond ideological fantasy, a realm that will be cleansed of the supposed distortions and symptoms of ideology. Rather ideological fantasy is something we should affirm and accept as the positive structure or framework that determines the reality in which we live. Ideological fantasy should not be opposed to reality; the Real should not also therefore be posited as a realm of encounters or situations beyond reality which would be freed from ideology. Rather, we must accept and positively affirm

that there is nothing beyond ideological fantasy. Ideological fantasy constitutes our reality.

... and film studies

Thus far, film studies seems to have been come across only tangentially in this chapter, but readers should be assured that it is towards film studies that I have been heading. The main thesis of my argument is this: political modernists in film studies have continually pushed for a transcendent filmic Real, while my contention is that Žižek instead offers film studies a way of conceiving of an ideological filmic reality. Again I should stress that Žižek's analysis is entirely positive: there is nothing wrong with proposing a filmic reality that is ideological. On the contrary, to propose an ideological filmic reality presents us with a way to get out of the deadlock of symptomatic readings, a way beyond political modernism's continued dismissal of the reality of films in favour of an impossible filmic Real. Such is Žižek's great contribution to film studies.

An excellent example of the persistence of the political modernist paradigm in film studies, that framework which criticizes cinema's ideological reality by proposing a transcendent Real beyond ideology, is Geoff King's *Spectacular Narratives*. Concentrating on Hollywood blockbuster films of the 1990s, King provides an argument with which readers must be now quite familiar: Hollywood films do not offer a 'true' reality, but only distortions. A true reality – the Real – can be discovered only beyond or behind the surface appearances of Hollywood. 'These films', argues King, 'offer large measures of resistance. They confront difficult issues', he continues, 'but in a superficial way. Real underlying contradictions remain' (King 2000: 27). Such is the framework of King's book: Hollywood films are 'superficial', while beyond such films is a 'Real' which those films fail to deal with. In other words, we can say that, for King, Hollywood films offer ideological realities, whereas what he thinks films should do is to offer a transcendent Real.

King's analyses should, however, not be dismissed. He offers tremendous insights into the films he discusses, and perhaps the best of these is his discussion of *Independence Day* (1996), surely an 'ideological' film if ever there was one. King astutely unpacks the film's ideology along three fronts.

First, *Independence Day* offers its characters the possibility of transcendent experiences; that is, its characters are allowed to encounter the Real. King explains this in the following (non-Lacanian) terms:

The reluctant genius David Levinson (Jeff Goldblum) is freed from work for a cable television company, enabled instead to put his intellect to the ultimate in worthwhile ends: saving the world. President Thomas Whitmore (Bill Pullman), a former Gulf War pilot [from the first Gulf War, that is], abandons the manipulations of electoral politics to lead a global fightback and takes to the skies himself in the final conflict. Captain Steven Hillier (Will Smith), a black pilot turned down by NASA, flies an alien craft to deliver the crucial blow, while Vietnam veteran Russell Casse (Randy Quaid) recovers from alcoholic haze to die in redemptive kamikaze glory. (King 2000: 21)

In short, these characters are taken out of their mundane 'ideological reality' and placed into a zone where they can encounter 'limit experiences'. Following the alien invasion which forms the film's core plot, the existing structures of reality have broken down and these characters now have the opportunity of coming into direct contact with the Real, an ultimate transcendence expressed nowhere better than in Casse's ecstatic, deadly conflagration.

Second, the Real emerges in another guise in *Independence Day*: via the aliens themselves. It is a common trope in Žižek's writings that warlike tensions and animosities are motivated by racial otherness (see, for example, Žižek 1991: 165; 1993: 200–37). In *Independence Day*, this racial otherness takes the form of a race of alien invaders. In other words, following on from the previous point, here we might say that the characters, in their quest for a transcendent experience, come face-to-face with the Real: the aliens themselves.

Third, King's most impressive point, and the point at which the symptomal mode of ideology critique is at its most evident, is that the film mediates or controls this 'contact with the Real' by inventing an ideology which accommodates its contradictions. It achieves this by fusing the contradictory aims of two myths: the frontier myth and the myth of technology.

- The myth of the frontier is one of the USA's founding mythologies: the dream of expansion westwards, of the pioneer doing battle with brute nature and a hostile wilderness, of cowboys taming the savage and sometimes barbaric land, and finally, of the 'extreme experience', where one can leave civilization behind and encounter the naked Real of things. This then, is the myth satisfied by our heroes' battles with the aliens, their encounters with the Real.
- The myth of technology is in many ways a counterpoint to the frontier myth: where the myth of the frontier is that of the human return to nature, the myth of technology posits science's triumph

over nature. The aliens themselves are technologically superior, and their technology signifies the threat of technology *per se*: that in the wrong hands, technology is evil and will bring about the destruction of life as we know it.

In *Independence Day*, the defeat of the alien invaders is achieved by way of a mixture of the 'limit experience' of the frontier (the film's fighter pilots are modern-day cowboys) and sophisticated computer wizardry (the alien mothership is rendered vulnerable by the hacking of the computer genius), a blend of the human and the technological. Thus, the film's ideological message would seem to be that, if technology is put into the hands of the 'good guys', then the world will be fine. Furthermore, the non-technological aspects of existence – the frontier experiences of 'getting in touch with nature' and testing the limits of organic existence – will still be possible, again, if technology is put in 'safe hands'.

This is certainly a powerful reading: that *Independence Day* assuages anxieties about new technologies (remembering that in 1996 the World Wide Web was just about to assume massive proportions and Microsoft's 'Windows '95' desktop-based operating system had just been launched; not to mention the emergence of cyborg technologies which threatened the distinctiveness of the human, along with fears about climate change and the destruction of the Earth that had been wrought by industrial technology; and finally even the threat of digital cinema itself – of which *Independence Day* is an exceptional example – as that which would nullify the 'naturalness' and 'indexicality' of analogue celluloid) by assuring its audiences that technology can reside peacefully alongside more natural human aspirations, with the proviso that technology should be used only by 'safe hands' and for 'proper ends'.

There is little doubt that these observations on the ideological fantasy of *Independence Day* are important, but King fleshes out the details of this ideology only for the purposes of declaring it fraudulent:

> Frontier mythology tends to be politically reactionary in form, often blatantly elitist, racist, sexist or homophobic. In theory, the frontier, as a place 'outside' or on the edge, opens up the possibility of a subversive blurring of boundaries. More often, in Hollywood, it provides the opportunity for a re-establishment of dominant structures. (King 2000: 40)

Thus, the frontier myth and the myth of technology turn out to be precisely what they seem: myths, and for King, myths are not

good things. Rather, myths go hand-in-hand with ideologies and, like myths, ideologies are no good either. King's reading is a classic symptomatic reading: *Independence Day* offers us illusions of reality which cover over a truer, deeper reality. These illusions, myths or ideologies cover over the 'true' symptoms; the ideological fantasy merely covers over those symptoms and fails to deal adequately with the 'Real underlying contradictions' (King 2000: 27).

In fact, the best way, against King himself, to understand King's quest is in Žižek's Lacanian terms: King is dissatisfied with reality and instead pursues the Real; he refuses the ideological fantasy of reality in the quest to go beyond that reality in order to discover the Real itself. As I have already claimed, this is a trope endemic to political modernism in film studies: to reject the reality of film in the quest for a beyond of film that would supposedly allow us to come face-to-face with the Real.[51] For King, like other political modernists, films are only symptoms which hide the true nature of reality.

The Žižekian lesson of *Independence Day* would posit an approach entirely opposed to that made by King. The lesson of *Independence Day* is that one must suppress the Real in order to reveal an ideological reality; the aliens must be defeated in order for contradictions between the myths of technology and the frontier to be resolved. *And there is nothing wrong with positing such resolutions.* In fact, isn't this precisely what Quesalid does for his patients and his tribe? He produces an entirely fictitious gob of 'bloody down' and in doing so, disposes of the symptomal alien, the 'foreign body' causing the illness, as Lévi-Strauss so evocatively puts it (Lévi-Strauss 1963b: 175). The 'bloody down' is nothing other than the Lacanian *objet a*: a little piece of the Real, a miraculous messenger of the Real, which allows the fantasy structure – the ideological fantasy – to take hold. But the effectiveness of this 'magic' is decisive: it allows the patient and the community to function as a stable society; as a community of shared interests. In the same way, *Independence Day*'s resolution of its contradictory myths at the very least proposes an argument about the way any society might function in a cohesive manner. The fact that it does so by way of an ideological fantasy does not mean that it is wrong – just because it is not my or King's ideological fantasy does not thereby mean that it must be dismissed because it is an ideological fantasy. Perhaps this is the major political lesson to be taken from Žižek: to dismiss a position as an ideological fantasy is to reject reality itself.

Žižek's position is not one of resignation or cynicism: his point is not that we simply must accept ideological fantasies as some kind

of demeaning form of social existence, that we have to give up on hoping for a better life or that we must somehow 'fall into line' with the ideology of a film like *Independence Day* because there are no alternatives. Quite the contrary: ideological fantasies can always compete with one another – as they do in the case of the neighbouring tribe in Lévi-Strauss's story of the sorcerer over which Quesalid's method of the 'bloody down' usurps the neighbouring tribe's prevailing cure; Quesalid's ideological fantasy triumphs over the neighbouring tribe's ideological fantasy. The lesson of all of this is that struggles over the nature of reality always take place upon the terrain of ideological fantasy: one ideological fantasy might always fall so that another takes its place; indeed, such transitions are occurring all the time.

Such a perspective allows an even more penetrating analysis of *Independence Day*, for what that film communicates so effectively is the transition from an ideological fantasy focused on the Cold War (and any science fiction film from *The Day the Earth Stood Still* (Robert Wise, 1951) to *Total Recall* (Paul Verhoeven, 1990) to one that is resolutely post-Cold War. By 1996, there is no longer a communist threat, for liberal democracy has won a decisive and universal victory. The only threats to 'our way of life' in these Western, liberal democracies of which the USA is the model now comes from a realm that is entirely beyond understanding, an alien force which cannot even be negotiated with and which is the embodiment of a pure evil. Such is the threat posed by the aliens which invade in *Independence Day*. And it did not take long for this ideological fantasy to become a reality: *avant la lettre*, *Independence Day* demonstrated the reality that was to come, the reality of living with the fear of a 'war against terror', against an 'axis of evil' with whom it is impossible to negotiate, an alien culture who have no aims other than, so it seems, that of robbing liberal democracies of their freedom, of their 'way of life'. And no coincidence, perhaps, that the attacks on the World Trade Center and the Pentagon in 2001 were foreseen by *Independence Day*'s images of the destruction of the White House, by the very thought of an attack launched against the USA on a massive scale. One might be tempted to conclude that *Independence Day* was about as far away as one could get from being a fantasy: what it displayed was nothing less than ideological reality. For King's take on these issues see King 2005.

Ultimately, then, this is the reason why Žižek reverses the stakes of the World Trade Center attacks in lieu of films like *Independence*

Day: the attacks were not 'eruptions of the Real', they were not 'returns of the repressed'. On the contrary, they were emanations or images of ideological fantasy. They were 'demonstrations' of the deep underlying fantasy which sustains the reality of American 'way of life' – such is the argument Žižek puts forward in *Welcome to the Desert of the Real* (Žižek 2002). We should be entirely clear here about the point we are trying to make. The ideological fantasy of defeating the aliens in *Independence Day* might not be 'morally' correct; it might not be a fantasy we agree with – indeed, any left-leaning commentator no doubt finds it more than slightly repugnant, especially in so far as it lays out the parameters of a fantasy that became a reality under the presidency of George W. Bush. But that does not mean it can therefore be discounted as 'unreal', or that it can be dismissed as 'ideological' from a point of view that sees itself as being beyond ideology. Absolutely not, for Žižek. Rather, political struggles or moral victories are always fought on the terrain of ideological fantasy so that *Independence Day* stands as a brilliant – if morally scandalous – evocation of filmic reality: an ideological fantasy that, within a few short years, became a full-blown reality.

I leave the final word here to Ernesto Laclau. Ideology is always part of a struggle, a struggle to establish the (impossible) fullness of society; it is not just a game or joke:

> For historical actors engaged in actual struggles, there is no cynical resignation whatsoever: their actual aims are all that constitute the horizon within which they live and fight. To say that ultimate fullness is unachievable is by no means to advocate any attitude of fatalism or resignation; it is to say to people: what you are fighting for is everything there is; your actual struggle is not limited by any preceding necessity. (Laclau 2000: 196)

7 Filmic reality and the aesthetic regime

9 Some things to do: *The Far Country*
(Anthony Mann, 1954)

What contribution does the philosopher Jacques Rancière make to an understanding of filmic reality? While Rancière's approach to cinema, and to aesthetics more generally, is strategically ambivalent – he is a philosopher who is not keen to 'take sides' in specific debates (see Rancière 2009: 21) – that ambivalence raises questions worth considering for the notion of filmic reality. Rancière is at his most confident when describing what cinema is *not*, and his collection of essays, *Film Fables*, is built around critiques of specific theoretical approaches to cinema, especially those of Jean Epstein, Bazin, Deleuze and Jean-Luc Godard. He is kinder to some classic film directors – Fritz Lang, Chaplin, Nicholas Ray and Anthony Mann among them (see Rancière 2006). Rancière also tries to

position the cinema in relation to the wider cultural and aesthetic sphere and, in this regard, there is no doubt he reserves a very special place for the cinema. With regard to the explicit nature of what I call 'filmic reality', I presume this is a term of which Rancière would disapprove. Nevertheless, the radical reconfiguration he brings to an understanding of the arts in recent times, and of cinema, will allow another approach to the notion of filmic reality to be defined.

Rancière's approach to cinema builds on his understanding of what he calls the 'aesthetic regime' of art. The aesthetic regime designates the modern understanding of the term 'aesthetics', a term which took on a specifically modern connotation in the late eighteenth century, especially under the influence of Kant and the broader trends of German Romanticism and Idealism (Schiller, the Schlegels, Hölderlin, Hegel and others). For Rancière, most of the art, literature and music we consider modern or modernist can be considered part of a historical bloc defined by the aesthetic regime. On this score, Rancière is emphatically opposed to notions of 'postmodernism'. Rather, for him, the arguments of the postmodernists tackle the same issues as those of the moderns and, thus, there can be nothing 'post' about postmodernism. Precisely what is at stake for modernists and postmodernists alike is the very definition of aesthetics. That is why Rancière calls it the aesthetic regime: a period in which 'aesthetics', as we today understand it, is invented, so that arguments over what can properly or legitimately be called 'aesthetic' define the very stakes of that regime. The questions of 'what is aesthetics?' or 'what is aesthetic?' are ones that can be asked only under the conditions of the aesthetic regime.

Aesthetics means, ultimately, that which pertains to *aisthesis* – sensibility. 'This', argues Rancière, 'is what "aesthetics" means: in the aesthetic regime of art, the property of being art is no longer given by the criteria of technical perfection but is ascribed to a specific form of sensory apprehension' (Rancière 2009: 29). Sensory apprehension is therefore of paramount importance for the aesthetic regime. Perhaps more importantly, however, aesthetics refers to a whole new way of understanding what art is or can be, and of what role art plays in the everyday lives of a people, community or state. Perhaps the most accurate way of characterizing Rancière's position is to declare that the aesthetic regime brings about a new way of defining the relationship between art and life. If, prior to the aesthetic regime, making 'art' was a specific task or function defined by particular technical criteria, criteria which were separated from the other spheres of existence (art was not 'play' or 'pleasure' or

even an 'experience'), then the aesthetic regime defines art in a new way: as that which pertains to the sensible.

At length, therefore, Rancière surveys the importance of the Kantian breakthrough. '[A]esthetics', he writes, 'can be understood in the Kantian sense – re-examined perhaps by Foucault – as the system of *a priori* forms determining what presents itself to sense experience' (Rancière 2004c: 13; see also Foucault 1984). From such a perspective, what the aesthetic regime makes available is a particular understanding of the way in which sensibility functions: that sensibility is itself generated and constrained by specific spheres of understanding, an understanding guided by a quest to determine what the 'aesthetic' is and an understanding, therefore, of what the possibilities and functions of 'art' are. The aesthetic regime 'is based', writes Rancière 'on distinguishing a sensible mode of being specific to artistic products' (Rancière 2004c: 22).

If the aesthetic regime is only something which comes into being in the late eighteenth century and which intensifies and becomes dominant during the nineteenth century, what preceded it? Rancière argues that the logic of aesthetics and sensibility associated with modernism can be differentiated from the regime of art which came before it. And that regime was the 'representative regime' of art. This regime of art was one in which things were re-presented – they were not things that were present. By being re-presented, artworks were placed at a remove from those things that were deemed *present*, things such as life, work and politics. The representative regime functions by analogy rather than sensibility: the function of art is to 'mirror' life, to copy the forms of everyday existence and never to be confused with – or fused with – those forms of presence.

And yet the representative regime should not be confused with what is more widely referred to as representation – indeed, much of this book has been dedicated to opposing a logic of representation. For Rancière, to represent does not merely mean to imitate or copy; which is to say that, under the conditions of the representative regime, the function of art is not one of copying or reproducing nature, for example. Rather, especially considering the predominance of representations of the classical world or of religious subjects during the period, the function of representing during this period is something which lies a long way away from imitative reproduction. Rather, the representative regime is organized by way of a system of *presenting images or words according to rules*. Whether one is attempting to paint according to the laws of a genre or attempting to master the formal parameters of a sonnet, what

one finds in the representative regime is a notion of art as one based on the refinement of specifically learned techniques. The outcomes of art, argues Rancière, were that they re-present – in the sense of 'presenting again' or 'making present again' – the laws, hierarchies, genres and academic rules that had been passed down to them. In other words, the function of representing was not one of copying but was instead one of making present by way of analogy the forms and structures of the society in which works of art were produced. There were rules on how to represent angels, the Virgin Mary, the King, and so on, and to represent such things was to reproduce the systemic codes according to which societies were structured (say, with the King at the top and Jesus higher still).

The other important function of the representative regime is derived most closely from Aristotelian poetic form: it is that of telling stories. The representative regime is one of classical narrative storytelling. But that regime is not merely one of telling stories. Rather, it provides a specific way of telling stories, for it tells stories which are 'about' life or which offer commentaries on life, analogies with life. They are re-presentations – a Shakespeare who sets his stories in remote Denmark or Venice, or in the shadowy past of Rome or England; a Milton who relies on the Old Testament or the classical world; or a Poussin whose prime motivation is to 'paint the picture and tell the story' (and for him, again, it is mainly a matter of stories derived from the classical world).[52] These are authors and artists of representation: they re-present, by way of analogy, as I have already claimed, the structures and hierarchies of given social orders. By contrast, the aesthetic regime begins to tell stories the aim of which is no longer to reflect or represent life. Instead, their stories attempt to become fused with life: Balzac, Flaubert and Zola in France, and Gaskell, Eliot and perhaps even Dickens in England, begin to write stories of presence. The aesthetic regime does not tell stories *about life*; it tries to tell stories that *are* life.

Perhaps a simpler way of conceiving of this process of telling stories is to understand how, for Rancière, the notion of storytelling changes its role under the aesthetic regime. Formerly, when the function of stories was to provide representations, the fictional story was itself a way of defining the truth. In other words, as defined by the representative regime, fictional stories offer access to the truth – stories are (or can be) true. From this perspective, then, if stories are true, what is false? For Rancière, if fictions in the representative regime are true, they are distinguished as true because they are not

lies. Fiction is true (or, at the very least, fiction has a 'relation to truth') while lies are false (Rancière 2004c: 36).

By contrast, the opposition between the true and the false is radically redrawn for the aesthetic regime. For the aesthetic regime, it is now facts or history that are true (or which have a relation to the truth), and any fiction that is divorced from history or facts is deemed false or illusory. What this means is that fictional writers – or other practitioners of fictions in painting, sculpture, poetry and so on – must adopt the procedures of history or 'factuality' in order to maintain a relation to truth. Again here, Rancière's favoured literary examples are Balzac and Flaubert, but it is no less true of the rise of 'realism' in painting or the invention of photography, not to mention to refinement of naturalism and realism in the theatre (Ibsen, Chekhov, Strindberg). So too, of course, is realism posited as a basic dream of cinema.

The dream of cinema

For Rancière, all of this adds up to a very complicated prehistory of cinema. The dream of cinema, he argues, was that it had the capacity to be aesthetic in a way could eclipse all the other arts: here, at last, was an artform whose fictional links were entirely connected with facts. For these visionaries – Jean Epstein being exemplary for Rancière – 'cinema was to the art of telling stories what truth is to lying' (Rancière 2006: 1). If the cinema is to be true, then it cannot tell stories, for if it does so, it will be lying. It will no longer be showing facts. Thus, it will fall victim to the traps of the representative regime. For the pioneering cinematic dreamers, on the contrary, the true destiny of cinema was to reject stories. If it achieved this, it would become the foremost art of the aesthetic regime. Rancière tries to characterize the logic central to the dream of cinema:

> Life is not about stories, about actions oriented towards an end, but about situations open in every direction. Life has nothing to do with dramatic progression, but is instead a long and continuous movement made up of an infinity of micro-movements. (Rancière 2006: 2)

From this perspective cinema should not distort the world by imposing stories upon it, but rather should use its capacities to put us directly in touch with the real: cinema's destiny is to provide an aesthetic of sensibility by means of which one can touch the world. Cinema's contact with the real, but, even more so, its ability to reveal a real beyond the confines of the human eye: this was

supposed to be cinema's destiny. 'Thus cinema', Rancière argues, 'could lend itself to carrying out the vast utopia that pervaded the esthetic regime of the arts: the idea of a language proper to the sensible' (Rancière 2000: 252). From this perspective, the cinema is an art of the aesthetic regime, an art dedicated to the exploration of the sensible, and not an art suited to the telling of stories.

And yet, as Rancière makes clear, this dream didn't quite come true; 'this esthetic purity is illusory', he claims (ibid.). Instead, cinema told stories in ways that surpassed all the storytelling that had emerged before it. 'The young art of cinema', Rancière writes, 'did more than just restore ties with the old art of telling stories: it became that art's most faithful champion' (Rancière 2006: 3). Not only did cinema offer a promise of fulfilling the dreams of the aesthetic regime, it also managed somehow to exemplify the characteristics of the representative regime. Everything which the modern arts had tried to put behind them – the end of imitative figuration in painting; the deformation of literary traditions in modern literature; Brechtian distanciation in the theatre; the emergence of dissonance in music – were, on the contrary, embraced by much of cinema: the 'old' ways of telling stories returned. Rancière is certain that much of the allure of cinema has lain in its ability to fuse these two seemingly contradictory attractions: on the one hand, the purity of cinematic facts and sensations which are, on the other hand, fused with a mimetic taste for classical style. Not only, then, is the cinema part of the aesthetic regime but, curiously, it serves the aims of the representative regime quite well too. Thus Rancière contends:

> Cinema is not only a visual art, suited to support the idea of a pure language of sensation. It is also an art of fiction and, as a young art of fiction, it bestowed a new youth upon genres, types, codes, verisimilitudes, and conventions of representative fiction that literature had overthrown. So it is an art that very rapidly became involved in the contradiction between the esthetic regime of images that 'speak by themselves' and the representative tradition of the fitting together of fictional actions and typologies. (Rancière 2000: 252)

We might see here more than anything that Rancière upsets what had been put in place by political modernism in film studies. For him there is no modernist 'reality' that can be opposed to a classical 'illusion'. In order to become what it has been, the cinema does not need to purify itself by disposing of classical forms in favour of modern ones. Or, to put it in the terms we examined in the first chapter of this book, the cinema does not need to expunge narrative illusions in the quest for a picaresque reality (as Wollen (1985)

had claimed) or for reality's contingent ambiguities (as Margulies (2003b) advocates). Story does not need to be dismissed in favour of 'attractions' (as Gunning (1989; 1990b) has promoted for many years now). Instead, Rancière argues that the cinema is an art that stands somewhere between the aesthetic and representative regimes, between the sensibility of *aisthesis* and the hierarchies of narrative.

The Westerns of Anthony Mann

One of the finest examples of this fusion of the aesthetic and representative regimes, which (for Rancière) has helped to make cinema what it is, can be found in the Westerns of Anthony Mann. Rancière's essay on Mann's Westerns, 'Some things to do', carefully discusses the complexities of Mann's cinematic forms, with an overarching emphasis on what things 'have to be done' in those films. Broadly speaking, what has to be done is this: the hero of the film must restore stability to the town or territory upon which he has stumbled, and thus, as a consequence, the filmmaker will also fulfil his own obligation, which is to deliver to the audience an ending, an ending which, in accordance with the codes and regulations of the particular kind of filmmaking in which Mann partakes – that of Hollywood genres – must be 'happy' to some degree. Rancière neatly sums up this way of things (with specific reference to *Winchester '73* (1950)):

> There seems to be a perfect harmony between the doing and the having-to-do of the director and his character, between a narrative logic that is sure to satisfy every semiotician and the moral of the story, where justice triumphs at the end of a number of trials. (Rancière 2006: 73)

On this score, Mann's Westerns unashamedly accentuate features of the representative regime: they tell good stories, stories in which civilization triumphs over barbarity and where order is granted in places it has never been before.

At the same time, however, these films' triumphant endings seem 'forced' in a very peculiar way. It is not that these endings are implausible – they do not feature miraculous and contrived outcomes arising from poor plotting. It is rather that, even as much as we want the hero to triumph and as much as we are satisfied and relieved when he does, there is also a sense in which his triumph is somehow 'empty'. The world of these films has become too rotten for one man to make any difference, and his one gallant act of saving a small corner of the West from falling into the chaos of treachery

is merely one small battle won in a war that the forces of injustice are winning comprehensively. Furthermore, it is always as though our hero did not much want to enforce justice anyway – it instead becomes something 'he has to do'. The heroes of Mann's Westerns would rather be elsewhere, away from the struggle, unconcerned about battles for justice, left alone and away from the troubles societies have brought upon themselves. They only stay and fight because they are forced to – there end up having to be 'some things to do'. What does he have to do? Well, he has to get back the Winchester in *Winchester '73*; he has to avenge the murder of Ben in *The Far Country* (he can't go on alone); he must cash in on the bounty in *The Naked Spur*; he must get supplies to the settlement in *Bend of the River*; he has to avenge the cruelty meted out to him in *The Man from Laramie*; he has to defeat the disillusioned general in *The Last Frontier* and he is forced to confront the demons of the past in *Man of the West*.

> It doesn't much matter whether Mann's hero is a man of justice or a reformed criminal, since that is not the source of his quality. His hero belongs to no place, has no social function and no typical Western role: he is not a sheriff, bandit, ranch owner, cowboy, or officer: he doesn't defend or attack the established order, and he does not conquer or defend any land. He acts, and that's it, he does some things. (Rancière 2006: 78)

This is where, in Mann's films, aspects of what Rancière calls the aesthetic regime take hold: in that which exceeds the classical hierarchies of the representative regime. Most emphatically this occurs in a different logic of storytelling which, instead of following the ordered and balanced form expected of the classics, unfolds according to a logic of the encounter, which can occur only in a haphazard way, in terms of the intensities which take the hero from one moment to the next. Rancière argues that, once the action of these films departs from the expectations of the representative regime, 'it is left at the mercy of each moment's varying intensity, much as the hero is at the mercy of a hand twitching towards a belt or a kiss distracting his vigilance' (Rancière 2006: 83).

We might be tempted to say that Mann's Westerns emphasize a certain sensibility that is in accord with the aesthetic regime, where actions are defined not by their harmonious relationship to a hierarchy of forms, but rather by their expression of a sensibility that is nothing less than aesthetic, what Rancière claims is 'the logic of chance and of thinking from one episode to the next' (2006: 82). (This is what Rancière calls, with reference to Mann but also to

other tendencies of the aesthetic regime, the 'logic of the encounter'; see Rancière 2009: 56–9).

And there we have it: Mann's films lie between the aesthetic and the representative regimes – and Rancière will want to generalize to the extent of declaring something like Mann shows us something intrinsic to cinema: that it is a combination of, or that it most adequately lies somewhere between, the representative and aesthetic regimes. It is neither one nor the other, but contains aspects of both. And while we might agree that Rancière makes a good case for this – they are, after all, his own terms – there is also a sense in which this claim is unremarkable. We might feel there is a sense in which this argument does not tell us much, or that it will tell us something of significance only if we build upon it as a starting point. That is indeed what I intend to do here.

The art of cinema

Rancière concludes his chapter on Mann with a rather cryptic claim: that he is neither a Romantic artist nor a non-artist. As a consequence, Rancière argues, this is 'why his films seem so distant to us' (Rancière 2006: 92). Why do Mann's films seem distant to us? One might easily argue the contrary, that his films are brilliant precursors of today's post-genre age, of today's 'spectacular narratives', as Geoff King calls them (King 2000). So why would Rancière accentuate Mann's apparent distance from us? In making his claim, Rancière is drawing upon analyses made elsewhere on the aesthetic regime. By being neither a Romantic nor a non-artist, Anthony Mann exemplifies neither that strand of the aesthetic regime characterized by the Romantic autonomy of art nor the tendency towards the heteronomy of a purported non-artist which characterizes the other dominant strand of the aesthetic regime. As such, so Rancière's argument goes, he is a figure who cannot fulfil the desires expected of the aesthetic regime.

Again we might think this is all well and good: Mann is not a modernist, surely a conclusion that could have been made without the invention of Rancière's categories. But – again – I think we have to examine the wider stakes of Rancière's claims. What he is arguing is that Mann's films, and films and cinema more generally, cannot be expected to achieve the demands of *autonomy* or the demands of *heteronomy* expected of the aesthetic regime. Autonomy, Rancière argues at a number of points, refers to the kinds of artworks, or the aims of artworks, that are utterly separated and distinct from

'everyday life'. If art is to be effective and, furthermore, if it is to lead to some kind of emancipation or to the founding of a new social order, then it must be totally distinct from the forms of everyday life to which we are accustomed. Only by doing this will art be able to shock us out of our daily slumber and inspire us to invent new worlds for ourselves. This, above all, is the dream of abstract art: that it should refuse to replicate the forms and features of everyday life to invent instead a world of new forms, forms that would, according to that dream, lead to a new world and a new life. And this is not merely the dream of ardent modernist painters – Malevich, Kandinsky, Mondrian and so on – but also the dream of a certain kind of cinema, of which Jean Epstein is the great spokesperson, according to Rancière. This dream is that cinema could show us worlds 'beyond perception', beyond everyday life, a secret and new world of the senses. The power of cinema, for these dreamers, was to show us a life beyond the ordinary or everyday. As we already know, this is a dream cinema could not live up to.

The aesthetic regime, while advocating the autonomy of art on the one hand, also advocates the heteronomy of art on the other. The task of heteronomous art is to be *fused with life* to the point where one will no longer be able to tell the difference between art and life. If autonomy advocates an art as totally distinct from life, then heteronomy promotes the exact opposite. Art becomes life, as it were. Again, one way to consider this is in terms of Rancière's claim that, 'In the aesthetic regime, art is art to the extent that it is something else than art' (Rancière 2002: 137). That something else, for heteronomy, is 'life' as such. From this perspective life itself becomes an aesthetic experience, a journey of the sensible, and life can be interpreted as a work of art, as much as a work of art can be aestheticized as life. Rancière does not have to look far for evidence of this transformation in the status of art – again his most convincing examples are Balzac, Flaubert and Zola, writers for whom the sensible details of everyday life become of central artistic concern. Here, the dizzying description of the minutiae of everyday life becomes integral to the artistic project. For painting and the plastic arts as well, the invention of 'realism' with Courbet leads certainly to Manet, the Impressionists and Van Gogh's *Peasant Shoes*, but also to the Bauhaus and its forms of art which are no longer 'merely' art but are objects which also function in everyday life. And so too for contemporary installation arts which have their roots in 'happenings' and other forms are art as 'experience', where it is no longer quite clear where everyday life ends and something called 'art' begins.

There is, thus, a distinction for Rancière between autonomy and heteronomy in so far as they found the dreams of the aesthetic regime. But strange as it might seem, Rancière does not so much wish to accentuate what distinguishes these approaches as much as he wants to claim they are effectively two sides of the same dream: that each is devoted to discovering the new forms of a new life. 'It was on this common programme that the two figures of pure art', that is, autonomy and heteronomy,

> were able to intersect in the 1910s and 1920s; that Symbolist and Suprematist artists could join Futurist or Constructivist denigrators of art in identifying the forms of an art which was purely art with the forms of a new life abolishing the very specificity of art. (Rancière 2007: 21)

In another context, Rancière argues again for the conjunction of these two approaches to the aesthetic regime, for 'in this regime', he writes, 'art is art in so far as it is also non-art, or something other than art' (2009: 36). If art is separated from life, in other words, it is only separated in so far as it points the way to a new life and to new forms of life. 'The work's solitude carries the promise of emancipation. But the fulfilment of that promise amounts to the elimination of art as a separate reality, its transformation into a form of life' (ibid.).

Now, if all of this is a dream of modernism or of the aesthetic regime, there have certainly been filmmakers who have tried to bring this dream to fruition: Eisenstein, Godard, Rossellini and others. But Anthony Mann is not one of these dreamers – and this is the reason Rancière feels he might seem so distant from us: he does not answer the call of the modernist dream. But Mann does not fulfil the requirements of the dream to the same extent that cinema itself could not or cannot fulfil those requirements, for Mann's films and the cinema itself are certainly part of the aesthetic regime, but they are also part of the representative regime.

What is cinema?

Rancière's claims here raise serious questions for the project of political modernism especially as outlined in the first chapter of this book. Central to political modernism, if we adopt Rancière's perspective, was the call for cinema to be true to life – suffice it to recall Wollen's advocacy of 'reality' in opposition to 'illusion': cinema could only be worthy or free from sin if it eschewed illusion

and instead delivered reality (Wollen 1985). But it is also possible to delineate strands of heteronomy and autonomy in the political modernist project. The advocacy of avant-garde cinematic practices which one finds in Wollen, Heath, Baudry and Laura Mulvey sit fairly and squarely on the autonomous side of the argument (suffice it to recall Mulvey's plea 'to free the look of the camera into its materiality in time and space and the look of the audience into dialectics and passionate detachment' (1989: 26)). Cinema could reach its true potential only if it definitively separated itself from the shallow prison of everyday life, and only in this way might it then be 'true to life'.

One also finds for political modernism defenders of a heteronomy of cinema – such is the position occupied by defenders of the 'modernity thesis', whose central argument relies on the assumption that early cinema was in fact 'true to life', that it replicated the experiences of modernity in an immediate and undiminished way. This 'true' cinema was then dismantled by the strategies of narrational morality introduced by D. W. Griffith and others when the American cinema slowly began to dominate international screens. All of this was – so the argument goes – part of turning the true 'cinema of attractions' into a false cinema of illusions: the aesthetic dream of heteronomy and the sensual extravaganza of early cinema were, for these writers drowned by the classical standards of the representative regime (as Rancière calls it).[53] Additionally, for a writer like Miriam Hansen, the only option is to debase cinema as such: to expose its illusions as illusions, for its illusions are merely those of the commodified phantasmagorias of everyday life itself. As Hansen writes, 'the reality conveyed by the cinematic apparatus is no more and no less phantasmagoric than the "natural" phenomena of the commodity world' (Hansen 1987: 204). Or again: cinema, as it stands, can lead only to a 'numbing of the sensorium', instead of an *aisthesis* of emancipation (Hansen 2009: 370). Such arguments go directly back to Balzac, Flaubert's Emma Bovary (punished for her addictions to those numbing phantasmagorias), Aragon's *Paris Peasant* and others as part of the crumbling yet utopian dream-world of commodities so brilliantly described by Walter Benjamin. Cinema's potential to be true to life becomes signals to wake up from that life and to discover a new life, a 'true' life.

We might also think that some of the writers defended in this book could be seen as theorists of the extreme autonomy or heteronomy which Rancière isolates as disturbing traits of the aesthetic regime. Rancière is himself very critical of Gilles Deleuze's supposed

defence of the autonomy of the work of art. Against all figuration, against the organicity of forms and resemblance, Deleuze defends, according to Rancière, 'the pure sensible' or 'the unconditioned sensible' (Rancière 2004a: 7). For cinema, Deleuze divorces the pure matter or spirit of images from the 'old art of telling stories' (Rancière 2006: 6). The cinematic arts are artistic only to the extent that they reveal what has been lost to everyday life and it is their difference – autonomy – from everyday life that will enable a new life to be born (Rancière 2004a: 8). If I am to defend Deleuze against Rancière's accusations, then I will defend him on the basis that Rancière has emphasized an aspect of Deleuze's works that he has wished to discover.[54] Against that, I have expounded a Deleuze whom I have wished to discover: a Deleuze who defends the power of telling stories in the cinema alongside its sensory aspects. If Deleuze's analyses lean towards isolating the autonomy of cinematic works, then that is because he wishes to define a place for cinema's own reality: different from everyday life, but no less real for that. That the reality of film Deleuze discovers is different from the filmic reality articulated by Rancière should come as no surprise.

And would not Bazin offer the most extreme case of the heteronomy of cinema, a cinema which I have argued, is to be 'true to life'? Cannot Bazin therefore be dismissed as a cinematic dreamer whose call for realism was destined to fail? But the fact that Bazin's name so often appears in conjunction with Deleuze's in *Film Fables* – the implication being, for Rancière, that it is Deleuze who perfects and systematizes Bazin's bits and pieces of disjointed criticism – implies his centrality to the aesthetic regime's dream that art could uncover the 'spiritual secret of beings' (Rancière 2006: 12). We might say, in concert with Rancière, that both Bazin and Deleuze achieve similar ends, with Bazin taking the path of heteronomy and Deleuze that of autonomy. But again, if I am to defend Bazin here against Rancière's criticisms, then I can only say that my Bazin is not his, that Bazin's call for a cinema that is 'true to life' is not a call for a cinema fused with life, but rather one which inspires collective, social forms of life, a project central to a political aesthetics, even for Rancière.

The places of art

There are no simple resolutions of these debates, but we can at the very least ask where it is that Rancière might be positioned amid this cacophony of competing visions. Rancière argues that there

are specific places where art 'occurs' in the representative regime, but that, with the onset of the aesthetic regime, the specificity of that place where art is distinguished from life's other concerns disappears. In the representative regime, art is separated from the concerns of the life of the community: its functions are not related to the functioning of the socio-political order – or, at least, they are not related in the same ways as they are with the aesthetic regime (Rancière 2004c: 16–17). In the representative regime, artworks might very well reflect their social and political contexts – as, for example, a portrait of Louis XIV is a display of his power (see Marin 1988), as much as Holbein's *Ambassadors* is a display of the new wealth of a golden age of commerce (as well as symbolizing the vanity and finitude of such wealth). As Rancière claims, such works 'form an analogy with the socio-political order' (Rancière 2004c: 17). Modernism and the aesthetic regime overturn all of this. Art is no longer separated from the concerns of the socio-political order; rather, it can and does intervene in those orders. This is a claim other scholars have made: for example, T.J. Clark argues that modernism is born with the unveiling of David's *Death of Marat* in 1793: this a painting the function of which is to intervene directly in political debates (Clark 1999).

Rancière has his own particular take on these issues. For him, what happens with the emergence of the aesthetic regime is that art begins to play a role of suspension – or, at the very least, one of the most important functions of art becomes that of putting in place a process or activity of suspension. 'The aesthetic state', he writes, 'is a pure instance of suspension, a moment when form is experienced for itself' (Rancière 2004c: 24). This formulation is rather unclear, and its religious or transcendent overtones might sound initially unnerving. But Rancière is trying to discern the ways artworks changed their roles in the late eighteenth and nineteenth centuries, and his claims come down to working out how people's relationships to and understandings of art changed. The moment of what he calls 'suspension' is integral to understanding this change, for it inaugurates, he claims, 'an identification of art with the life of the community' (ibid.: 25). In other words, the process of suspension introduces a sense in which artworks no longer need to function merely by way of analogy, but instead they can function as part of the way a community understands itself and its socio-political ways of being.

An important text in the development of this new sense of the artwork was Friedrich von Schiller's *Letters on the Aesthetic Educa-*

tion of Man (1794). There, it is argued that one of the functions of art, if not its most important function, is that of aesthetic education. In the many places Rancière discusses the importance of Schiller's intervention (2004b, 2004c, 2009), he emphasizes how matters of art become, for Schiller, matters of education: aesthetics becomes a programme that in some way beckons a community towards reflecting upon itself. Rancière will go so far as to assert that this amounts to positing a relation between aesthetics and politics that is a distinguishing feature of the aesthetic regime (Rancière 2002: 137).

Perhaps the best way to work out more precisely what Rancière means by the notion of 'suspension' is to focus on the instances of artistic practice which he sees as falling short of the aesthetics of suspension. Consider the following. Rancière argues, on the one hand, that today there is an aesthetics that 'merely serves to increase the forms of derision and relaxation that today belong to the dominant imaginary and to the ordinary discourse of the media and advertising' (Rancière 2000: 256–7). On the other hand, he claims, 'I wanted to counter these formulas for nonsense with the procedures of rarefaction or suspension of meaning that are specific to art' (ibid.: 257). Again, such claims might at first sound alarming: here is another French master dismissing the ills of television and other 'low' forms of media, all in the name of rescuing the decency and legitimacy of cinema as an art. Proper artworks, Rancière seems to be arguing, have a disruptive function, while those works which fall short of art are ones that make no difference: they merely reinforce the dominant status quo.

Rancière's point is not, however, quite so simple. What he dismisses most categorically about the forms of 'media and advertising' which fail the test of 'suspension' is that they replay the dream of heteronomy that is one of the key strands of modernist discourses. In becoming indistinguishable from life, these works effectively lose their status as art; one might even claim that they lose their desire to be artworks in aiming to go beyond art. Rancière's clearest denigration of this kind of approach to the fusion of art and life might be this: 'By making what is ordinary extraordinary, it makes what is extraordinary ordinary too' (Rancière 2002: 145). Here there is no prospect for change, no prospect of difference, just an endless repetition of the same.

The flipside of this position – that all art becomes fused with life – is that all aspects of life instead become works of art. Therefore, if one side of this equation for Rancière is that everyday, banal, ordinary instances of production become interpreted and under-

stood in one way or another as 'art', or at the very least as objects worthy of semiotic attention à la the Barthes of *Mythologies*, then the other side of the equation occurs when works of art begin to pretend not to be art, and instead desire to become everyday, banal, ordinary objects. Art becomes life:

> The danger in this case is not that everything becomes prosaic. It is that everything becomes artistic – that the process of exchange, of crossing the border [between art and life] reaches a point where the border becomes completely blurred, where nothing, however prosaic, escapes the domain of art. This is what happens when art exhibitions present us with mere reduplications of objects of consumption and commercial videos, labelling them as such, on the assumption that these artefacts offer a radical critique of commodification by the very fact that they are the exact reduplication of commodities. (Rancière 2002: 146)[55]

For Rancière, then, it is not only the so-called 'low' forms of culture – media and advertising, as he puts it – that fail the test of 'suspension' but also much of today's so-called 'high' culture – installation arts, exhibitions such as *Let's Entertain* or *Voilà*.[56] What we witness here is perhaps none other than what Fredric Jameson noted some years ago as a change from parody to pastiche, from the kinds of artworks in the first half of the twentieth century which openly and critically attacked and denounced political institutions and programmes to the late twentieth century's acceptance that power and privilege are all merely 'part of the show' (Jameson 1984). Rancière dismisses the appeal to a postmodern transformation à la Jameson and instead claims that art's critical processes have turned in upon themselves. The contemporary works of which he disapproves still function by way of critique, he argues, but

> they work by turning in on themselves, just like deriding power in general has taken the place of political denunciation. Or else their function is to make us sensitive to this automaticity itself, to delegitimize the procedures of deligitimization at the same time as their object. Thereby does humorous distanciation take the place of the provocative shock. (Rancière 2009: 52)

What Rancière is trying to say is that these works are content to merely display 'how the system works' or 'how power functions' as though this is enough to be offering a critique. What they achieve, however, is quite the contrary: they function in much the same way as the media and advertising themselves do – these artworks' dismissals or unmaskings of deligitimization as *passé* necessarily

drain them of any deligitimizing potential: 'in their passage from the critical to the ludic register, these procedures of deligitimization have almost become indiscernible from those spun by the powers that be and the media or by the forms of presentation specific to commodities' (Rancière 2009: 54). Rancière's denunciation of 'media and advertising' is therefore part of a long and carefully considered critique of recent instances of image production in general, and not at all a denunciation of 'low' culture.

Mann and the art of cinema

What, however, about the cinema and the films of Anthony Mann? We have already discovered that Mann is no modernist, and that for this reason his films, as Rancière claims, 'seem distant to us'. Curiously, however, television and the audience enter into Rancière's discussion in an intriguing way. They do so in a way that will allow us to isolate the features of a mode of 'suspension' specific to the cinema. I shall attempt to unpack what Rancière is trying to say here about the films of Mann and their audiences:

> The hero's invincibility, of course, is primarily a matter of the contract between the director and the audience, a contract Mann subscribes to without reservations. It is only fitting for the hero to triumph, for the man who said 'I'll do this' to do it, for the hero to fulfil the desires of all the people out there in those darkened rooms who have gotten used to the fact that they'll never do what they would have hoped to do. (Rancière 2006: 75–6)

Surely this seems an unfair rejection of Mann's films and his audiences, a proclamation that the bottom line for his films is that they provide escapist fare for audiences whose expectations and dreams have failed to materialize? But we should not be too hasty in accepting Rancière's comments here, for he follows them up with comments even more devastating:

> Tragedy, Aristotle writes, must have a beginning, middle, and an end. It is only right for the bad guys to be shot down, or else the Western, missing an end, would never have come into being in the first place – the same is true of tragedy. Meanwhile, for all those who'd rather never have done with anything, providence invented television and the serial, both of which can last as long as the world: all they need do is announce that tomorrow, like today, nothing will happen either. (ibid.: 77)

When art becomes life there is nothing more to do. There are no longer even 'some things to do'.

Mann's works are not autonomous ones, even if they are at times subject to a sensuous logic of the encounter. Nor are they heteronomous, for they still have beginnings, middles and ends. These limiting factors affirm that Mann's Westerns still carry with them the baggage of the representative regime alongside that of the aesthetic regime, as we have already seen. But ultimately this means that what is at stake in these films – and in the cinema more generally for Rancière – is its capacity to play these regimes and dreams off one another: the dreams of autonomy exist alongside their counterparts in heteronomy while each also undermines the other; the utopian longings of the aesthetic regime push against the hierarchical structures of the representative regime, while each also acts as a limit on the excesses of the other. And it is this conflict, this capacity for the cinema to be 'both-and', which comprises for Rancière what I would call 'filmic reality'. I might even go so far as to say that here cinema becomes a product of its own compromises: if it becomes too 'aesthetic' it ends up with vacuous, if still sensitive, impossibilities; too 'representative' and all it can do is to replicate existing hierarchies. Too autonomous and we end up with something like the video installations of which Rancière is so dismissive (or, along the same lines, we end up with *Histoire(s) du cinéma*). Too heteronomous, on the other hand, and we have television. Perhaps even more to the point, Rancière emphasizes the equivalence of these approaches, an equivalence between the 'high' autonomy of the work and its 'low', heteronomous twin. And yet there is cinema, defiantly, resolutely in between. For Rancière, such is the reality of film.

All the same, there is a suspension proper to cinema, and it works in this way. It consists of the operation of the aesthetic regime upon the representative regime in order to produce the 'suspension' proper to art. And this is precisely what Mann achieves: to the traditional, representative hierarchies of the Western he introduces an aesthetic dimension, an upsetting or derailing suspension which displays directly the impact of the aesthetic revolution upon the representative regime. It is this act of disruption – that the cinema discovers it has 'some things to do' – which makes cinema special for Rancière, and so too does it make Mann's Westerns exemplary.

It is this speciality that will lead Rancière to claim, when speaking of Bresson, that 'The image is never a simple reality. Cinematic images are primarily operations' (Rancière 2007: 6). He then continues at length:

> This is the sense in which art is made up of images, regardless of whether it is figurative, of whether we recognize the form of identifiable characters and spectacles in it. The images of art are operations that produce a discrepancy ... [T]he commonest regime of the image is one that presents a relationship between the sayable and the visible, a relationship which plays both on the analogy and the dissemblance between them. (Rancière 2007: 7)

To put it another way, the images of art are ones which introduce into the hierarchical analogies of the representative regime a dissemblance or discrepancy that 'suspends' the anticipated relations, just as Mann presents us with stories straight out of the representative canon only to disrupt them with an uneasy suspension of the logic of those stories. For Rancière, the cinema achieves this disturbance naturally, as it were, as a consequence of the stories it tells and of the stories it has told, of the forms it has made of itself. We should stop worrying about what the cinema could be or should be, what it might have the potential to become or what it might once have been but is no more. When we have stopped dreaming such dreams we will have arrived at the reality of film. That reality is what film is.

Afterword

I began this book by declaring the difficulty I had in defining just what is meant by 'filmic reality' and that a cause for that difficulty had been the location of this concept beyond the normal paradigms of thinking about film. 'Filmic reality' is simply not a concept film studies would wish to foster, for we all know that films are not real. They are, on the contrary, escapes, illusions or representations. And while I have done my best to counter this tendency of film studies to dismiss films in this way and to defend a claim for the reality of film, I have still been unable to define precisely what filmic reality *is*. Rather, what this book has presented are several approaches to the notion of filmic reality; several ways of conceiving of filmic reality. If I were to draw a conclusion from these approaches, then the simple conclusion that can be drawn is that there is no *one* reality of film. On the contrary, there are myriad ways of conceiving of filmic reality, and it might be the case that in this book I have merely touched the surface of those ways.

Filmic reality is an attitude. It is a way of approaching films as primary things. It is a way of approaching films as 'characteristic of real being' (as Cornelius Castoriadis puts it; 1997a: 5). To conceive of films in this way is to avoid approaching them as 'deficient or secondary modes of being' (ibid.), for to conceive of films in that deficient mode has been the typical way in which films have been theorized. Throughout this book I have tried to call this characterization of film's deficiencies, of its illusions, 'political modernism', for it is by way of political modernism that this approach to the deficiencies of cinema has become entrenched for many film scholars.

I have therefore tried to outline several approaches here to 'filmic reality', the ones that have seemed most important to me and which have allowed me to think through this 'attitude'. Many other thinkers might have been found: Walter Benjamin, Siegfried Kracauer, Victor Perkins and many more besides. One hope might

be that such thinkers would provide fuel for future research. But, without question, the six theorists whose thoughts I have traced in this book are not the only theorists of filmic reality. As I have discovered, filmic reality is far less a thing than an attitude. If nothing else, I hope readers of this book come away with a different attitude towards films: to think of them as primary beings, not as illusions or escapes, and not even to conceive of them as 'only' films such that their events are ones that 'could only happen at the movies'. The lesson of all the theorists approached here has been that films are far more important than that: they are parts of our lives, parts of the ways we conceive or ourselves, our societies, and our relations to other people. If we are used to dismissing films as being 'only films', then this book has tried to do nothing less than prove that films are more important than the dismissals we are so used to directing towards them.

Perhaps the reader will be dismayed that I have failed to chart the discrepancies between the approaches I have discussed. How can Deleuze be placed alongside Metz, Rancière alongside Bazin, Deleuze alongside Cavell and so on? Perhaps most audacious is the seemingly happy relationship between psychoanalytic approaches (Metz, Žižek) and that of Deleuze, for Deleuze is surely one of the most vehement critics of Freudian and Lacanian theories. Žižek has even published an entire book critical of Deleuze (Žižek 2004), while Rancière (as we have already discovered) finds serious short-comings in Deleuze's approaches to film and aesthetics. I should therefore stress that I have deliberately avoided pitting these theories against one another. I wanted to avoid a scorecard by means of which I could discover who provides the best theory. Instead, my point was to emphasize something which all of these theorists offer against the prevailing trends of film studies. Each of these theorists is keen to stress the reality of all films, rather than dismiss films or types of films as illusory, and instead of dividing films by way of judgements about which films are good and which are bad. That, for me, is how I have tried to arrive at the attitude of filmic reality.

'Refractions' of reality?

John Mullarkey's book *Refractions of Reality* (2009), published while I was drafting the present book, offers something approaching a theory of the reality of film. His thesis on 'refractions' of reality is explicitly opposed to theories of film which posit them as 'reflections' of reality, and on this point I am in firm agreement. For Mullarkey,

films are refractions of reality but only in so far as reality itself is composed of refractions. In other words, reality never emerges in a pure form but is always bent, reshaped, reformulated and filtered by myriad factors. The key philosophical figure here is Bergson, from whom Mullarkey develops an interesting take on Bergson's critique of cinematographic thinking. He writes that Bergson's critique amounts to declaring that 'cinema is important as the model of how we normally *misunderstand* reality' (Mullarkey 2009: 97), or further, that '[t]he cinematic illusion is in truth a variant of normal perception' (ibid.: 149). Needless to say, these are theses similar to ones I have defended in this book.

And yet, what Mullarkey calls 'reality' feels remarkably divorced from the kinds of realities I have tried to present throughout this book. The discrepancy comes down to an interpretation of Bergson's notion of 'image'. Where I have tried to argue that for Bergson (and for Deleuze after him) an 'image' is a conjoining of the perceiver with what is perceived, Mullarkey instead claims (against Deleuze) that 'by "image" we are meant to understand a percept without a perceiver' (ibid.: 100). In other words, for Mullarkey, images are freed from the impositions and distortions *we* might give them, whereas from my perspective the kinds of distortions or illusions we might happen to impose on images are part and parcel of those images.

What, then, are the ramifications of this discrepancy between Mullarkey's understanding of images and my own? (I am less interested in which is the correct interpretation of Bergson than by the consequences of each of our (mis)interpretations.) For Mullarkey, the consequence is that his understanding of reality is one that is freed from the distortions and impositions of human thought. At one point he declares, for example, that '[t]he autonomy of the Real leaves all philosophies relative' (ibid.: 205). Indeed, for Mullarkey, a true form of thinking, and a true form of 'film thinking', is one freed from the limitations of human thought: a true discovery of film thinking will be, in other words, something we, as humans, have never been able to think before.

> With regards to cinema, film's own thinking would reside in its freedom to refract our attempts to think it – a freedom that *we* only see as a shortfall of reflection, a *failure of proper thought*. (ibid.: 190)

On this view, Mullarkey's understanding of cinema's realities is quite different from my own. I have contended throughout this book that the reality of film is not something that could (or should

or would) be freed from our own thoughts. On the contrary, I have emphasized that 'the only access we have to reality is by way of the capacities of human subjectivity' (p. 61). I have also stressed that it is the capacities of human imagination that films have the capacity to invoke over and above any material or physical reality. It is not any supposed reality 'in front of the camera' which is the focus of the reality of film, but a reality of conception, of imagination, of fantasy and, even, of ideology. It is perhaps on this latter point – ideology – that Mullarkey's view can be most sharply contrasted with my own, for Mullarkey seems intent on discovering a reality – and a filmic reality – freed from the distortions of ideology. In the terms in which I put it in Chapter 6, Mullarkey desires a transcendent filmic Real, not an ideological filmic reality. Any reader of this book will know I have tried to defend the latter conception. Other readers will no doubt also have noticed that Immanuel Kant is mentioned in each chapter of this book, a factor which has no doubt delivered to my conception of filmic reality something of an idealist tone (and for which I have no need to apologize). Nevertheless, I am certainly tempted to declare that both Mullarkey and myself have proposed theories of filmic reality, but that our understandings of just how that reality might be constituted differ in important ways.

It happened ...

Mullarkey's book is nevertheless an important one: it is imbued with a love and enthusiasm for film I find lacking in most works by scholars trained in film studies (Mullarkey trained as a philosopher). I find the arrogant disdain for cinema practised by so many scholars to be baffling, almost as though a proper training in film studies is one which teaches you to regard most films with contempt. One might then hope to discover one's niche in order to spend a career proving how much better this niche is than 'ordinary' or 'orthodox' cinema (Godard's films are important because they are unorthodox; melodramas are important because they differ from ordinary cinema; documentaries are special because they are not like normal cinema, and so on). But cinema, inherently, in its essence, at its core, is no good. What the scholar must endeavour to do is to teach it to be good. Consider the following:

> Movies consistently erect insuperable obstacles to the fulfilment of their protagonists' desires, and then engineer implausible 'happy endings' that could, as they say, 'only ever happen in the movies'. One of the most fundamental sources of the pleasure that movies offer their

audiences is the demonstration of their magical power to fulfil their impossible promise by resolving the incompatibilities and paradoxes around which they construct their plots. This is, of course, also the principal occasion of their unreality, the 'escapism' of which they are so conventionally accused. If Hollywood's movies lie to us, they do so most often by teaching us that nothing is so emotionally satisfying as the reconciliation of irresolvable contradictions. (Maltby 2005: 222)

The contempt for cinema here is quite breathtaking, for in the movies we are presented with unrealities, and such unrealities are the kinds of things which can 'only ever happen on film'. Films have nothing to do with our lives except inasmuch as they offer magical escapes from those lives, escapes for 'their audiences' (for such scholars it is always *them*, never *me*), fabricated by movies which 'lie to us' (so they lie not only to *them*, but also to *us*). And all this from a well respected film professor with an impressive *curriculum vitae*.

The film being discussed in the above quotation is none other than Capra's *It Happened One Night*, also examined in Chapter 4 above. There *It Happened One Night* was praised for its ability to realize fantasies, to make them real; not to fabricate them as escapes or lies. My argument there centred on trying to understand or appreciate why Hollywood's fantasies have been so magically powerful and why its dreams are ones worth taking seriously, rather than merely dismissing them as dreams. Hollywood films most certainly do encourage us to dream, but that need not amount to a turning away from reality. Instead, what I have tried to emphasize in a number of contexts throughout this book is that films can present us with dreams that become realities, that, and more often than not, cinema's dreamworlds *are* its realities. These are realities then, that we should attempt to clarify and understand, not ones we should dismiss as ones that dupe 'their audiences', that offer only escapes, that are emotionally satisfying only because they show impossibilities.

The scholar quoted above concludes his analysis of *It Happened One Night* in the following way:

That is the hidden reason why Hollywood movies have happy endings. The reestablishment of order renders the viewer's experimentation with expressive behaviour a matter of no consequence, contained as it is within the safe, trivialized space of entertainment. No matter how vividly we have experienced Hollywood's imaginary landscapes and utopian possibilities, we leave the theater reminding ourselves that what we have seen is 'only a movie'. (Maltby 2005: 235)

Phew! We need not take movies seriously, then, for we know they are 'only' movies, and that they have no consequences. Movies are 'safe' and 'trivial'; we need not ever confuse them with reality (a reality that must, I assume, be dangerous and non-trivial in ways that Hollywood movies refuse to be).

If this book has a guiding aim, then it is that we stop conceiving of films as illusions or distortions of reality in ways that sever films from the concerns of the (so-called) 'real world'. Rather, my desire has been to foreground films and our experiences of them and ways of understanding them as parts of reality. Not as divorced from reality, but as composed of the kind of stuff that is real for us: thoughts, feelings, dreams, emotions, points of view. There are other ways this might have been done – for example, I might have set my project as one that tried to counter the general philosophical tone of a Debord ('society of the spectacle'), an Adorno ('the culture industry') or even a Heidegger ('the age of the world picture'). These are all so many ways in which our media world and our image world have been declared defunct and fraudulent or 'bad for us', so many ways of instructing us that we do not know what to do with films and that they will be harmful in ways that we cannot know about (they further try to convince us that only experts can allow us to know about such things, such as the scholar above who dismisses Hollywood films and 'their' audiences). Again, this book has tried to counter those who believe films and other images are inherently 'evil', deceitful or illusory. To reiterate Deleuze's marvellous Bergsonain claim that 'an image does not represent some prior reality; it has its own reality' (2006a: 215). The images of films – as well as their sounds, memories, evocations, illusions and imaginings – are all part of a reality we inhabit and dream about. That is the reality of film.

Notes

1 On the question of films and their adherence or faithfulness to some preconceived conception of the 'real world', see the discussion in Barker and Brooks 1999.

2 On this point see Bordwell 1995.

3 In *The Crisis of Political Modernism* (Rodowick 1994), D.N. Rodowick details the oppositions at work in political modernism. He writes that, on the basis of political modernism, 'The task of criticism divides into two separate but related paths. First is the critique of commercial, narrative film as illusionistic. By offering a narrative based on principles of unity, continuity, and closure, so the argument goes, Hollywood films efface the materiality of the film medium and through this transparency of form promote an identification with, and unquestioning acceptance of, the fictional world offered by the film. Secondly ... [t]he task here is to recover forms that resist or contest this transparency and illusionism' (xiii).

4 Wollen's 'seven deadly sins' are opposed to the 'seven cardinal virtues' in the following manner (Wollen 1985: 501):

Narrative transitivity	Narrative intransitivity
Identification	Estrangement
Transparency	Foregrounding
Single diegesis	Multiple diegesis
Closure	Aperture
Pleasure	Unpleasure
Fiction	Reality

5 Rodowick 1994: viii. Rodowick's book arrived before the critique of film theory raised by 'Post-Theory' (see Bordwell and Carroll 1995). It appears, however, that most film theorists — at least, those theorists influenced by continental 'Theory' (Barthes, Lacan, Derrida, Benjamin, Kracauer, Brecht and so on) — have by and large ignored the arguments of 'Post-Theory'. As this chapter demonstrates, film theory continues with a political modernist goal, undeterred by the criticisms raised by Bordwell, Carroll and others.

6 For an interesting discussion of issues related to the 'modernity thesis', see David Bordwell 1997: 140-9; and Bordwell 2005: 244-9.

7 In an article on 'Primitive' cinema, Gunning demonstrates his indebt-edness to another champion of political modernism: Noël Burch. See Gunning 1990a. Also see Burch 1973; 1990. For a stimulating recent discussion of Burch, see Bordwell 1997.

8 On the notion of the 'reality effect' see Barthes 1986; Bonitzer 1990; and Oudart 1990.

9 Gunning argues, for example, that 'The sudden, intense, and external satisfaction supplied by the succession of attractions was recognised by Kracauer as revealing the fragmentation of modern experience' (Gunning 1989: 42). Also see Kracauer 1995.

10 Hansen refers to Metz (1982) and Baudry (1985).

11 In a variety of articles, Hansen expands this notion of 'something altogether more critical' in terms of a spectator's capacities for 'play' and 'innervation'; see Hansen 1999, 2003, 2008.

12 See, for example, Willeman 1977, MacCabe 1985.

13 Margulies is fully aware of this argument; she writes that discourse of political modernism 'polarised classical and countercinema practices, constantly pitching Hollywood cinema's deceptiveness and illusionism against an avant-garde whose task was the promotion of the critical awareness of the materiality of the medium' (Margulies 2003b: 7).

14 Margulies writes at another point that contingency is 'the central quality of the cinema' (2003b: 9).

15 David Bordwell refers to the dominant form of Grand Theory in the wake of 'subject position' theory as being 'culturalism'. I think he is correct to do so. See especially Bordwell 1995: 8-12.

16 Joyrich places a footnote here which acknowledges the writings on Sirk of a number of authors, many of whom can be considered political modernists; e.g., Paul Willeman and Laura Mulvey.

17 Joyrich places another footnote here, which lists some classic contribu-tions to debates on melodrama (see, for example, Gledhill 1987).

18 Joyrich includes another reference here to a debate on melodrama in *Screen*. See Pollock, Nowell-Smith and Heath (1977).

19 A recent, very sympathetic reading of Bazin affirms this view: 'Bazin's theory of cinematic realism is chiefly concerned with forms of film-making which correspond to our perception of perceptual reality, and which create a framework within which the spectator can explore freely' (Aitken 2001: 186).

20 As I have already suggested, this is a key strategy in dismissals of Bazin (see the earlier references to Stam and Flitterman-Lewis (1992), and Hallam and Marshmant (2000)).

21 Digital effects were very much evident in the twenty-fifth anniver-sary release of the film (2007). These 'updated' special effects do not, however, concern me here.

22 For an analysis of Sirk's films from this perspective, see Wollen 1981.

23 I rely here on the selection of Diderot's writings on art in Diderot 1994.

24 Few film scholars today would accept the rough history of cinema

presented by Bazin in 'The evolution of the language of cinema' as being historically accurate (see, for example, Bordwell 1997: 46–82). In Bazin's defence, however, it is worth arguing that he was writing from *within* the history he is trying to chart, a history monumentally skewed by the Second World War. Thus, the history of cinema was, for Bazin, the history of *his experience* of cinema, not, by today's standards, an objective, scholarly or academic one.

25 The original French reads, 'Ces deux séquences consituent sans doute la « performance » limite d'un certain cinéma, sur le plan de ce que l'on pourrait appeler « le sujet invisible », je veux dire, totalement dissous dans le fait qu'il suscité' (Bazin 1990: 326).

26 The portrayal of Maria in the kitchen seems to me to be echoed by Jeanne Dielman's meticulous attention to her household chores in Chantal Akerman's *Jeanne Dielman, 23 Quai du Commerce, 1080 Bruxelles* (1975). Ivone Margulies describes Akerman's approach as 'hyperreal', and delicately unpacks the complex nature of Akerman's modes of address, with reference to her 'theatricality' in the light of Fried's theories. See Margulies 1996: 54–6.

27 Bordwell, as I have already mentioned (see Bordwell 1997), is certainly one scholar who has taken Bazin to task for his inaccuracies.

28 Fried's most recent book (2008) again takes up issues of absorption and theatricality, this time in relation to photography.

29 As Fried argues when examining Diderot's review of Greuze's *A Young Girl Weeping for Her Dead Bird*, this absorptive painting both *elicits and resists* the beholder's intervention 'in' the painting; which is to say that absorptive works of art both explicitly invite the beholder's view, but they simultaneously acknowledge their separateness from the beholder (Fried 1980: 59).

30 In an essay on 'Anti-Cartesianism', Pippin explains the way in which his Hegelian approach to the question of subjectivity is different from, on the one hand, the Heideggerian notion of 'thrownness', in which the actions of any individual human (or *Dasein*) are predetermined by the sociality of the world in which they occur and thus are divorced from any subjective intentionality, and, on the other hand, from a Cartesian solipsism, in which the question of a human's being-in-the-world is reduced to the mind of the individual as a 'thinking thing'. Definitive for Pippin, derived from his interpretation of Hegel, is the relationship between a potentially intending subjectivity and the social world in which those intentions matter. I think this is also precisely what is at issue for the notions of absorption and authenticity: the stretching of the human being's relationship from subjectivity to sociality. Pippin refers to this as 'mutually affirming free subjectivity' (Pippin 1997: 392).

31 Pippin tries to work through some of these issues with reference to Heidegger's and Merleau-Ponty's notions of being-in-the-world (Pippin 2005: 589–94), while Staiger (1984) also addresses the relations between Merleau-Ponty and Bazin. Recently Annette Kuhn has argued, with

Merleau-Ponty in the foreground, that 'Bazin was interested in getting to the very heart of cinema; in understanding its special qualities, its inherent nature, what makes film different; and in how the world on screen presents itself to us, engaging our being-in-the-world' (Kuhn 2005: 405).

32 Bazin refers to an article by Rosenkranz that appeared in *Esprit* in 1937 (Bazin 1967e: 99).

33 The importance of 'bodies in space and time' is central to Bazin's conception of realism in the cinema. See especially his comments on William Wyler's *The Best Years of Our Lives* (1946) (Bazin 1997e: 14–15).

34 For a misinterpretation in this regard, see Grodal 1997: 103–5.

35 On this point see Cowie 1997: 140.

36 Slavoj Žižek is fond of referring to this Lacanian motif. See, for example, Žižek 2008: 329.

37 Fried himself seems unable to come to terms with Brecht. In a recent article he merely refers to Brecht as 'a highly ambiguous figure with respect to the issue of theatricality' (Fried 2005: 574).

38 On the notion of the spectatorial contract, see Comolli 1980. Metz discusses this article in Metz 1979: 23.

39 Metz includes a reference here to his '*Trucage* and the film' (Metz 1977).

40 Much of the ire directed against 'classical Hollywood' takes the form of critiques of Bordwell, Staiger and Thompson's *The Classical Hollywood Cinema* (1985) rather than explicit critiques of Metz. See, for example, Cowie 1998. Kristin Thompson has mounted a very convincing defence of the notion of 'classical' Hollywood style; see Thompson 1999.

41 Cavell uses these terms in 'What photography calls thinking'; 2005b: 118.

42 For more of my own thoughts on the relationship between acknowledgement and cinema, see Rushton 2010.

43 For a sustained discussion of the relationship between Cavell's and Deleuze's approaches to cinema see D.N. Rodowick 2007.

44 Thus begins one of Deleuze's final pieces, written with Félix Guattari: 'We require just a little order to protect us from chaos' (see Deleuze and Guattari 1994: 201).

45 I have tried to argue this point in Rushton 2008 and 2009.

46 Ronald Bogue has detailed the way that Deleuze borrows from the art historian Elie Faure to substantiate this position: 'the mechanical art of cinema presents movement and duration directly, showing us through the camera's non-human eye – through unexpected framings, shot angles, slow motion, fast action, stop action – features of the world as yet unperceived by human beings'. He continues, 'The cinema's moving images directly affect the mind and bring about an 'intimate union of the material universe and the mental / spiritual universe' (Bogue 2003: 166).

47 Žižek has a particular fondness for Lévi-Strauss's essay 'Do dual organizations exist?' (Lévi-Strauss 1963a). See Žižek 2005: 263–4.

48 The only reference to this essay of Lévi-Strauss's that I can find in Žižek is in 2001: 161.

49 Following the publication of Laclau's *On Popular Reason* (2005), a rather heated debate ensued between Laclau and Žižek in the pages of *Critical Inquiry*. See Žižek 2006a, 2006b and Laclau 2006.

50 A very similar argument occurs in Žižek 2001: 166.

51 For the most recent evocation of this perspective, by a Lacanian, see McGowan 2007.

52 I refer here to Louis Marin (Marin 1999).

53 See, for example, Abel 1999, 2006 and Grieveson 2004.

54 Rancière's most incisive critique of Deleuz's *Cinema* books occurs in his essay, 'From one image to another? Deleuze and the ages of cinema', in Rancière 2006: 107–24.

55 See also, 'Problems and transformations of critical art', in Rancière 2009: 45–60.

56 Rancière discusses these exhibitions in 2007: 25–9, and 2009: 45–60.

References

Abel, R. (1999) *The Red Rooster Scare: Making Cinema American, 1900–1910*, Berkeley, Los Angeles and London: University of California Press.

Abel, R. (2006) *Americanizing the Movies and 'Movie-Mad' Audiences, 1910–1914*, Berkeley: University of California Press.

Aitken, I. (2001) *European Film Theory and Cinema: A Critical Introduction*, Edinburgh: Edinburgh University Press.

Allen, R. (1995) *Projecting Illusion: Film Spectatorship and the Impression of Reality*, New York: Cambridge University Press.

Allen, R., and Smith, M. (1997) 'Introduction: film theory and philosophy', in Richard Allen and Murray Smith (eds), *Film Theory and Philosophy*, Oxford: Clarendon Press, 1–35.

Althusser, L. (1969) *For Marx*, trans. Ben Brewster, London: Allen Lane.

Althusser, L (1971) 'Ideology and ideological state apparatuses (notes towards an investigation)', in *Lenin and Philosophy and Other Essays*, trans. Ben Brewster, New York: Monthly Review Press, 85–126.

Barker, M., and Brooks, K. (1998) *Knowing Audiences: Judge Dredd, Its Friends, Fans and Foes*, Luton: University of Luton Press.

Barker, M., and Brooks, K. (1999) 'Bleak futures by proxy', in Melvyn Stokes and Richard Maltby (eds), *Identifying Hollywood's Audiences: Cultural Identity and the Movies*, London: BFI, 162–74.

Barthes, R. (1977a) 'The photographic message', in Stephen Heath (ed. and trans.), *Image-Music-Text*, New York: Noonday Press, 15–31.

Barthes, R. (1977b) 'Diderot, Brecht, Eisenstein' in S. Heath (ed. and trans.), *Image-Music-Text*, London: Fontana, 69–78.

Barthes, R. (1981) *Camera Lucida: Reflections on Photography*, trans. Richard Howard, New York: Hill and Wang.

Barthes, R. (1986) 'The reality-effect', in *The Rustle of Language*, Berkeley and Los Angeles: University of California Press, 141–8.

Baudry, J.-L. (1976), 'The apparatus', *Camera Obscura* 1, 104–26.

Baudry, J.-L. (1985) 'Ideological effects of the basic cinematographic apparatus', in B. Nichols (ed.), *Movies and Methods Volume II: An Anthology*, Berkeley, Los Angeles, CA., and London: University of California Press, 531–42.

Bazin, A. (1967a) 'The ontology of the photographic image', in *What Is Cinema?* trans. Hugh Gray, Berkeley, Los Angeles and London: University of California Press, 9–16.

Bazin, A. (1967b) 'The evolution of the language of cinema', in *What Is Cinema?* trans. Hugh Gray, Berkeley, Los Angeles and London: University of California Press, 23–40.

Bazin, A. (1967c) 'The myth of total cinema', in *What Is Cinema?* trans. Hugh Gray, Berkeley, Los Angeles and London: University of California Press, 17–22.

Bazin, A. (1967d) 'Theater and cinema (part one)', in *What Is Cinema?* trans. Hugh Gray, Berkeley, Los Angeles and London: University of California Press, 76–94.

Bazin, A. (1967e) 'Theater and cinema (part two)', in *What Is Cinema?* trans. Hugh Gray, Berkeley, Los Angeles and London: University of California Press, 95–120.

Bazin, A. (1967f) 'The virtues and limitations of montage', in *What Is Cinema?* trans. Hugh Gray, Berkeley, Los Angeles and London: University of California Press, 41–52.

Bazin, A. (1971a) 'An aesthetic of reality: Cinematic realism and the Italian school of the liberation', in *What Is Cinema? Volume II*, trans. Hugh Gray, Berkeley, Los Angeles and London: University of California Press, 16–40.

Bazin, A. (1971b) 'De Sica: Metteur en scène', in *What Is Cinema? Volume II*, trans. Hugh Gray, Berkeley, Los Angeles and London: University of California Press, 61–78.

Bazin, A. (1971c) 'In defence of Rossellini', in *What Is Cinema? Volume II*, trans. Hugh Gray, Berkeley, Los Angeles and London: University of California Press, 93–101.

Bazin, A. (1971d) '*Umberto D*: A great work', in *What Is Cinema? Volume II*, trans. Hugh Gray, Berkeley, Los Angeles and London: University of California Press, 79–82.

Bazin, A. (1971e) '*La Terra Trema*', in *What Is Cinema? Volume II*, trans. Hugh Gray, Berkeley, Los Angeles and London: University of California Press, 41–6.

Bazin, A. (1971f) '*Bicycle Thief*', in *What Is Cinema? Volume II*, trans. Hugh Gray, Berkeley, Los Angeles and London: University of California Press, 47–60.

Bazin, A. (1981) *French Cinema of the Occupation and Resistance: The Birth of a Critical Esthetic*, trans. Stanley Hochman, New York: Frederick Ungar, 1981.

Bazin, A. (1990) *Qu'est-ce que le cinéma?* ed. Guy Hennebelle, Paris: Éditions du Cerf.

Bazin, A. (1997a) '*Germany, Year Zero*', in *Bazin at Work: Major Essays and Reviews from the Forties and Fifties*, ed. Bert Cardullo, New York and London: Routledge, 121–4.

Bazin, A. (1997b) 'The case of Marcel Pagnol', in *Bazin at Work: Major Essays and Reviews from the Forties and Fifties*, ed. Bert Cardullo, New York and London: Routledge, 53–60.

Bazin, A. (1997c) 'The life and death of superimposition', in *Bazin at Work:*

Major Essays and Reviews from the Forties and Fifties, ed. Bert Cardullo, New York and London: Routledge, 73–6.

Bazin, A. (1997d) 'Will CinemaScope save the film industry?', in *Bazin at Work: Major Essays and Reviews from the Forties and Fifties*, ed. Bert Cardullo, New York and London: Routledge, 77–92.

Bazin, A. (1997e) 'William Wyler, or the Jansenist of directing', in *Bazin at Work: Major Essays and Reviews from the Forties and Fifties*, ed. Bert Cardullo, New York and London: Routledge, 1–22.

Beasley-Murray, J. (1997) 'Whatever happened to neorealism? – Bazin, Deleuze, and Tarkovsky's long take', *Iris* 23, Spring, 37–52.

Benjamin, W. (1996) 'One-way street' in *Selected Writings Volume 1, 1913–1926*, ed. M. Bullock and M.W. Jennings, Cambridge, MA, and London: The Belknap Press, 444–88.

Benjamin, W. (2002) 'The work of art in the age of its technological reproducibility: second version (1936)', in *Selected Writings Volume 3, 1935–1938*, edited by M. W. Jennings, Cambridge, MA, and London: Harvard University Press, 101–33.

Benjamin, W. (2003) 'The work of art in the age of its technological reproducibility: third version (1939)', in *Selected Writings Volume 4, 1935–1938*, edited by M.W. Jennings, Cambridge, MA, and London: Harvard University Press, 251–83.

Bergson, H. (1911) *Creative Evolution*, trans. Arthur Mitchell, New York: Henry Holt.

Bergson, H. (1996) *Matter and Memory*, trans. N.M. Paul and W.S. Palmer, New York: Zone Books.

Bogue, R. (2003) *Deleuze on Cinema*, London and New York: Routledge.

Bonitzer, P. (1990) '"Reality" of denotation', in N. Browne (ed.), *Cahiers du cinéma, 1969–1972: The Politics of Representation*, Cambridge, MA: Harvard University Press, 189–202.

Bordwell, D. (1995) 'Contemporary film studies and the vicissitudes of grand theory', in D. Bordwell and N. Carroll (eds), *Post-Theory: Reconstructing Film Studies*, Madison: University of Wisconsin Press, 3–36.

Bordwell, D. (1997) *On the History of Film Style*, Cambridge, MA, and London: Harvard University Press.

Bordwell, D. (2005) *Figures Traced in Light: On Cinematic Staging*, Berkeley, Los Angeles and London: University of California Press.

Bordwell, D. and Carroll, N. (eds) (1995) *Post-Theory: Reconstructing Film Studies*, Madison: University of Wisconsin Press.

Bordwell D., Staiger, J. and Thompson, K. (1985) *The Classical Hollywood Cinema: Film Style and Mode of Production to 1960*, London: Routledge.

Burch, N. (1973) *Theory of Film Practice*, trans. H.R. Lane, New York: Praeger.

Burch, N. (1990) *Life to Those Shadows*, trans. Ben Brewster, London: BFI.

Carroll, N. (1988) *Mystifying Movies: Fads and Fallacies in Contemporary Film Theory*, New York: Columbia University Press.

Castoriadis, C. (1997a) 'The imaginary: creation in the socio-historical domain', in *World in Fragments: Writings on Politics, Society, Psychoanalysis, and the Imagination*, ed. D.A. Curtis, Stanford, CA: Stanford University Press, 3–18.

Castoriadis, C. (1997b) 'The state of the subject today', in *World in Fragments: Writings on Politics, Society, Psychoanalysis, and the Imagination*, ed. D.A. Curtis, Stanford, CA.: Stanford University Press, 137–71.

Castoriadis, C. (1997c) 'Radical imagination and the social instituting imaginary', in *The Castoriadis Reader*, ed. D.A. Curtis, London: Blackwell, 319–37.

Cavell, S. (1969) 'The avoidance of love: A reading of *King Lear*', in *Must We Mean What We Say? A Book of Essays*, New York: Charles Scribner's, 267–353.

Cavell, S. (1979) *The World Viewed: Reflections on the Ontology of Film*, enlarged edition, Cambridge, MA, and London: Harvard University Press.

Cavell, S. (1981) *Pursuits of Happiness: The Hollywood Comedy of Remarriage*, Cambridge, MA, and London: Harvard University Press.

Cavell, S. (2005a) '*Groundhog Day*', in *Cavell on Film*, ed. W. Rothman, New York: SUNY Press, 221–2.

Cavell, S. (2005b) 'What photography calls thinking', in *Cavell on Film*, ed. W. Rothman, New York: SUNY Press, 115–34.

Clark, T.J. (1999) *Farewell to an Idea: Episodes from a History of Modernism*, New Haven and London: Yale University Press.

Colebrook, C. (2002) *Understanding Deleuze*, Sydney: Allen and Unwin.

Comolli, J.-L. (1980) 'Machines of the visible', in Teresa De Lauretis and Stephen Heath (eds), *The Cinematographic Apparatus*, London: Macmillan, 121–42.

Cowie, E. (1997) *Representing the Woman: Cinema and Psychoanalysis*, London: Macmillan.

Cowie, E. (1998) 'Storytelling: Classical Hollywood cinema and classical narrative', in S. Neale and M. Smith (eds), *Contemporary Hollywood Cinema*, London and New York: Routledge, 191–208.

Currie, G. (1995) 'Film, reality, and illusion', in D. Bordwell and N. Carroll (eds), *Post-Theory: Reconstructing Film Studies*, Madison: University of Wisconsin Press, 325–44.

Deleuze, G. (1986) *Cinema 1: The Movement-Image*, trans. H. Tomlinson and B. Habberjam, London: Athlone.

Deleuze, G. (1989) *Cinema 2: The Time-Image*, trans. H. Tomlinson and R. Galeta, London: Athlone, 1989.

Deleuze, G. (1995a) 'Doubts about the imaginary', in *Negotiations: 1972–1990*, trans. Martin Joughin, New York: Columbia University Press, 62–7.

Deleuze, G. (1995b) 'On *The Time-Image*' in *Negotiations: 1972–1990*, trans. Martin Joughin, New York: Columbia University Press, 57–61.

Deleuze, G. (2006a) 'Portrait of the philosopher as a moviegoer', in *Two Regimes of Madness: Texts and Interviews, 1975–1995*, ed. David Lapoujade, New York: Semiotexte, 213–21.

Deleuze, G. (2006b) 'The brain is the screen', in *Two Regimes of Madness: Texts and Interviews, 1975–1995*, ed. David Lapoujade, New York: Semiotexte, 282–91.

Deleuze, G., and Guattari, F. (1987) *A Thousand Plateaus: Capitalism and Schizophrenia*, trans. Brian Massumi, Minneapolis: University of Minnesota Press.

Deleuze, G., and Guattari, F. (1994) *What Is Philosophy?* trans. Graeme Burchell and Hugh Tomlinson, London and New York: Verso.

Diderot, D. (1994) *Selected Writings on Art and Literature*, trans. Geoffrey Bremner, London: Penguin.

DiIorio, S. (2007) 'Total cinema: *Chronique d'un été* and the end of Bazinian film theory', *Screen* 48, 1, 25–44.

Doane, M.A. (2003) 'The object of theory', in I. Margulies (ed.), *Rites of Realism: Essays on Corporeal Cinema*, Durham and London: Duke University Press, 280–9.

Foucault, M. (1984) 'What is enlightenment?' in *The Foucault Reader*, ed. Paul Rabinow, New York: Pantheon Books, 32–50.

Frampton, D. (2006) *Filmosophy*, London: Wallflower.

Freud, S. (1955) 'Notes upon a case of obsessional neurosis', in *The Standard Edition of the Complete Psychological Works of Sigmund Freud, Volume X*, Trans. James Strachey, London: Hogarth Press, 153–318.

Freud, S. (1961) *The Ego and the Id*, in *The Standard Edition of the Complete Psychological Works of Sigmund Freud, Volume XIX*, trans. James Strachey, London: Hogarth Press, 1–66.

Freud, S. (1977) 'Fetishism', in *The Pelican Freud Library, Volume 7: On Sexuality*, trans. James Strachey, London: Penguin, 351–8.

Freud, S. (1984) 'The splitting of the ego in the process of defence', in *The Pelican Freud Library, Volume 11: On Metapsychology: The Theory of Psychoanalysis*, trans. James Strachey, London: Penguin, 457–64.

Freud, S. (1990) 'Creative writers and daydreaming', in *The Pelican Freud Library, Volume 14: Art and Literature*, edited by Albert Dickson, London: Penguin Books, 129–41.

Fried, M. (1980) *Absorption and Theatricality: Painting and Beholder in the Age of Diderot*, Chicago and London: The University of Chicago Press.

Fried, M. (1988) *Realism, Writing, Disfiguration: On Thomas Eakins and Stephen Crane*, Chicago and London: The University of Chicago Press.

Fried, M. (1990) *Courbet's Realism*, Chicago and London: The University of Chicago Press.

Fried, M. (1996) *Manet's Modernism, or, the Face of Painting in the 1860s*, Chicago and London: The University of Chicago Press.

Fried, M. (1998) 'Art and objecthood', in *Art and Objecthood: Essays and Reviews*, Chicago IL., and London: The University of Chicago Press, 148–72.

Fried, M. (2002) *Menzel's Realism: Art and Embodiment in Nineteenth-Century Berlin*, New Haven and London: Yale University Press.

Fried, M. (2005) 'Barthes's *Punctum*', *Critical Inquiry* 31, 239–74.

Fried, M. (2008) *Why Photography Matters as Art as Never Before*, New Haven and London: Yale University Press.

Gledhill, C. (ed.) (1987) *Home is Where the Heart Is: Studies in Melodrama and the Woman's Film*, London: BFI.

Grieveson, L. (2004) *Policing Cinema: Movies and Censorship in Early-Twentieth-Century America*, Berkeley, Los Angeles, London: University of California Press

Grodal, T. (1997) *Moving Pictures: A New Theory of Film, Feelings, and Cognition*, Oxford: Clarendon Press.

Gunning, T. (1989) 'An aesthetic of astonishment: Early film and the (in)credulous spectator', *Art & Text* 34, 31–45.

Gunning, T. (1990a) '"Primitive" cinema: a frame up? Or the trick's on us', in T. Elsaesser and A. Barker (eds), *Early Cinema: Space, Frame, Narrative*, London: BFI, 95–103.

Gunning, T. (1990b) 'The cinema of attractions: Early film, its spectator and the avant-garde', in T. Elsaesser and A. Barker (eds), *Early Cinema: Space, Frame, Narrative*, London: BFI, 56–62.

Hallam, J., with Marshmant, M. (2000) *Realism and Popular Cinema*, Manchester: Manchester University Press.

Hansen, M. (1987) 'Benjamin, cinema and experience: "The blue flower in the land of technology"', *New German Critique* 40, 179–224.

Hansen, M. (1999) 'Benjamin and cinema: Not a one-way street', *Critical Inquiry* 25, 306–343.

Hansen, M. (2003) 'Room-for-play: Benjamin's gamble with cinema', *October* 109, 3–45.

Hansen, M. (2008) 'Benjamin's aura', *Critical Inquiry* 34, 336–75.

Harvey, S. (1978) *May '68 and Film Culture*, London: BFI.

Heath, S. (1974) 'Lessons from Brecht', *Screen* 15, 2, 103–28.

Heath, S. (1975) 'Film and system: terms of analysis, part I', *Screen* 16, 1, 1975, 7–77.

Heath, S. (1981a) 'Narrative space', in *Questions of Cinema*, London: Macmillan, 19–75.

Heath, S. (1981b) 'Film performance', *Questions of Cinema*, London: Macmillan, 113–30.

Henderson, B. (1985) '*The Searchers*: An American dilemma', in Bill Nichols (ed.), *Movies and Methods, Volume II: An Anthology*, Berkeley, Los Angeles and London: University of California Press, 429–49.

Jameson, F. (1984) 'Postmodernism, or the cultural logic of late capitalism', *New Left Review* 146, July–August 1984, 53–92.

Joyrich, L. (2004) 'Written on the screen: mediation and immersion in *Far From Heaven*', *Camera Obscura* 19 (issue 57), 186–219.

Kant, I. (1929) *Critique of Pure Reason*, trans. Norman Kemp Smith, London: Macmillan.

Kibbey, A. (2005) *Theory of the Image: Capitalism, Contemporary Film, and Women*, Bloomington: Indiana University Press.

King, G. (2000) *Spectacular Narratives: Hollywood in the Age of the Blockbuster*, London: I. B. Tauris.

King, G. (2005), '"Just like a movie"?: 9/11 and Hollywood spectacle', in G. King (ed.), *The Spectacle of the Real: From Hollywood to Reality TV and Beyond*, Bristol: Intellect Books, 47–58.

Klein, M. (1986) 'The importance of symbol formation in the development of the ego (1930)', *The Selected Melanie Klein*, ed. Juliet Mitchell, London: Hogarth Press, 95–111.

Kracauer, S. (1995) 'Cult of distraction: On Berlin's picture palaces', trans. T.Y. Levin in *The Mass Ornament: Weimar Essays*, Cambridge, MA, and London: Harvard University Press, 323–8.

Krutnik, F. (2002) 'Conforming passions?: Contemporary romantic comedy', in S. Neale (ed.), *Genre and Contemporary Hollywood*, London: BFI, 130–47.

Kuhn, A. (2002) *Family Secrets: Acts of Memory and Imagination*, London: Verso.

Kuhn, A. (2005) 'Thresholds: film as film and the aesthetic experience', *Screen* 46, 4, 229–42.

Lacan, J. (1988) *The Seminar of Jacques Lacan, Book 1: Freud's Papers on Technique, 1953–1954*, ed. Jacques-Alain Miller, Cambridge: Cambridge University Press.

Lacan, J. (1992) *The Ethics of Pychoanalysis, 1959–1960: The Seminar of Jacques Lacan, Book VII*, ed. Jacques-Alain Miller, London: Routledge.

Lacan, J. (1998) *On Feminine Sexuality, The Limits of Love and Knowledge, 1972–1973: Encore, The Seminar of Jacques Lacan, Book XX*, ed. Jacques-Alain Miller, New York: Norton.

Laclau, E. (1997) 'The death and resurrection of the theory of ideology', *MLN*, 112, 3, 297–321.

Laclau, E. (2000) 'Structure, history and the political', in J. Butler, E. Laclau and S. Žižek, *Contingency, Hegemony, Universality*, London: Verso.

Laclau, E. (2005) *On Popular Reason*, London: Verso, 2005.

Laclau, E. (2006) 'Why constructing a people is the main task of politics', *Critical Inquiry* 32, 646–80.

Lee, J. S. (1991) *Jacques Lacan*, Amherst: University of Massachusetts Press.

Lévi-Strauss, C. (1963a) 'Do dual organizations exist?', in *Structural Anthropology Volume 1*, trans. Claire Jacobsen, New York, Basic Books, 132–63.

Lévi-Strauss, C. (1963b) 'The sorcerer and his magic', in *Structural Anthropology Volume 1*, trans. Claire Jacobsen, New York, Basic Books, 167–85.

MacCabe, C. (1985) 'Realism and the cinema: Notes on some Brechtian theses', in *Theoretical Essays: Film, Linguistics, Literature*, Manchester: Manchester University Press, 33–57.

McGowan, T. (2004) 'Lost on Mulholland Drive: Navigating David Lynch's panegyric to Hollywood', *Cinema Journal* 43, 2, 67–89.

McGowan, T. (2007) *The Real Gaze: Film Theory After Lacan*, New York: SUNY Press.

Maltby, R. (2005) 'It Happened One Night', in J. Geiger and R.L. Rutsky (eds), *Film Analysis: A Norton Reader*, New York: Norton, 216–37.

Margulies, I. (1996) *Nothing Happens: Chantal Akerman's Hyperrealist Everyday*, Durham and London: Duke University Press, 1996.

Margulies, I. (ed.) (2003a) *Rites of Realism: Essays on Corporeal Cinema*, Durham and London: Duke University Press.

Margulies, I. (2003b) 'Bodies too much', in I. Margulies (ed.), *Rites of Realism: Essays on Corporeal Cinema*, Durham and London: Duke University Press, 1–23.

Marin, L. (1988) *Portrait of the King*, trans. Martha Houle, Minneapolis: University of Minnesota Press.

Marin, L. (1999) 'Reading a picture from 1639 according to a letter by Poussin', in *Sublime Poussin*, trans. Catherine Porter, Stanford: Stanford University Press, 5–28.

Marrati, P. (2008) *Gilles Deleuze: Cinema and Philosophy*, trans. Alisa Hartz, Baltimore: Johns Hopkins University Press.

Martin-Jones, D. (2006) *Deleuze, Cinema and National Identity: Narrative Time in National Contexts*, Edinburgh: Edinburgh University Press.

Metz, C. (1974a) 'The cinema: Language or language system?', in *Film Language: A Semiotics of the Cinema*, trans. M. Taylor, New York: Oxford University Press, 31–91.

Metz, C. (1974b) 'On the impression of reality in the cinema', in *Film Language: A Semiotics of the Cinema*, trans. M. Taylor, New York: Oxford University Press, 3–15.

Metz, C. (1974c) *Film Language: A Semiotics of the Cinema*, trans. M. Taylor, New York: Oxford University Press.

Metz, C. (1977) '*Trucage* and the film', *Critical Inquiry* 3, 657–75.

Metz, C. (1979) 'The cinematic apparatus as institution – an interview with Christian Metz', *Discourse: Journal for Theoretical Studies in Media and Culture* 3, 7–38.

Metz, C. (1982) *Psychoanalysis and Cinema: The Imaginary Signifier*, trans. C. Britton, A. Williams, B. Brewster et al., London: Macmillan.

Monaco, J. (1978) *Alain Resnais: The Role of Imagination*, London: Secker & Warburg.

Morgan, D. (2006) 'Rethinking Bazin: Ontology and realist aesthetics', *Critical Inquiry* 32, 446–58.

Morin, E. (2005) *The Cinema, or the Imaginary Man*, trans. Lorraine Mortimer, Minneapolis: University of Minnesota Press.

Mullarkey, J. (2009) *Refractions of Reality: Philosophy and the Moving Image*, London: Palgrave.

Mulvey, L. (1989) 'Visual pleasure and narrative cinema', in *Visual and Other Pleasures*, London: Macmillan, 14–26.

Mulvey, L. (2006) *Death 24x a Second: Stillness and the Moving Image*, London: Reaktion.

Olkowski, D. (1999) *Gilles Deleuze and the Ruin of Representation*, Los Angeles, Berkeley and London: University of California Press.

Oudart, J.-P. (1990) 'The reality effect', in N. Browne (ed.), *Cahiers du cinéma, 1969–1972: The Politics of Representation*, Cambridge, MA, Harvard University Press, 248–53.

Panofsky, E. (1995) 'Style and medium in the motion pictures', in *Three Essays on Style*, ed. I. Lavin, Cambridge, MA, and London: MIT Press, 91–125.

Pippin, R. (1997) 'On being anti-Cartesian: Hegel, Heidegger, subjectivity and sociality', in *Idealism as Modernism: Hegelian Variations*, New York, Cambridge and Melbourne: Cambridge University Press.

Pippin, R. (2005) 'Authenticity in painting: Remarks on Michael Fried's art history', *Critical Inquiry* 31, 575–98.

Pisters, P. (2003) *The Matrix of Visual Culture: Working with Deleuze in Film Theory*. Stanford, CA: Stanford University Press.

Pollock, G., Nowell-Smith, G., and Heath, S. (1977) 'Dossier on melodrama', *Screen* 18, 105–19.

Prince, S. (2004) 'The emergence of filmic artifacts: Cinema and cinematography in the digital era', *Film Quarterly* 57, 3, 24–33.

Rancière, J. (2000) 'Cinematic image, democracy, and the "splendour of the insignificant"', *Sites: The Journal of 20th-Century French Studies* 4, 249–58.

Rancière, J. (2002) 'The aesthetic revolution and its outcomes: emplotments of autonomy and heteronomy', *New Left Review* 14, March–April, 133–51.

Rancière, J. (2004a) 'Is there a Deleuzian aesthetics?', *Qui Parle* 14, 2, 1–14.

Rancière, J. (2004b) 'The sublime from Lyotard to Schiller: Two readings of Kant and their political significance', *Radical Philosophy* 126, 8–15.

Rancière, J. (2004c) *The Politics of Aesthetics*, trans. Gabriel Rockhill, New York: Continuum.

Rancière, J. (2006) *Film Fables*, trans Emilio Battista, Oxford: Berg.

Rancière, J. (2007) *The Future of the Image*, trans. Gregory Elliot, London and New York: Verso.

Rancière, J. (2009) *Aesthetics and Its Discontents*, trans. Steven Corcoran, Cambridge: Polity.

Rodowick, D.N. (1994) *The Crisis of Political Modernism: Criticism and Ideology in Contemporary Film Theory*, 2nd edition, Urbana: University of Illinois Press.

Rodowick, D.N. (1997), *Gilles Deleuze's Time Machine*, Durham: Duke University Press.

Rodowick, D.N. (2007), *The Virtual Life of Film*, Cambridge, MA, and London: Harvard University Press.

Rosen, P. (2003) 'History of image, image of history: Subject and ontology in Bazin', in I. Margulies (ed.), *Rites of Realism: Essays on Corporeal Cinema*, Durham and London: Duke University Press, 42–79.

Rosenbaum, J. (1995) 'The importance of being perverse: Godard's *King Lear*', in *Placing Movies: The Practice of Film Criticism*, Berkeley and Los Angeles: University of California Press, 184–9.

Rothman, W. (2003) 'Cavell on film, television, and opera', in Richard Eldridge (ed.), *Stanley Cavell*, Cambridge: Cambridge University Press, 206–38.

Rothman, W. (2008) 'Bazin as a Cavellian realist', *Film International* 30, 54–61.

Rothman, W., and Keane, M. (2000) *Reading Cavell's The World Viewed: A Philosophical Perspective on Film*, Detroit: Wayne State University Press.

Rushton, R. (2007) 'Douglas Sirk's theatres of imitation', *Screening the Past* 21. www.latrobe.edu.au/screeningthepast/21/douglas-sirk-theatres-imitation.html.

Rushton, R. (2008) 'Passions and actions: Deleuze's cinematographic *Cogito*', *Deleuze Studies*, 2, 2, 121–39.

Rushton, R. (2009) 'Deleuzian spectatorship', *Screen* 50, 1, 45–53.

Rushton, R. (2010) 'Acknowledgement and unknown women: The films of Catherine Breillat', *Journal for Cultural Research* 14, 1, 85–101.

Shaviro, S. (1993) *The Cinematic Body*, Minneapolis: University of Minnesota Press.

Silverman, K. (1996) *The Threshold of the Visible World*, New York and London: Routledge.

Stacey, J. (1994) *Star Gazing: Hollywood Cinema and Female Spectatorship*. London and New York: Routledge.

Staiger, J. (1984) '*Theorist*, yes, but what *of*? Bazin and history', *Iris* 2, 2, 99–109.

Stam, R., and Flitterman-Lewis, S. (1992) *New Vocabularies in Film Semiotics: Structuralism, Post-Structuralism, and Beyond*, London and New York: Routledge.

Thompson, K. (1999) *Storytelling in the New Hollywood: Understanding Classical Narrative Technique*, Cambridge, MA, and London: Harvard University Press.

Willeman, P. (1977) 'On realism in the cinema', *Screen Reader 1: Cinema / Ideology / Politics*, London: The Society for Education in Film and Television, 47–55.

Wilson, E. (1998) '*Three Colours: Blue*: Kieślowski, colour and the postmodern subject', *Screen* 39, 4, 349–62.

Wollen, P. (1981) 'Towards an analysis of the Sirkian system', in *Screen Reader 2: Cinema and Semiotics*, London: The Society for Education in Film and Television, 11–22.

Wollen, P. (1985) 'Godard and counter cinema: *Vent d'Est*', in B. Nichols (ed.), *Movies and Methods, Volume II: An Anthology*, Berkeley, Los Angeles and London: University of California Press, 500–9.

Žižek, S. (1989) *The Sublime Object of Ideology*, London: Verso.

Žižek, S. (1991) *Looking Awry: An Introduction to Jacques Lacan Through Popular Culture*, Cambridge, MA, and London: MIT Press.

Žižek, S. (1992a) *Enjoy Your Symptom! Jacques Lacan in Hollywood and Out*, New York and London: Routledge.

Žižek, S. (1992b) *Everything You Always Wanted to Know About Lacan (But Were Afraid to Ask Hitchcock)*, London and New York: Verso.

Žižek, S. (1993) *Tarrying with the Negative: Kant, Hegel, and the Critique of Ideology*, Durham: Duke University Press.

Žižek, S. (1997) *The Plague of Fantasies*, London: Verso.

Žižek, S. (2000) *The Art of the Ridiculous Sublime: On David Lynch's Lost Highway*, The Universiy of Washington Press..

Žižek, S. (2001) *The Fright of Real Tears: Krzysztof Kieślowski Between Theory and Post-Theory*, London: BFI.

Žižek, S. (2002) *Welcome to the Desert of the Real: Five Essays on September 11 and Related Dates*, London: Verso.

Žižek, S. (2004) *Organs Without Bodies: Deleuze and Consequences*, New York and London: Routledge.

Žižek, S. (2005) 'Between symbolic fiction and fantasmatic spectre: Toward a Lacanian theory of ideology', in *Interrogating the Real*, ed. Rex Butler and Scott Stephens, New York Continuum.

Žižek, S. (2006a) 'Against the populist temptation', *Critical Inquiry* 32, Spring, 551–74.

Žižek, S. (2006b) '*Schlagend, aber nicht Treffend!*', *Critical Inquiry* 33, Autumn, 185–211.

Žižek, S. (2008) *In Defence of Lost Causes*, London and New York: Verso.

Index